Faces of the
Twentieth Century

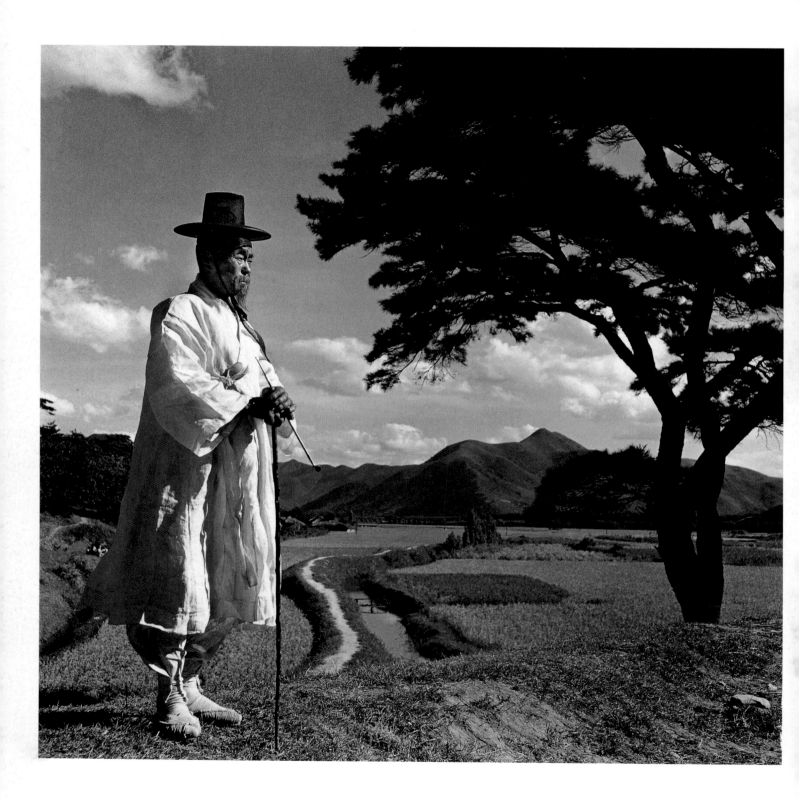

Faces of the
Twentieth Century

Master Photographers and Their Work

Mark Edward Harris

Foreword by Vicki Goldberg

Abbeville Press
Publishers
New York
London
Paris

To my first photography teacher, Bob Harris, to my first editor, Sheila Harris, and to Ana Jones, who provided me with a forum for my initial interviews.

Front cover: Edouard Boubat, *Paris, 1952* (see page 98).

Back cover: Gordon Parks, *Muhammad Ali after the Henry Cooper Fight in London, England,* 1966 (see page 69).

Page 2: Horace Bristol, *Korean Patriarch,* 1946.

Page 6: Edouard Boubat, *India,* 1964.

Page 8: Mary Ellen Mark, *Wealthy Retirement Community, Santa Barbara, California,* 1985.

Editor: Owen Dugan
Designer: Molly Shields
Production Editor: Meredith Wolf Schizer
Typesetter: Barbara Sturman
Production Manager: Lou Bilka

First edition
10 9 8 7 6 5 4 3 2 1

B12 822 518 0

Library of Congress Cataloging-in-Publication Data

Harris, Mark Edward.
 Faces of the twentieth century: master photographers and their work / Mark Edward Harris.
 p. cm.
 Includes bibliographical references and index.
 ISBN 0-7892-0334-0
 1. Portrait photography. 2. Photography, Artistic. I. Title.
TR680.H28 1998
779'.092'2—dc21 97-44129

Contents

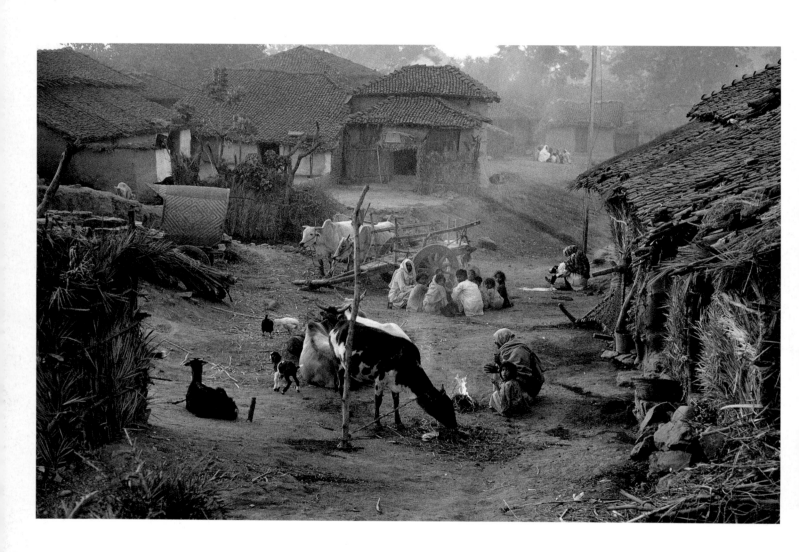

Foreword

by Vicki Goldberg

The Renaissance had its frescoes, the twentieth century its photographs. In both eras, history got tied up and handed down in images—religion and its controversies, wars and their effects, cultural ideals. And though most of the world is more literate today than centuries ago, millions still learn about major events and icons of contemporary worship from artistic representations, no longer made by Raphael and Michelangelo but by men and women with cameras and plane tickets and determination.

It is not just the recording means that are different but the intent of the record as well. In earlier centuries, the central images represented what was already known. The art that illustrated Greek legends or bible stories was meant for people who knew the tales by heart or were hearing explanations by poets or preachers even as they looked. The pictures merely made vivid in the present what had long since been established in the culture.

Photographs, on the other hand, deliver new information. They reveal what no one could have known before because it had not happened: MacArthur wading ashore in the Philippines, a flag rising over Iwo Jima. Or people and places shut off from us by time, or distance, or lack of access: migrant laborers during the Depression, Shinto celebrants in Japan, a gang in Harlem.

And then the camera freezes moments that sum up new movements and responses: a young woman offering a flower to soldiers with fixed bayonets. Even photographic fictions and styles can amount to news bulletins about the culture: nudes in neck braces, fashion as extraterrestrial fantasy.

Photographic news persists while the events themselves pass away. Images mumble and shout, they romp, they glow in memory. We forget an acquaintance's name and a friend's address but recall the sailor who kissed a nurse so passionately in Times Square on V-J day. The photographs haunt us. They are the unresting ghosts of our common past, and we would not rid ourselves of them if we could, for fear of losing too much of our history and heritage.

But each of us sees a photograph just a bit differently, and each photograph's meaning can shift when its context does. Alvarez Bravo's image of a shopfront full of eyes speaks of voyeurism beside his photograph of a reclining nude. The layers of meaning in Elliott Erwitt's picture of a black boy who laughs while holding a toy gun to his own head grow even deeper beside Erwitt's image of a woman grasping the pistol of a slot machine that masquerades as a cowboy.

Some photographers are wise about the nature of their work (and others no smarter than the rest of us). Carl Mydans remarks that even the man with the camera cannot recall all the great images he somehow missed. Mary Ellen Mark expresses the photographer's passion for the world: "You can never art-direct reality, it just brings itself to you. You can never do anything better than what's real."

Even in the last, digital years of the twentieth century we cling to the remnants of reality, the camera's compact transcriptions of the world. Photography stubbornly, persistently records new information and then delivers history and culture, in a fraction of a second, directly to the storehouse of the mind.

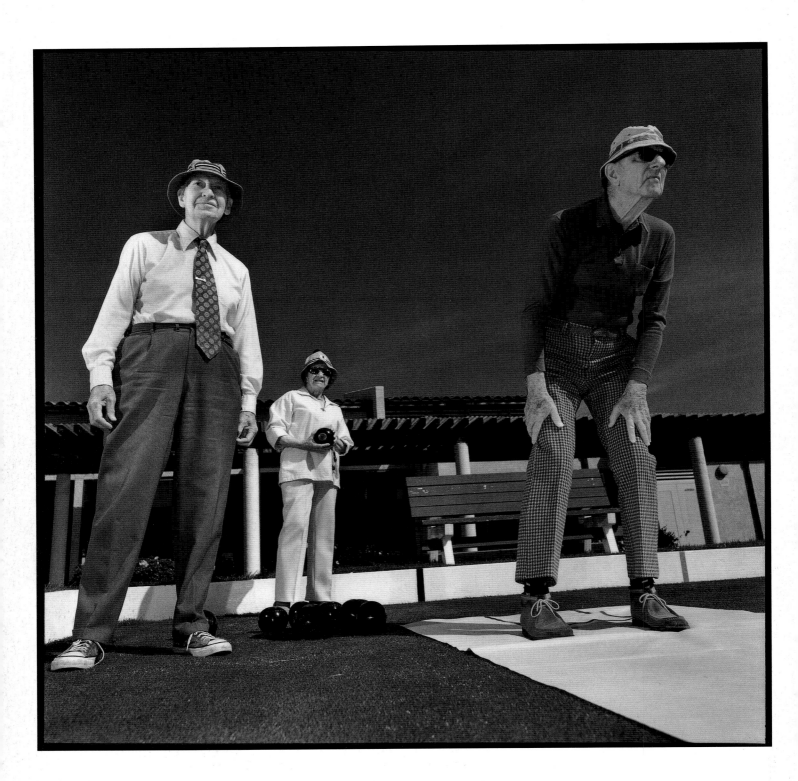

Introduction

by Mark Edward Harris

When the Gregorian calendar indicates the year 2000, we will have completed the first century in history with a complete photographic record of itself.

This book is about photographers who helped put a face on the twentieth century. Their approaches differ in subject matter and style, yet there is a continuity in their vision. Alfred Eisenstaedt's portrait of a Japanese woman and her son sitting amid the rubble of Hiroshima and Herb Ritts's Masai mother and child bear striking similarities, even though these two photographers at face value might seem antipodal in approach. In each image the photographer has captured the strength of the human spirit.

For this book, which originated as a series of interviews for *Camera & Darkroom* magazine, I interviewed and photographed a cross section of the many great photographers who through their visual awareness and technical prowess have documented the events and personalities of their time. Their candidness and unflagging generosity are acknowledged and deeply appreciated.

At the turn of the twentieth century individuals were exploring this planet, fixing the shadows of subjects that inspired them, creating visual records of people, places, and things as they were at a specific moment that, once past, would be gone forever. While Eugène Atget photographed his beloved Paris, Edward S. Curtis used his camera to document a vanishing people and published a twenty-volume survey on the customs and way of life of Native Americans. The photographic firm of Raja Deen Dayal in India produced before-and-after photographs to show the positive effects of a food relief program for starving people in Ayurangabad. Waldemar Franz Herman Titzenthaler photographically documented living and working conditions in his native Germany, while Lewis W. Hine, who had planned to be a teacher, educated America with his camera by documenting the plight of child laborers and, later, war relief programs and the depression era. His book *Men at Work* includes extraordinary images of the construction of the Empire State Building from start to finish.

Arnold Genthe's 1906 *Smoke and Flames after the San Francisco Earthquake* and Alfred Stieglitz's *The Steerage*, which transports us into the world of immigrants in 1907, are early-twentieth-century representatives of single images that tell a significant story.

Stieglitz, Atget, Curtis, Hine, Jacques-Henri Lartigue, Imogen Cunningham, Edward Steichen, Paul Strand, André Kertész, Man Ray, Brassaï, László Moholy-Nagy, Robert Capa, Alexander Rodchenko, Dorothea Lange, Ansel Adams, Edward Weston, W. Eugene Smith, and other members of the photographers' pantheon have left the physical world, but they live on in their work and in the words, actions, and

images of current generations of photographers. Many of them have been cited as inspirations by the photographers interviewed here. Like their photographic forefathers and mothers—without exception—the descendants have tapped into their own souls to put something of themselves into every picture. And they too will inspire photographers setting out to reveal the face of the twenty-first century.

The men and women in this book have not only photographically recorded history from their unique perspectives; they have often been participants in its dramatic moments.

As I sat face-to-face with Alfred Eisenstaedt in his twenty-eighth-floor *Life* magazine office, stacked to the ceiling with proof sheets, prints, books, and correspondence, he vividly recounted to me the afternoon of April 12, 1918. His eyes glazed over as he went back to that day. Placing my hand on the bump on his left leg, he described how as a soldier in the German army he was wounded in both legs so badly that at first it seemed necessary to amputate. Twenty-seven years, a continent, and another war later, "Eisie" was in Times Square shooting for *Life:* "I ran ahead of the sailor because he was grabbing any woman in sight . . . fat or thin. But as he was in navy blue and everybody he grabbed was also wearing dark clothes, you couldn't see. So I ran ahead of him. When I looked over my shoulder he grabbed somebody in white, and I photographed four or five pictures of the same thing. I turned the film in and forgot about it. The next day they told me what a great picture I had made and I said, 'What picture?'"

Joe Rosenthal, speaking of his historic Iwo Jima flag-raising photo, taken earlier in 1945—wrongly accused of being a set-up shot—echoes Eisenstaedt: "I had no notion that anything historic had happened though I thought it should be a good shot if I got it . . . but you don't say 'tell the office I got it' until it's developed."

Carl Mydans had a similar experience with his image of General Douglas MacArthur's dramatic return to the Philippines, and he recognizes that it is more the norm than the exception. "In many cases photographers who have made what have come down through the years as historical pictures were not aware when they pressed the shutter that what was frozen in their camera was a great picture."

Years earlier, advice to a young Carl Mydans from Roy Stryker, head of the photographic division of the Farm Security Administration (FSA) in the 1930s, helped clarify what he was to look for as an FSA photographer documenting the devastation across the forty-eight United States. Mydans would find that "what was happening to the people during these depression years would be written on their faces."

Horace Bristol was acutely aware of this, recalling his trips with John Steinbeck to central California to document the plight of the migrant workers who had fled Oklahoma during the Great Depression. Bristol's images ran in *Life*, while Steinbeck's impressions were expressed in his literary epic *The Grapes of Wrath*.

Half a century later and at the opposite end of the economic strata, Peter Lindbergh's studies of the faces of supermodels are an interesting contrast to the depression-era images. Using the same medium to interpret his subjects—black-and-white film—Lindbergh has been able to pierce the facade of glamour to show us the person underneath.

While some photographers may be decidedly aware of where their work is coming from, Manuel Alvarez Bravo in our discussion acknowledges that, even though the Aztec influence on Mexican society and growing up in revolutionary Mexico have greatly affected his work, "One doesn't really know how one receives influences. One just receives them and absorbs them. It's like food. You eat it and then it affects you."

Like Bravo in Mexico, Eikoh Hosoe in Japan and Brazilian-born Sebastião Salgado give their unique perspectives on life and photography outside the so-called Western world.

The twentieth century, like all those preceding it, has had its share of warfare. Photographic documentation of military conflicts started in the nineteenth century with the Mexican-American War (1846–48), followed by Roger Fenton's in-depth coverage of the Crimean War (1853–56), Felice Beato's recording of the Second Opium War (1856–60), and the massive efforts of Mathew Brady and his team of photographers during the Civil War (1861–65), with numerous skirmishes covered in between. Because of technical limitations, war coverage concentrated on environmental portraits of soldiers and on the aftermath of battles. A landscape of Civil War dead following the bloodbath at Gettysburg, *The Harvest of Death* by Timothy H. O'Sullivan, serves only too well as an example.

Exposures using wet-collodion plates—the most popular method of the day, which replaced the even slower daguerreotype—were counted in seconds, not fractions thereof. But the scenes of misery that bring us down to what war is—man killing man—have not changed, though their recording has. Late-nineteenth- and early-twentieth-century photographic technology has given us the ability to freeze moments in battle, while more sensitive films allowing for faster shutter speeds and more

compact camera designs have given photographers the equipment they needed to react spontaneously to action on the battlefield.

Photography—an invention of the early decades of the nineteenth century—had by 1900 evolved to the point where it could be utilized to document moments of real life in real time. As Naomi Rosenblum points out in her *World History of Photography*, Alfred Stieglitz, after opposing the hand camera for years, by 1897 "had come to regard it as an important means of evoking the character of contemporary life. His suggestion that those using the hand camera study their surroundings and 'await the moment when everything is in balance,' seems to have forecast a way of seeing that thirty years later became known as the 'decisive moment.'"

The ability to capture the decisive moment—theorized and practiced so skillfully by Henri Cartier-Bresson—has been greatly aided by the advent of the 35mm camera. Andreas Feininger, with his selection of a 35mm camera as a prop in his portrait *The Photojournalist*, acknowledges that since the introduction of the Leica in 1925 the 35mm camera has been the overwhelming choice of photojournalists for recording events as they happen. Robert Capa's *Death of a Loyalist Soldier*, taken in 1936 during the Spanish Civil War, and Eddie Adams's *Street Execution of a Viet Cong Prisoner*, taken half a world and a little more than three decades later, are 35mm images indelibly woven into the visual fabric of this century. Within the category of war photography, scenes of compassion have given us ripples of hope in a sea of misery, perhaps no images more strongly than W. Eugene Smith's World War II photograph of a U.S. Marine holding a Saipanese baby.

After World War II a humanistic view of life in the vein of Smith was needed to shake off the scenes of devastation that overwhelmed the world. Nowhere was this movement stronger and perhaps more necessary than in France, where photographers including Robert Doisneau, Willy Ronis, Edouard Boubat, and Sabine Weiss highlighted the simple goodness of daily life. Boubat explains: "After the war, we felt the need to celebrate life, and for me photography was the means to achieve this." Jean-Philippe Charbonnier, who during the liberation of France recorded one of the most dramatic sequences of the century—a chronology of an execution of a collaborator—on one roll of 35mm film, turned his lens toward images that celebrated life after the last bullet of World War II was fired in 1945.

Marc Riboud, Sebastião Salgado, Gordon Parks, and Mary Ellen Mark continue to exemplify the postwar humanist approach. Brazil-born Salgado feels his photography and the work of others can spark dialogues that might lead to solutions to global problems. A trained economist with an acute awareness of the world economic situation and its effect on the environment and Third World countries, Salgado voices a global, humanist point of view: "The photographs that I do in places like the Sahel I do because I trust that with these pictures we can discuss problems— huge problems. . . . I don't believe in a quick solution to these problems. But humanity is just one humanity." Mary Ellen Mark, whose work, like Salgado's, shows an intimacy with and a compassion for her subjects, discusses her motivation: "I'm interested in the guy that doesn't have all the breaks in life and the people who live on the edge." Gordon Parks experienced years of racial injustice but refused to be a victim. We talked about how he was able to overcome

adversity to rise to the top of his field and gain a perspective on twentieth-century race relations.

Not all of life, of course, is a world event or serious issue. Perhaps no one is better at capturing the more subtle human and humorous aspects of our existence than Elliott Erwitt, who points out: "Life is not only misery and hysteria, it's also everything in between."

Other master photographers— Jeanloup Sieff, Herb Ritts, Peter Lindbergh—capture the beauty of our existence in the human form. They also create photographic movements along the way. In the 1980s Lindbergh, along with Bruce Weber, gave fashion a new direction with very real, reportage-style images.

In an occupation that tends to cubbyhole its practitioners into specific categories—documentary, fashion, product, fine art—with subdivisions of each, Annie Leibovitz has been able to rise above the status quo, moving back and forth between photographing celebrities in a controlled environment, often with highly stylized set design, and powerful reportage assignments. Her celebrity portraits are revealing documentary pieces. John Lennon and Yoko Ono's embrace photograph invites us to linger and study, perhaps gaining insight into the couple's relationship and the celebrity mystique. Eve Arnold had numerous photo sessions with Marilyn Monroe, and reveals for us the complex life of one of this century's most photogenic icons.

As with Leibovitz, Helmut Newton's strong personality comes through in his photographs, and he has used the camera to expose and attack the sexual mores of the last four decades of the century.

What becomes apparent in these interviews is that the singular vision that creates a photographic style, if it is to have any depth, comes from

within. Too often the demand put on young photographers, at times self-inflicted, to "have a style," causes many to try consciously to create a certain look. That outward search tends to lead to catching the tail end of the latest trend, leaving the body of work shallow. Eisenstaedt said that young people today want to learn overnight what took him a lifetime. Marc Riboud advises, "By looking very intensely we improve our way of seeing and our way of photographing and we develop a personal style." "Don't go out and search for a style, shoot what you feel and what you're inspired by" are words that echo in one form or another from each of the photographers. The strength of Atget's and Curtis's work a century after it was created stands as testimony to this. At the end of the twenty-first century the work and words of the photographers included here will undoubtedly do the same.

Among the extraordinary experiences I have had during the course of research for this book is a day I spent in Provence with Henri Cartier-Bresson and his wife, Belgian photographer Martine Franck, in August 1994. Before lunch Cartier-Bresson soon proved that his wit is as quick as his legendary eyes. Looking through an issue of *Camera & Darkroom,* he quipped, "You should change the name of the magazine to *A Dark Camera That Doesn't Take Room,* that's the only way to get good photographs. My Leica doesn't take room. It's the size of my hand. For me it has to be a very small camera and unnoticed."

Our only other discussion about equipment that day was about lenses: "With the wide angle, only once in a while, if the composition needs it . . . it works. But it's a trick. So many people use it as a permanent

thing. It shows very much. It's like a dish that has garlic."

We talked about farming in the region, and he explained how the "little people" were getting squeezed out. "The farmer here pays his debt to the bank for buying a piece of equipment, for three years. He leaves farming to become the *patron* [manager] of a bistro. It's abominable. Any Tom, Dick, or Harry can run a bistro, but a farmer . . . no, it takes generations." He suggests that I talk with Salgado, a trained economist, about this the next time I see him. "What does progress really mean? Computers replace imagination. Television is just something to swallow. At least radio uses some imagination."

While he declined to have his portrait taken and did not want to discuss his life in photography in any great detail—"that was twenty years ago"—Cartier-Bresson was happy to chat about life in general, reminisce about a few old friends, and tell me about his continued enjoyment of drawing. While he still shoots an occasional portrait, he hasn't done reportage since the early 1970s, when he decided to concentrate on drawing. But it became apparent that he had not lost interest in the photographic medium.

Looking through my portfolio of photographers' portraits, Cartier-Bresson spots an old friend: "I like Carl very much." I mention the fact that Carl Mydans covered five wars. "It can become addictive." Looking at a photograph of Edouard Boubat and renowned printer Pierre Gassmann: "Photography to me is about capturing the instant . . . instant drawing. That's why I had no interest in the darkroom, I had others like Pierre Gassmann to print." Looking at Manuel Alvarez Bravo's picture: "Somebody who is not known was his first wife Lola. She was a very

good photographer." He was astonished to hear that Eisie was still alive at the time of our first meeting: "Eisie's alive? Wooo! [Looking at the photograph of Eisie] He's doing very well. [Gjon] Mili did a very good film on Eisie. He was a company man. He's got his luggage there with his cameras all ready. A phone call . . . out he goes. It doesn't matter if he likes a story or not. There is something innocent about him."

There was something very innocent about Eisie. He lived as full, as long, and as good a life as anybody could ever hope to, but when he died a year later in August 1995, it was still a very sad day. I was honored when *Life* picture editor Marie Schumann telephoned me and said that they would like to run my portrait of Eisie as a final full-page memorial to him. Eisie had said that this was his favorite portrait of himself.

At the conclusion of each interview session I shot a simple environmental portrait of my interviewee, almost always using ambient light. The shoot usually lasted no more than a roll or two and in some cases, just a few frames. I've been asked how it felt to photograph these elite photographers. "Were you intimidated?" Intimidated, no. In awe, on more than one occasion.

As we move into the next millennium, the technology to fix a shadow—a dream of man since antiquity, a reality since the 1820s—continues to evolve, with high-quality motion picture, videotape, and digital possibilities. Yet the still image remains an irreplaceably powerful force—a moment in time frozen forever, to be studied and contemplated, capable of being far more moving in one sense than its motion picture counterparts.

Faces of the Twentieth Century

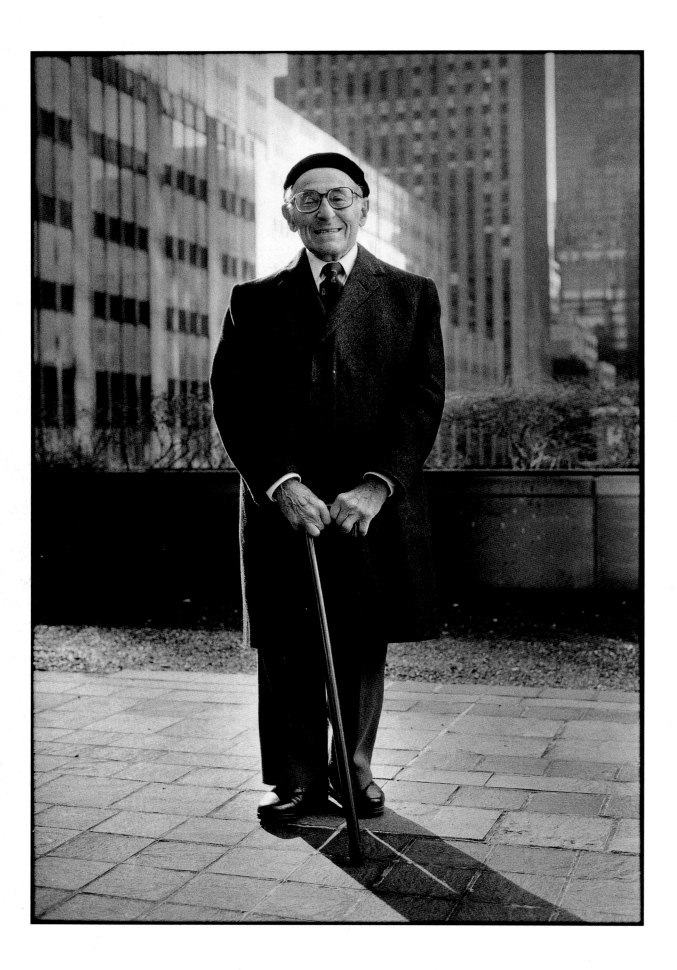

Alfred Eisenstaedt

In 1911 I got a camera from an uncle of mine. It was an Eastman folding camera #3 with red bellows. I photographed like any other young boy. I photographed just nonsense, like any amateur. I bought a daylight processing kit. I used the bathroom of my parents to develop everything. At sixteen and a half I was drafted into the German army. I was wounded on April 12, 1918. It was four in the afternoon. I got shot through both legs. They wanted at first to amputate my legs, but fortunately it wasn't necessary. After the war I became a salesman of belts and buttons. One of the most important pictures of mine happened in 1927 while I was on vacation with my parents in Bohemia. It was of a woman playing tennis. When I returned home, I printed it. It didn't look like anything. But a friend of mine who was also dabbling in photography told me that I could enlarge it. I had never heard that word before. I never studied photography formally. I said, "What's that?" He said, "Come to me and I'll show you." He slid my Zeiss Ideal 4x5 camera into some sort of wooden contraption with a matt bulb. He showed me that by enlarging, you can take everything out of the picture that you don't want. This opened my eyes. The picture of the tennis player is only of the tennis player and her shadow. But in the original print there are trees and benches and everything. Somebody said that I should show this photograph to a magazine called *Der Foto Freund*. I showed it, and it was printed in the magazine. Then I showed it to the weekly German equivalent of the *New York Times Magazine*, called *Der Welt Spiegel*, and the editor said, "I'll take it and I'll give you twelve marks [about three dollars]." I was such a virgin at that time. I said, "You can sell pictures?" I didn't know anything. He said, "Yes, and bring me more pictures like this. It was a beautiful picture." The editor of that magazine told me that if I want to go into photography I should buy the same type of camera that Dr. Erich Salomon used. He was a hero of mine. So I bought an Ermanox camera, a perfect camera for taking candid pictures. Then I met people from Pacific and Atlantic Photos [later the Associated Press] and started working for them as a freelancer. I did an enormous amount of parties, openings—especially music. My boss for selling belts and buttons told me I was a very bad salesman and to make up my mind within a week about what I wanted to do. I told him a week later that I was switching to photography. He had never heard that word. He looked at me as if I had lost my mind.

Joseph Goebbels, 1933

I photographed Goebbels in 1933 in Geneva four months after he became
propaganda minister. I was at the end of a row of three or four photogra-
phers. He talked to them and smiled at them. Then they left and I was
alone with Goebbels. He looked at me and saw an enemy. I also photo-
graphed him arriving in Geneva with his bodyguards. He was surrounded
like Castro. A few weeks later after I arrived back in Germany, two swas-
tika'd people who were Goebbels's bodyguards arrived at my apartment.
I thought they wanted to arrest me. But they were very friendly. They only
wanted the pictures that I had taken with them in it for souvenirs. Earlier,
before the Nazis had come to power, I went one evening to a movie. Inside,
some Nazis had created a disturbance. The police, who were then anti-Nazi,
surrounded the theater. I was arrested with all these Nazis. I was brought
in a van to police headquarters, where I sat with Reinhard Heydrich, who
when the Nazis came to power was responsible for killing hundreds of people.
[Known as "the Hangman," Heydrich was chief of the Gestapo until he was
assassinated in 1942.] At one point Heydrich pushed me aside and I fell to
the floor. I was interviewed by the police the next day, and they wanted
me to file charges against him, but I wouldn't do it. If I had, I wouldn't be
alive today. I left Germany in November of 1935 because I saw no future
there. Because I was a veteran of the World War, I had permission to take
all my possessions with me when I moved to New York. I was very fortu-
nate. At that time Mr. Kurt Korff, a former editor of the *Berliner Illustrierte
Zeitung*, got in touch with Mr. Luce for me. I worked as a freelancer for
Time on a project that was called "Magazine X." I did two dummies.
They told me if this magazine should ever be born, I would become a
staff member along with Margaret Bourke-White, Thomas McAvoy, and
Peter Stackpole. The magazine was *Life*.

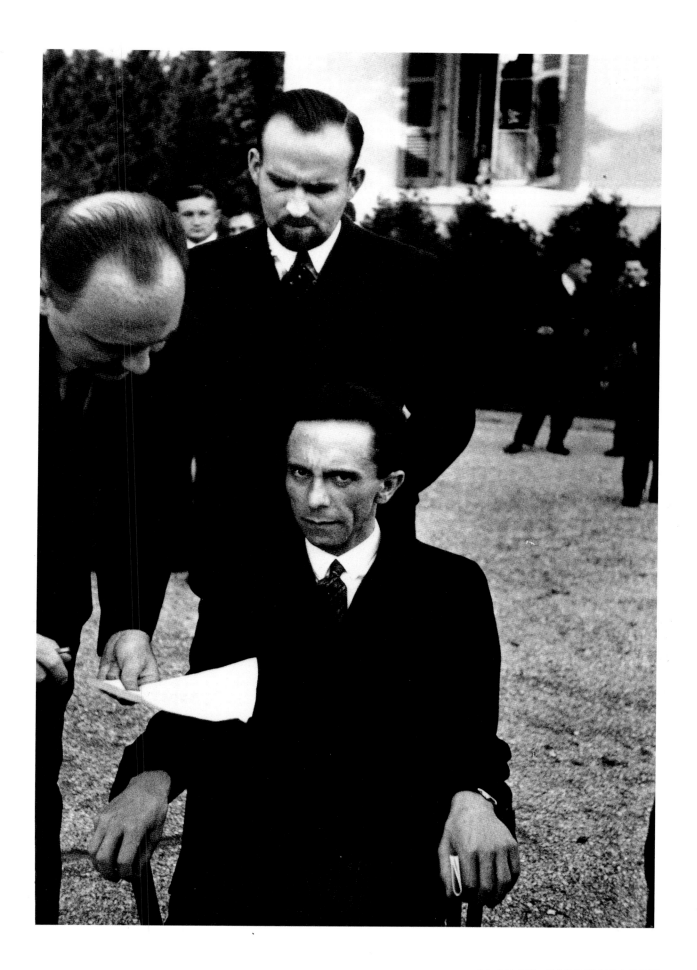

V-J Day Celebration in Times Square, New York City, 1945

I got an assignment to cover Times Square. I photographed an enormous amount of film, five or six rolls. I ran ahead of the sailor because he was grabbing any woman in sight . . . fat or thin. But as he was in navy blue and everybody he grabbed was also wearing dark clothes, you couldn't see. So I ran ahead of him. When I looked over my shoulder he grabbed somebody in white, and I photographed four or five pictures of the same thing. I turned the film in and forgot about it. The next day they told me what a great picture I had made and I said, "What picture?" And then I remembered it, a snapshot, an accident. I had no idea. There was so much going on at that time.

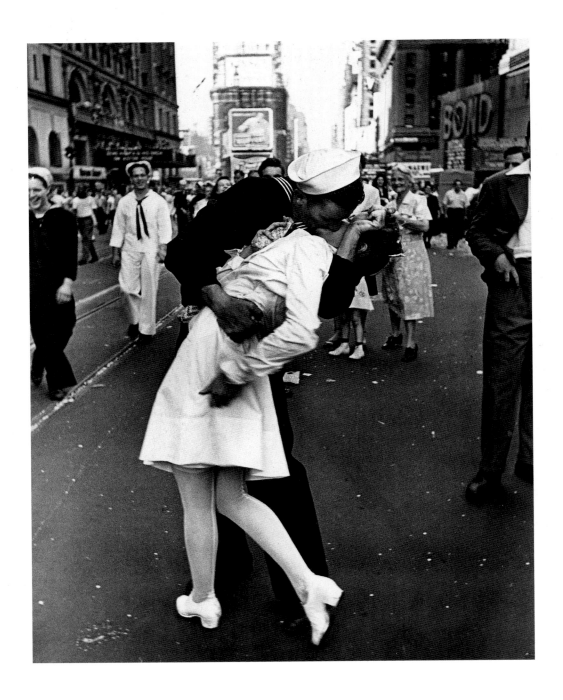

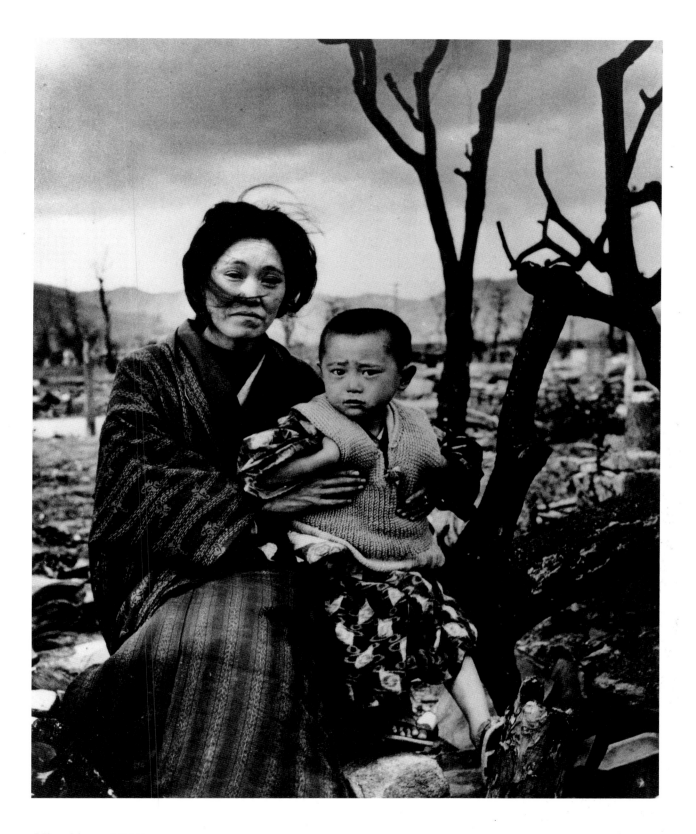

Hiroshima, 1946

In 1946 I went to Tokyo and photographed General MacArthur. Then I
flew in a Piper Cub to Hiroshima and Nagasaki. It was cold. It was terrible.
Everything was destroyed.

Sophia Loren in Character for the Movie
Marriage Italian Style, *Rome,* 1964

I've done so many assignments that I liked. I'm interested in everything.
I get along with people. I'm rereading my diaries and I just can't believe
how much I was working . . . day and night. I would come to the office
and they would say, "Tomorrow you're leaving for Akron, Ohio," and the
next afternoon I'd come back and go somewhere else. You see, I like almost
everything. I mean, there are things that I liked more and things that I liked
less. One thing I didn't like was to work at night. At night I want to sleep.
I get up between four and four-thirty in the morning, even if I go to bed
late after covering a theater opening. When I went on trips I had two or
three Nikons and two or three Leicas and loads of lenses. I used mostly
35mm, 50mm, and 90mm lenses. Some of the nicest assignments I've ever
had were the cover stories on Sophia Loren. We received over 2,500 letters
of complaint about the cover of Sophia in lingerie. One mother wrote that
she had to tear the cover off not to spoil the morals of her soldier boy in
Vietnam. He probably took coca leaves
and went with prostitutes. They had no
idea what was going on over there. This
was a decent picture compared to now.
Look at Madonna. . . . Young photogra-
phers don't come to me and ask me for
advice. No, I ask them for advice. They
know more about new cameras and new
techniques than I do. I admire them,
I'm not old-fashioned, I'm going with
the times. But you see, today is different.
It took me almost a lifetime to grow to
what I am now, but young people want
to do it in a few months.

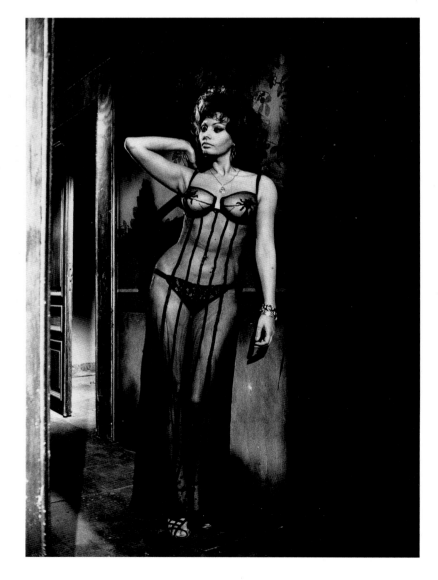

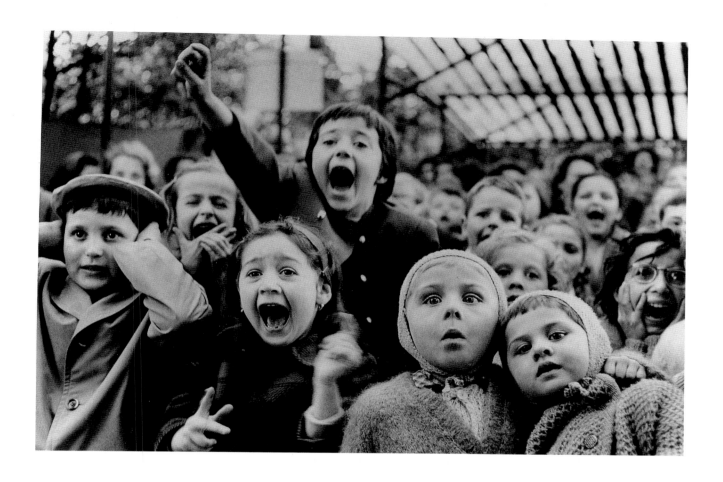

*Children Watching the Story of "Saint George and the Dragon"
at the Puppet Theater in the Tuileries, Paris,* 1963

1976

I love color more than black and white. But for exhibition black and white
is the only one. Do you remember the puppet theater photograph? In color
it wouldn't look good. Black and white for an exhibition looks so much
better, no comparison. But I love color. When I shoot flowers or fashion, it's
color. I would have loved to do more nature assignments like the one I did
in the Galápagos Islands. I'm a nature boy. But they told me—and they
were probably right—that I speak very easily with people.

Manuel Alvarez Bravo

As a boy, whenever I wouldn't go out with my friends on Sundays, I would go to one of two museums that were very close to where I lived. I lived in what is now called the Centro Histórico, where the pyramid in Mexico City's center was discovered and where all the digging is taking place to uncover it. One museum was the Anthropology and History Museum, which has pre-Hispanic art. This work is very important to me because of the cultural heritage. The other museum was the San Carlos Museum, which contains European art. At first I went there simply because I lived nearby. It had a great influence, but one doesn't really know how one receives influences. One just receives them and absorbs them. It's like food. You eat it and then it affects you. We are all, of course, influenced by what surrounds us culturally, physically, politically. But how that emerges from my work is for others to interpret. When one takes a photograph, one doesn't think about saying anything in particular. One doesn't think about making a statement but rather about creating something visual, which can later bear a meaning that one didn't intend to transmit, depending upon the viewer's interpretation but not necessarily on the photographer's. I work by impulse. No philosophy. No ideas. Not by the head but by the eyes. Eventually inspiration comes. Instinct is the same as inspiration, and eventually it comes.

I've never had a fixed path to follow. I must say that throughout my life I've never pursued anything. I just let things pursue me . . . they just show up. I'm never after things. Whatever shows up, I take. This is the way I've led my life, not just in photography, but in life.

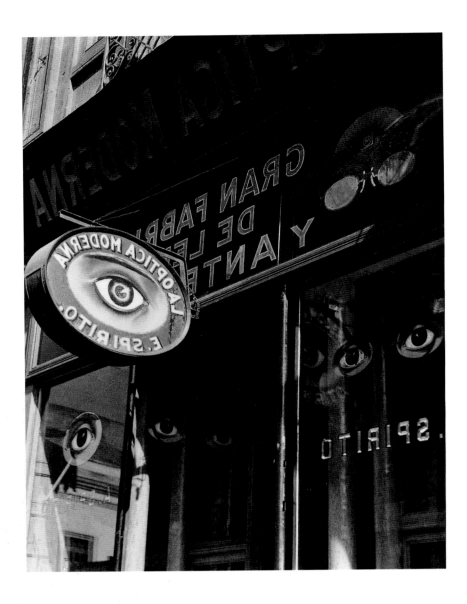

Parábola Optica *(Optical Parable)*, 1931

The name says it all; things are not like they seem to be, they're like a parable. When you stand in front of a window you see something one way. Then when you go inside you see it's the other way around. So that's why I've printed the image in reverse. I taught myself how to photograph and how to print. I had finished school early. It was closed at one point because of the revolution, and I never went back. I went to work instead. First I worked at a company that manufactured textiles, and then a year later at fourteen I took up a job in the government as a bureaucrat. I held several positions in the government. I was a good worker. At one time I was awarded the *Meritorio de la Tesorería* [a certificate of merit for work in the treasury] by Venustiano Carranza, who was the leader of the Constitutionalist Army. I never stayed in one job in the government for a long time, though. At one time I was the assistant to the *pagador* [paymaster] in the Second Regiment of Campaign Artillery. After that job I worked in the Ministry of Education. Altogether I worked from 1916 until 1943 in the government.

La Buena Fama Durmiendo *(Good Reputation Sleeping)*, 1939

André Breton asked me for a surrealist photograph for an exhibition. For this photograph it just occurred to me to tell a girl I was photographing to wrap elastic bands around her ankles and thighs. I had gotten the elastic from a friend of mine who was a doctor. I remembered I once took a photograph of ballet dancers at their rehearsal; all the girls wore those bands on their ankles. So I got the idea from there. But it had no particular meaning, it was just a last-minute setup because it had to be something surrealistic, so I thought maybe this might work. Except for a few photographs like *La Buena Fama Durmiendo*, I would say my work is more fantasy. Fantasy is totally from the imagination. Surrealism has a bit of reality in it. The photograph *La Buena Fama Durmiendo* was named on a whim. It's just a name; she was lying down. You can call things anything that you want. Most of my photographs have just a capricious title.

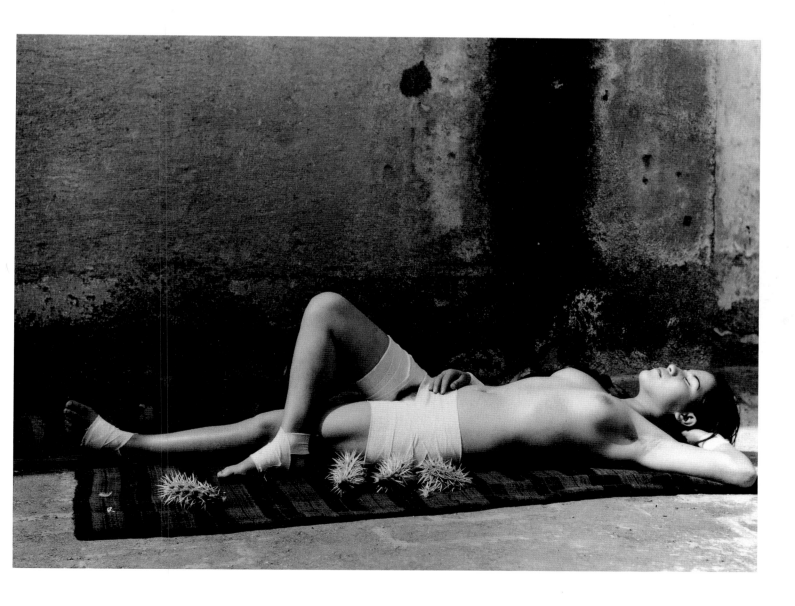

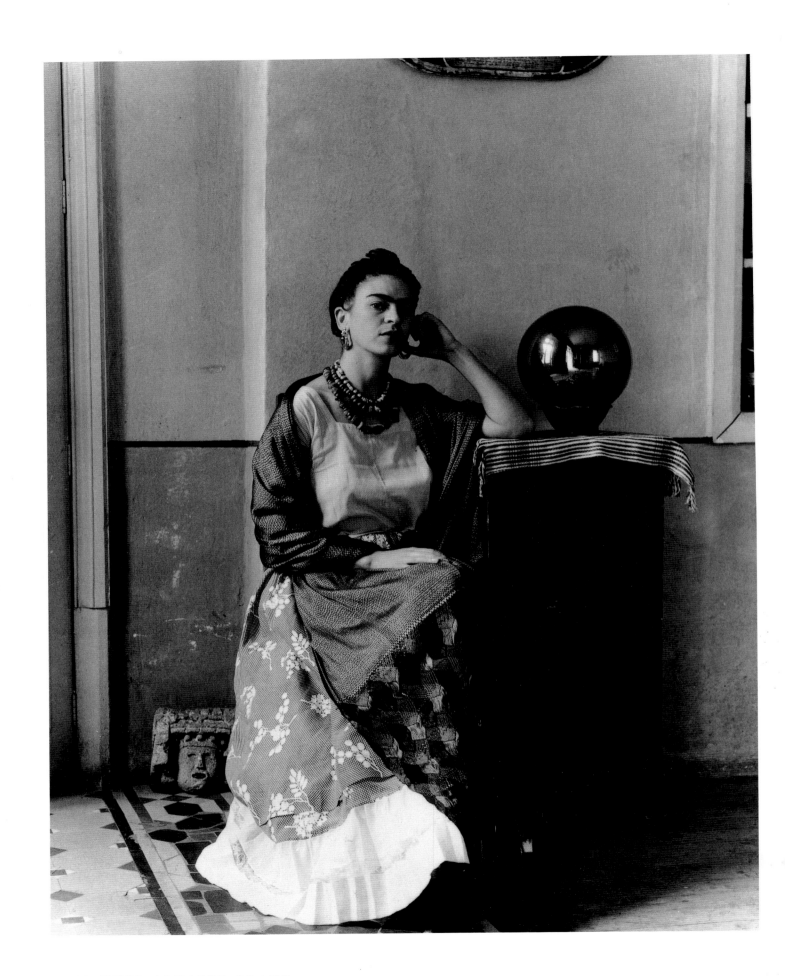

Frida Kahlo, 1930s

I started getting the knowledge and influence in painting and other art fields because of the interest of some of my friends whom I was working with in the government. One workmate was in fact the nephew of the painter Grancel. Around 1922 the first Picasso book arrived in Mexico. I saw it. Until that time the only painters I knew were classic painters, and suddenly Picasso revolutionized my mind. At that time I was drawn into painting. But it was very difficult to attend the painting lessons because they were evening classes. I was busy taking other courses at the School of Commerce and Administration. The schedules were incompatible. I thought that photography would be much easier. Eventually I found out that it was more difficult than painting because of the technical complications of the equipment in those days. That's why I needed photo magazines as technical guides. . . . I've been very fortunate to have made the acquaintances of so many great artists, not just photographers but painters and writers as well. I think in 1927 the muralist Paul O'Higgins introduced me to Tina Modotti, who was very helpful to me. When Tina left Mexico, I took over photographing paintings and murals for an art magazine she was working for called *Mexican Folkways.* That's how I became acquainted with people such as Diego Rivera and Frida Kahlo. Even though by this time Tina and Edward Weston were separated, she stayed in contact with him. She would show me pictures of his that he would send from San Francisco. At one point Weston received an invitation, I think from Germany, to put together an exhibition from the American zone. Tina was aware of this and wanted Weston to see my work and wanted him to include it. Unfortunately it arrived too late to be included in the show, but it was important to me that he had seen my work. I received a letter from Weston saying which images he liked. For example he liked very much the photograph of the young boy urinating. He also liked the photograph of the rock covered with lichen, which he felt showed that my nature work was influenced by [Katsushika] Hokusai. My nature photographs had that same "wave" movement. Before I had bought Picasso's book I had bought a book on Japanese classic art, which I liked very much. It had a copy of the Hokusai wave painting. I still have that book.

La Hija de los Danzantes *(The Daughter of the Dancers)*, 1933

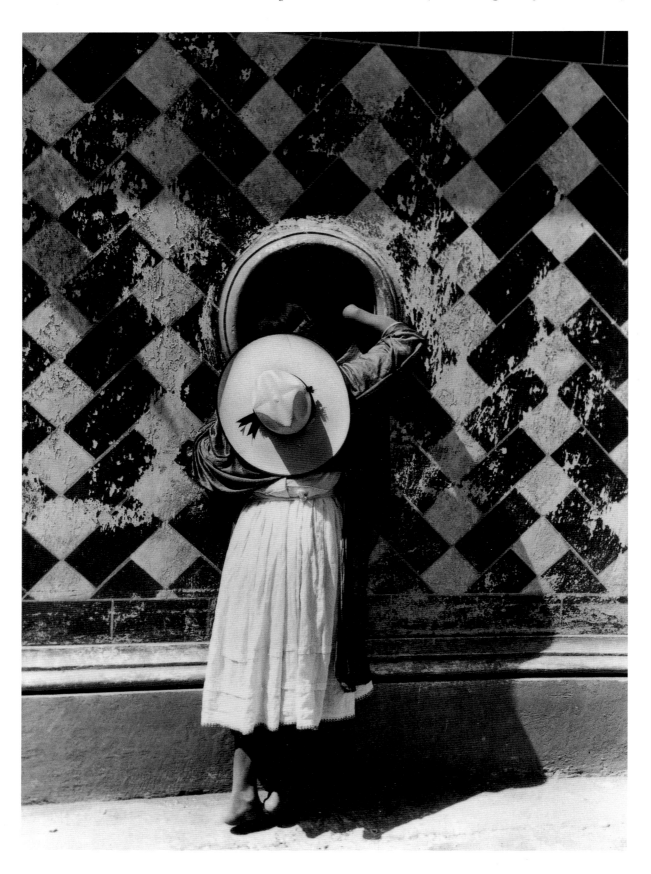

Coatlicue, 1987

On an impulse I casually set up my little mementos. This picture shows the direct influence of my visits to the museums near my house as a youth. It's a picture of life and death. This is where the influence of pre-Hispanic art is in my work. We take death very lightly in the sense that we view death as a natural part of life. This attitude comes from the Aztecs, the Toltecs, the Mayans, all the Indians; they led life in a very natural way. They were not scared of death, in fact death was important. It meant to be reborn. We still see death as a step beyond. Well, what happens with death is that you go on to a different life, you move on. You're not finished, you just move on. Your soul travels to another place. Death here is not the end. It's just a change, a transformation. Your soul travels to lead another life, another experience.

Horace Bristol

As with most photographers during the depression, I took any commercial assignments that came my way, but I've always identified with journalism because I grew up in a family of newspaper people. That's why I don't consider myself a photographer but a photojournalist. I'll illustrate the distinction with a story. One of my friends in San Francisco was Edward Weston. One night he and I were at dinner with Imogen Cunningham and Ansel Adams. I had just gotten hired by *Life*, and after a long stretch of not making much money I was feeling quite happy. I was describing something about sending in my exposed film unprocessed back to the office in New York. Edward said, "You mean to say that you let the editors handle your negatives and crop them?" I said, "Yes, that's my job." He said, "You're no artist, you're no photographer, you're just an artisan." I said, "Yes, that's true, I'm just like a stonemason working on a cathedral." I liked the title. Edward was so careful about his work. He would use an 8x10 and he would compose it right to the end. I was using a Linhof 4x5 and occasionally a Graflex and a Rolleiflex. He was a photographer, and I was a photojournalist. My idea was to get a picture to illustrate a point or a story. I really didn't care if it was f4.5 or f64 as long as the picture was successful in illustrating a story.

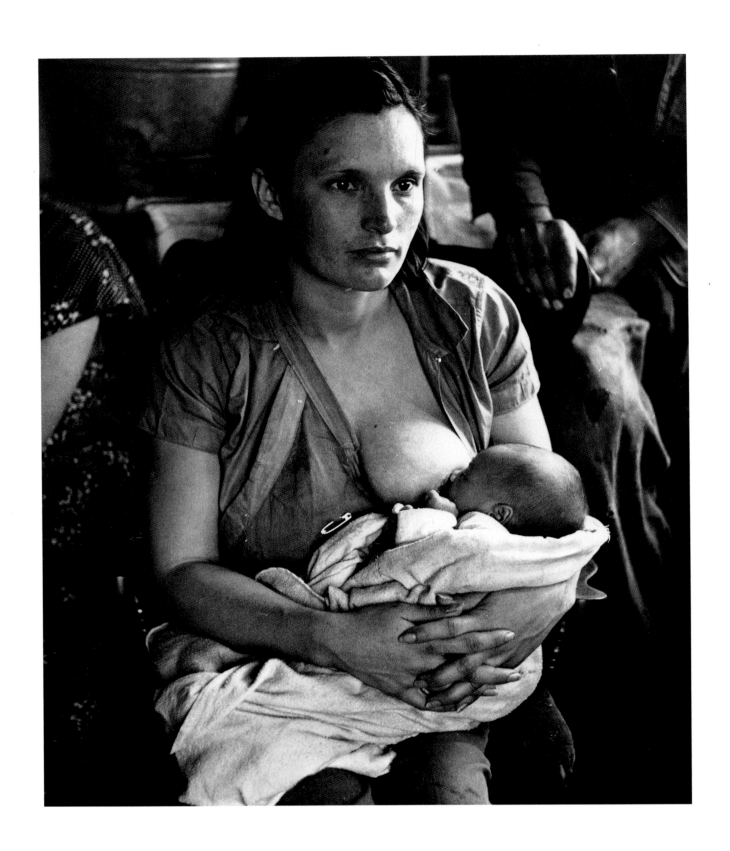

Rose of Sharon, 1938

Dorothea Lange, when she was working for the government—for the Farm Security Administration—went anywhere where they had migratory labor. I went out with her and her husband several times on day trips around California. I was so impressed with what she was doing that I decided to do a story for *Life* magazine on migratory labor. I described to the editors the misery of the people who had left the dust bowl, lured by false hopes of plentiful work in California. They turned it down, but I still wanted to do the story. At that time I saw a book by Margaret Bourke-White, who was also working for *Life*, and Erskine Caldwell—*You Have Seen Their Faces*— about poor people in the South. I thought my idea was even better because of the circumstances—the people were all dispossessed, and there was a mass migration. I thought I would have to find somebody like Erskine Caldwell to write it while I shot the photos. I decided to ask John Steinbeck after reading *In Dubious Battle*, a book about labor problems. So I called him up and asked him if he would be interested in doing a photographic book with me. He said, "Sure, come on down." He lived in Los Gatos, south of San Francisco. I think he was editing a play, *Of Mice and Men*, at the time. In any case, he was working during the week but he said that on the weekends we could work together. I would go to a Safeway market and buy leftover vegetables and cheap cuts of meat and then pick John up in my station wagon. We knew that the migrants would be glad to get it. We would drive down to the central valley and stop at places where these people would camp out along the roads and rivers. In the camp, it was government run and people were hesitant to speak as freely. The people of the central valley were very antagonistic because of labor relations. Steinbeck was paranoid about this. He thought that the farmers wanted to kill him. I would say to Steinbeck, "Nobody's going to hurt you." I never felt any danger at all. Nobody was going to risk having a dead photographer or writer on their hands. After not quite two months of working with him I called and said, "I think I have enough pictures for a good book." He said, "Well, I'm sorry Horace, but I'm going to write it as a novel. . . . It's too great a story." And he did. And it was a great story! The influence of *The Grapes of Wrath* has been compared with *Uncle Tom's Cabin* and things like that. And on top of that they made really a masterpiece of a movie. Twentieth Century–Fox asked if they could see my pictures to assist them in casting. Some of the characters look exactly like people I photographed.

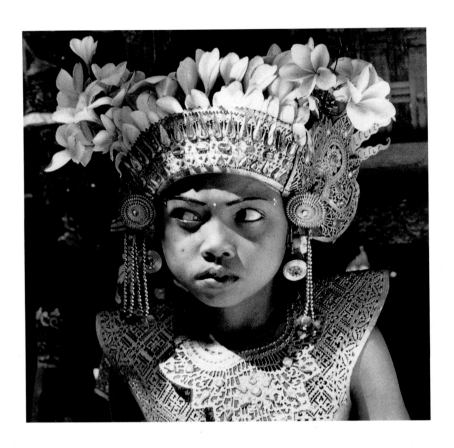

Young Girl in Frangipani Headdress, 1939

I told the people at *Life* that I wanted to do a story on the Dutch East Indies. Wilson Hicks said, "Where are the Dutch East Indies? I don't think the American people are interested in that sort of thing." So I said, "You know, the girls in Bali don't wear any tops at all and they dance." He said, "Well, maybe we'll do it. But you've got to pay the expenses, and we'll pay your salary to your wife." I was foolish enough to agree to it. I got on a freighter, and forty days later I was in the Dutch East Indies with a Rolleiflex for black and white and a 4x5 for color. I sent the film from there. Fortunately, KLM had a line that went right from Java to Holland then on to New York. After I finished the story I took a freighter back to San Francisco. When I arrived I just said hello to my family and went on to New York. When I got to New York I saw that no prints had been made but the negatives were all there. I chose about 300 11x14s that the *Life* laboratory printed. I had an armful of pictures that I very proudly took up to this photographic editor. They were good. He started looking at them, maybe eight or ten of them. Then he started going through them the way you do with a deck of cards. Finally he said that there were too many dance pictures. So I picked up the stack of pictures and my overcoat and started out of the office. His assistant, Ed Thompson, asked me where I was going. I said, "I'm going home. I don't have to put up with this crap." He said, "Calm down. Wilson Hicks has never been outside of Kansas City, he's just jealous of this exciting trip. We'll take these up to the managing editor." So we did and I got a cover and fourteen pages, which was the biggest essay they had done up until then.

Snow Storm in the Aleutians, 1943

Edward Steichen at age sixty-four decided to join the navy as an officer with the idea of putting together a unit of photographers. Steichen called and asked if I would like to join. This was such a wonderful idea. I was going to do something that I was good at and that I wanted to do that might be part of the war effort. And I was going to work for the greatest man in my profession. I couldn't ask for anything more. Of course there was an element of risk involved. But during wartime everybody was expected to do what they could. When I finished the training at Harvard I realized that while Steichen was a great photographer and a wonderful man, he didn't know much about a picture story. I realized just as I did with *Life* that I would have to make my own stories. After doing a story I would go back to Washington and work with the negatives and do anything that needed to be done. Then when I felt there was another story I would suggest it. I thought there was a story coming up on the Aleutians. At that time there was no fighting going on up there so I based the story on the long-range twenty-four-hour PBY patrol flights that took off from the islands and went almost to Russia looking for Japanese ships. After being there a while I went to a meeting of officers on a command ship, where they said that the next day we were going to attack Kiska. After the briefing I said to a friend, evidently too loud, "My pilot friends say that there is nobody on the island." The admiral overheard this and looked at me very suspiciously, wanting to know what a lieutenant commander was doing talking about an invasion that was planned for the next day. I realized that I better shut up. My pilot friends who flew over the island daily said that there had been less and less activity there. They didn't think there were any Japanese left on the island. We attacked and all we found were a lot of dogs. There were a lot of red faces. The last of the Japanese had been evacuated in the fog, probably by submarine.

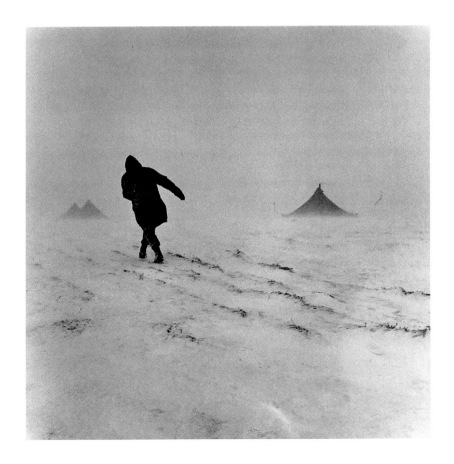

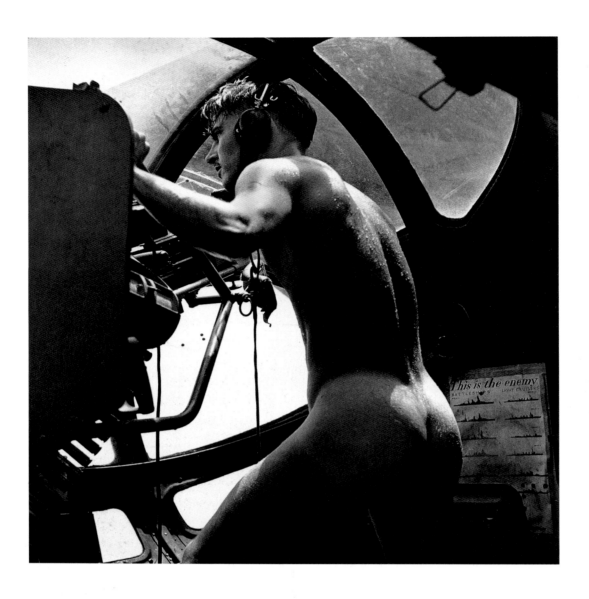

PBY Blister Gunner, Rescue at Rabaul, 1944

I was in the South Pacific in 1944. Every morning during bombing raids on Rabaul a PBY patrol plane would go out to pick up flyers that were shot down. This clumsy old plane could take off from either land or water. When the bombers would get shot down they were often able to coast down into Rabaul Bay, which fortunately was very big. We would circle around the island from a distance until someone would call, "Dumbo, Mayday, Mayday, I'm down in Rabaul Harbor, come get me!" The PBY was a flying elephant! In this particular case we got a call to pick up this man who was down in the bay. The Japanese were shooting at him from the island, and when they saw us they started shooting at us. The man who was shot down was temporarily blinded, so one of our crew stripped off his clothes and jumped in the water to bring him aboard. He couldn't have swum very well wearing his boots and clothes. As soon as we could, we took off. We were being shot at and we wanted to get the hell out of there! The naked man got back into his position at his gun in the blister of the plane. We weren't waiting around for anybody to put on formal clothes.

Shinto Shrine Melee, New Year's Day, 1946

After the war I decided to go to *Fortune* magazine and base myself in Japan. One of the first stories I did was on a celebration of the traditional Japanese New Year in a temple in central Japan. Young men dressed in what's known as *fundoshi* line up on a balcony and jump in to try to get one of these sort of paddles made from camphor wood thrown into the dark temple by priests. Because the temple is dark, these young men identify the pieces by smell. It's an honor to retrieve one of these pieces of wood. Since the inside of the temple was completely dark, I had to use a strobe to light it. I shot it as part of a *National Geographic* story, but since I had sent the 35mm rolls in undeveloped and they didn't run this particular image, I didn't see the picture until many years later. The people at *Geographic* called me and said they had a photograph of mine that they wanted to use for an exhibition at the Corcoran Gallery celebrating *National Geographic*'s hundredth anniversary. They discovered this negative when they were going through their files trying to find the most unusual and important images for the exhibition.

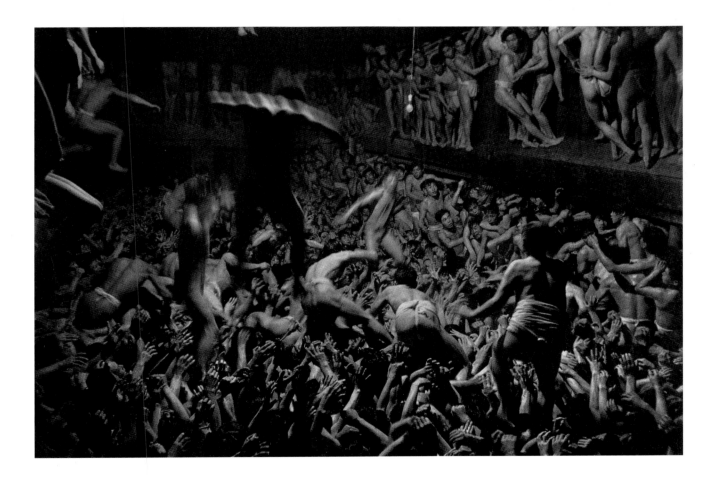

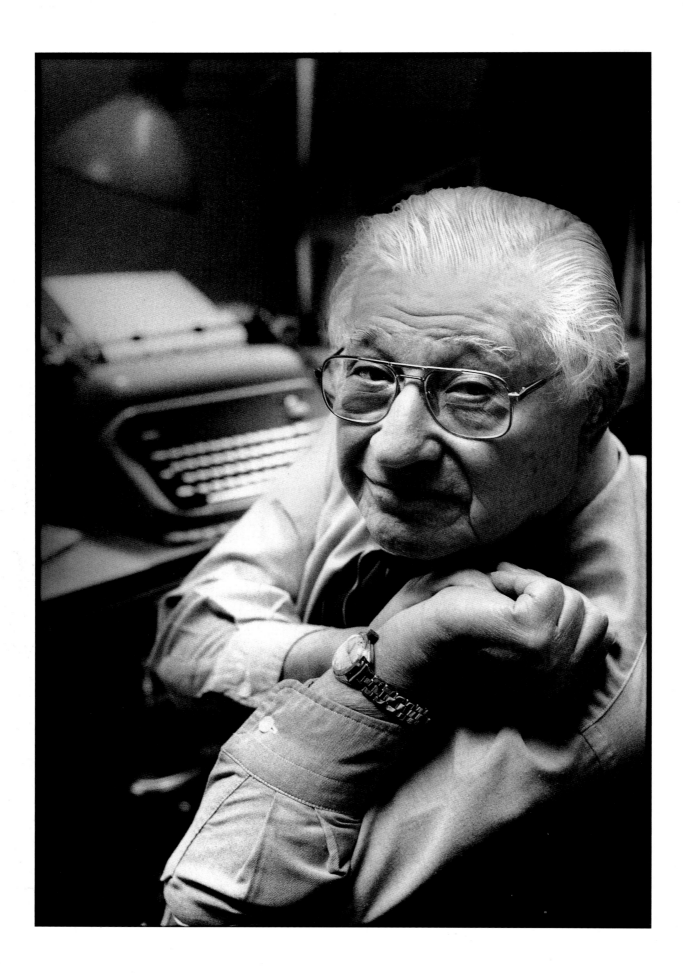

Carl Mydans

Sometimes I find it quite a thrill to go into the darkroom and watch an image I made fifty-five years ago come up in the developer just as good as when I saw it come up for the first time. There's a great drama about it. Watching the exposed white photographic paper in the developer as the image begins to form . . . begins to come up . . . there's a return in my mind and my feelings to that place half a century ago. There's a great deal about the creation of photography that is singular, that is about itself. Lots of people see photographers working. Most of them don't know just how much the photographer himself is moved by the pictures that he creates. "Eisie" talked to me about that too. When other people are looking at his photos and screaming about them, they have no idea how he feels himself about them. He's transferred, just as I'm transferred back to the moment when they're taken. Not many people understand how much the photographer is carried back to the moment, to the instant when he pressed the shutter. . . . A photojournalist is one who covers the events of his time. Some people have asked me over the years, "Why did you spend so much of your time covering war?" There is only one reason. War is not my delight. War was the event of my years. I began it in 1939 with the Russo-Finnish War, then the war in China, World War II, the Korean War, and finally the last of the wars I covered was

Vietnam. My first combat experience was during the Russo-Finnish War. It was a very terrible thing for me. I had never seen any war before. The first operation that I was sent into was in Finland, north of the Arctic Circle, at Kemi River. There, an entire Russian division was surrounded in the forest by the Finnish troops—men and their horses destroyed in subzero weather and frozen to death. I have seen many terrible scenes of war since then, but that first view of an entire division of men destroyed in the snow and the cold of the Arctic Circle left a very deep impression upon me. In a war, no matter whether you're winning or losing, it's a terrible place to be.

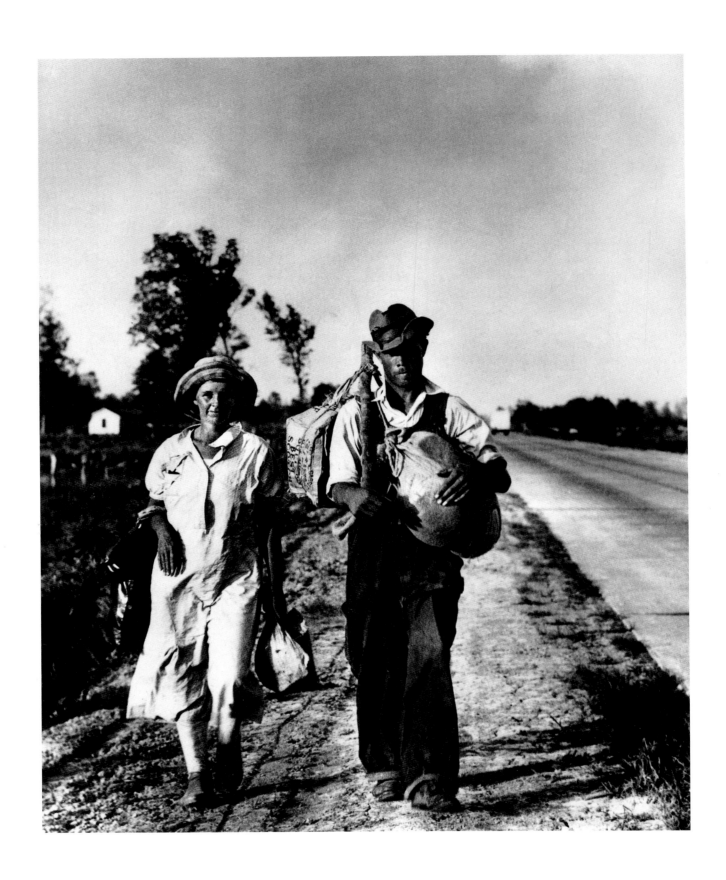

Transient Cotton Choppers in Crittenden County, Arkansas, 1936

When I graduated from the Boston University School of Journalism in 1930, my interest was in becoming a newspaperman, a reporter. In the years when I was writing for the *American Banker,* my interest in the camera increased. I used my lunch hours in New York City to use my Contax 35mm camera down in the Wall Street area where my office was. Back home at night in Brooklyn Heights I worked in a makeshift darkroom to process my film and make prints. On one of my lunch-hour picture-taking outings, I photographed Eugene Daniell standing on a soapbox, agitating against this country, saying things here were not equal. The year before he had thrown a stink bomb into the ventilating system of the Stock Exchange, stopping it for the first time during business hours since World War I. I approached Dan Longwell of *Time,* who decided to run the photo the following week. Dan was a strong supporter of the 35mm format, telling me at that first meeting that it was the wave of the future. Dan suggested to the Washington representative of the newly formed FSA [Farm Security Administration] that he look into me as a photographer. He was picking a small team of photographers to go out across the country and make pictures that would then be shown to the American public to draw support for Franklin Roosevelt's New Deal. Roosevelt had many departments doing many things—helping farmers, helping people who were overrun by flooding rivers, people who had no homes that were living in the fields, workmen in the cities who had lost their jobs who were standing on street corners selling apples to survive. Roy Stryker said to me that I was going to find that what was happening to the people during these depression years would be written on their faces. He was right. And I kept this in mind as I traveled and photographed the devastation across the country.

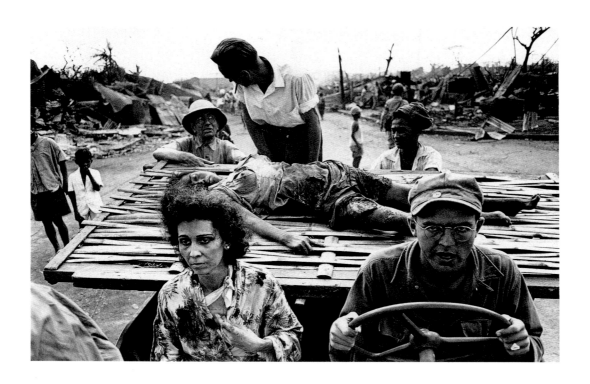

Wounded Filipina Women Are Carried to a Field Hospital in a Makeshift Ambulance during the Fight for Manila, 1945

When the Japanese attacked Pearl Harbor they attacked the Philippines as well, and my wife and I were captured in Manila as the fighting was going on throughout the city. By the time we tried to get out there were no ships or anything left to get out on. We were taken as a group of what the Japanese called "enemy nationals" from a lobby of a hotel where all of us, mostly Canadians and Americans, had fled. I must say that for the first few days, despite the reports that now fill books in the Philippines about the raping of women and the beating of people, not for some weeks did they treat us badly. One of the things they failed to do was feed us, but they had no food themselves. We spent two years in two prison camps, one in Manila— Santo Tomas—and then we were sent on a Japanese troop transport to Shanghai and put into another prison. We were civilian prisoners, and I think, not always, but largely, we were fed a little better and treated a little better than military prisoners. But it's only a matter of degree. All prison camps are bad places to be. We were exchanged two years after being imprisoned. They exchanged 1,500 Americans and Canadians on a ship that the Swedes provided for 1,500 Japanese who were in America and Canada. We were taken and exchanged in the neutral port of Portuguese Goa. The Americans and the Japanese just passed each other when we changed ships. When we got back to New York I was reaccredited to the U.S. Army and sent back into the war almost at once to Italy and the campaign for Cassino, Rome, and Florence. I was with American and French units that landed at Saint-Tropez when I got from my office a secret coded message: "Get ready to leave to go back to Asia because MacArthur is getting ready to return to the Philippines." I joined the MacArthur forces and was with him island-hopping until we entered Japan.

General Douglas MacArthur Wades Ashore at Lingayen Gulf in Luzon, the Philippines, January 9, 1945

I was on the ship that carried MacArthur to Luzon, the biggest island in the Philippines. When he landed at the northern part of Luzon we were in great strength, and all of us knew that if we could live through that fighting we would win the war in the Pacific. I got on the same navy landing craft with MacArthur and photographed him on that landing craft. When we neared the beach, which was some distance away, we saw that the Navy Seabees had gotten there ahead of us and put a pontoon float out. The float was not necessarily for the general. It was for any craft coming to that beach that could unload troops. Lots of people think that all this was done for MacArthur. I'm not sure in my own mind whether they knew they were heading to the float or not, but when his landing craft headed toward it I went ashore from the ramp on the landing craft onto the pontoon float, and when I did, I heard the motor of the landing craft rev up and I turned around and I saw it pulling back. I knew at once that he was going to land in the water and not on that float. I ran up the float and onto the beach and ran parallel to the landing craft along the beach. When the landing craft turned in toward the beach I stood and photographed him wading ashore, and my shoes were dry. Someone close to MacArthur knew what he wanted, and the coxswain on the landing craft was told not to land at the float but to go farther down the beach. If MacArthur wanted to, he could have landed with dry shoes as I did. He was a man of great drama. He understood the drama of a picture, and he knew wading ashore was far better for him than walking down a pontoon float.

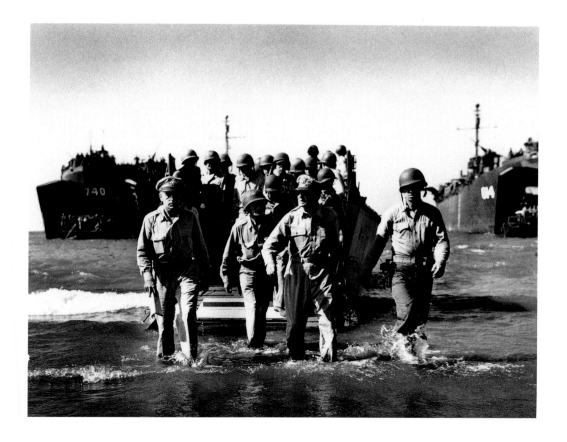

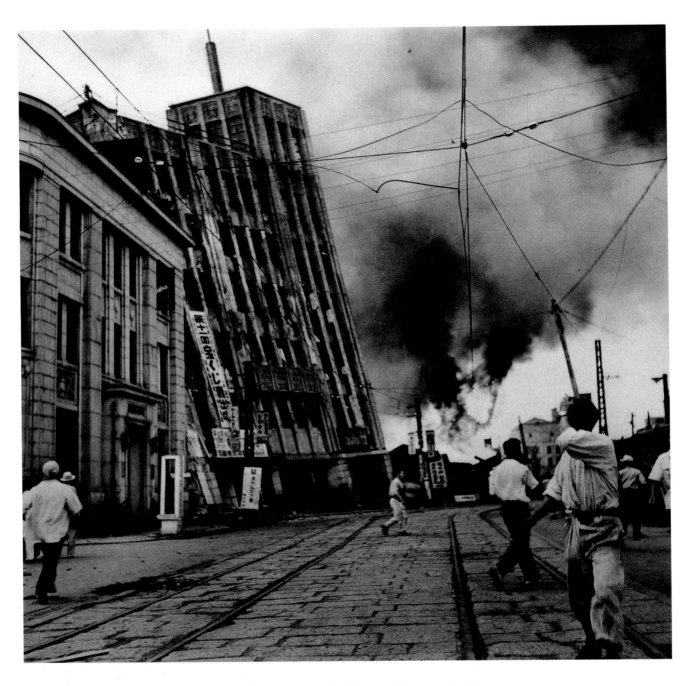

Earthquake in Fukui, Japan, 1948

That was something that nature played right into my hands. Any experienced photojournalist who happened to be where I was at the very center of the earthquake in Fukui would have done as good as I did or better. That kind of thing demanded of the photojournalist a knowledge of what he was doing and a knowledge of the importance of the pictures—how to work in those circumstances, and if I may say so the courage to go on working when the earth is shaking around you and splitting open under your feet. You must understand that when a photographer is talking about these things, you're talking with him because he has made a successful picture. There is no way of you knowing or him remembering how many times he was close to making that kind of picture but was unable to.

Headlines on a Commuter Train to Stamford, Connecticut,
November 22, 1963

I don't know if I'm an optimist. . . . I'm a human being who believes in human beings, and I believe that though we do many terrible things, we keep heading hopefully toward something better.

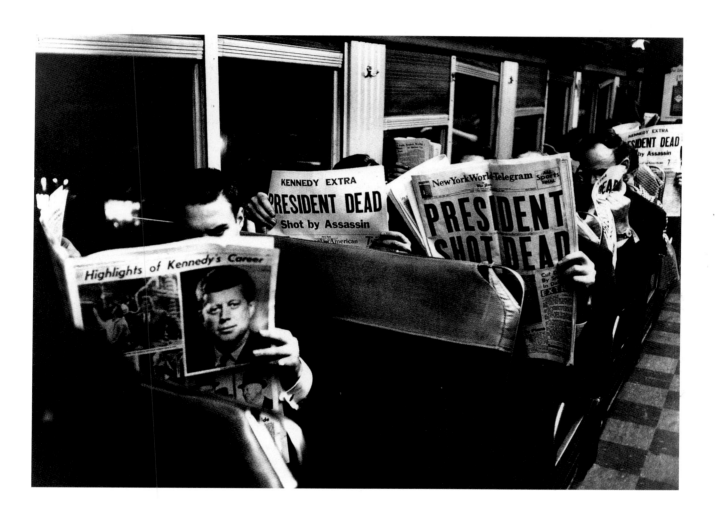

Joe Rosenthal

When I finished high school I wasn't really prepared for any specialty of any kind. Many people were out of work, and so was I. The stock market had crashed, long lines of jobless were forming, families were disintegrating because of financial stresses. So in the spring of 1930 I left Washington, D.C., for San Francisco. I had enough money for a one-way train ticket. I came out to join my brothers and an uncle and his family. I got a job as an office boy in a newspaper syndicate for fifteen dollars a week, sweeping floors, filing things, and using the copy camera to make copies of photos to be distributed. If I hadn't gotten this job I might have gotten a job with a grocery chain. So I learned photography at this place. After a short time they handed me a Graflex. A photographer there showed me how to use the camera. "The glass part goes toward the subject. You put film in the back. There's a little trigger." Basically I was told, "Go out and shoot a few pictures. Bring 'em back, we'll develop them, and tell you what you did wrong." I found it to be the best way of learning. First off, learn to see visually, then see what leads you to proper exposure. It wasn't long until I was out covering collegiate track meets. Then along came winter and football, which was a harder thing to cover because it is less predictable. It was a good practice year for me. Along about that time came the Speed Graphic, which was more

portable and easier to handle than the Graflex. After about two years I got another opportunity. A job opened on the *San Francisco News* for a reporter/photographer. I was with them from 1932 until 1935. I covered things on a beat basis: the emergency hospitals, the police headquarters, the courts. . . . The Great Waterfront Strike of 1934 was a big event. They were striking for an orderly process of being hired by the shipowners as opposed to having to come very early in the morning and hang around in the drizzling rain to be picked arbitrarily. I was greeted by a mob of rioters and sent to the hospital for eight days. The rioters did not want to be identified in pictures. They knocked me down. One guy whacked me over the head with a heavy cable wrapped around his fists. I was rescued by the police firing tear gas into the midst of the crowd and pulling me out. Of course I got most of the tear gas!

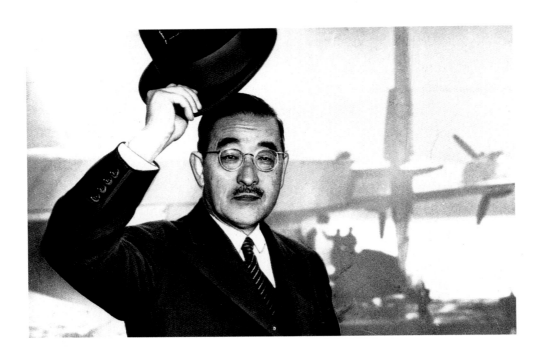

Saburo Kurusu, Japan's Special Envoy to Washington,
November 14, 1941

In the middle of November Special Envoy Kurusu arrived in San Francisco on the Pan American Flying Boat. He was going to catch another plane for Washington to help keep the peace, we thought. A month later we were at war. When Pearl Harbor was attacked, there was a lot of panic. Guys were rushing off. The big photographers were going to their posts. At that time I put in an application to go overseas but was passed over. The Associated Press had their veterans. So I languished doing hometown stuff. The preparations at home, the activities of the USO, the Red Cross. Feature after feature, I felt farther and farther away from the big story. I did get my draft card, and I went through all of the physical tests and everything was okay with the exception of my eyes. As long as I had glasses I could compete in the photo world. When I was rejected because of my eyesight, I had my first real feeling of rejection.

In the middle of 1943 a friend of mine in Washington called. "I'm setting up a correspondent section for the Maritime Service. If I can get you a waiver on the eye test, would you like to join?" I said, "Sure!" That would get me in the Merchant Marine and into convoys. In Britain my orders were to go around to the seamen's hospitals to get adventure stories. The notion was that this kind of excitement would attract volunteers. From England I went over to Algiers. After doing similar kinds of coverage I got an order to meet a writer in New Guinea. The Indian Ocean was cut off by the Japanese, so I flew into an airfield in South America and then up to Miami and across the U.S. to San Francisco. While there, I dropped into the office of the Associated Press. An assistant photo editor came up to me and said, "Hey, Joe, would you be interested in going out into the Pacific for AP?" Hold the phone! I resigned from the Maritime Service, got accredited, and went down to New Guinea as an Associated Press correspondent. This was the first time I was officially a war photographer.

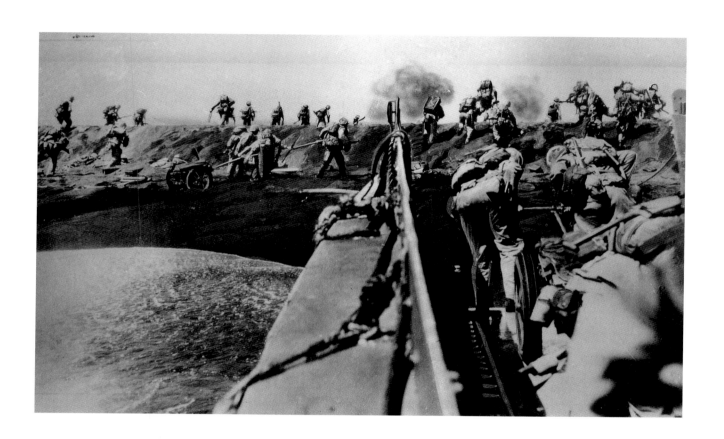

Marines Land at Iwo Jima, February 19, 1945

On Iwo Jima the sand is very heavy and coarse, which made running for cover very difficult. It was like plowing. You'd try to find a place maybe thirty feet away and get there. My main camera was a 4x5 Speed Graphic. For one thing, there is something about shooting rolls that is quite different from the feel of working with sheet film. The magazine photographers, like the *Time/Life* photographers, are keyed to shooting rolls of film. They could use several images to tell a story. The newspaper photographer is keyed more to the one shot that covers the subject.

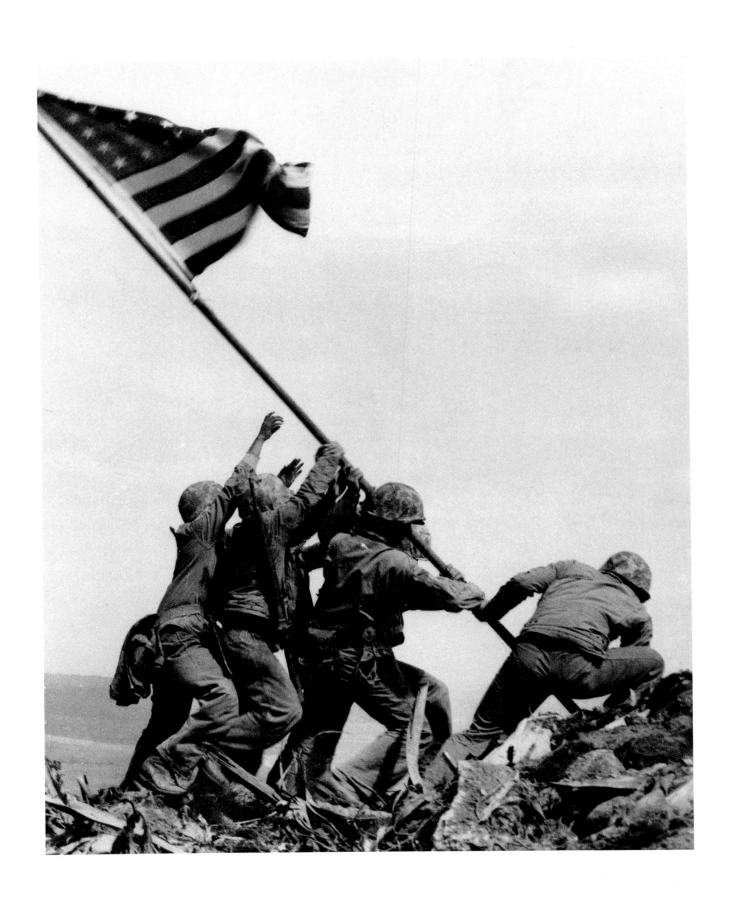

Flag Raising on Iwo Jima, February 23, 1945

On the fourth day of the battle I had gone out to the command ship to send a package of film back to Guam to be processed at headquarters. The next morning, I was informed that General Holland Smith and the secretary of the navy were on a smaller ship and were going in one mile offshore with binoculars to scan the battlefield. So I transferred to this boat. I took a photo of General Smith and Secretary of the Navy Forrestal at the railing with Mount Surabachi in the background. This was still in the morning, so I transferred to another boat so I could get closer to shore and then on to another that could take me in. I heard from a radioman that there was a patrol going up the mountain to plant our flag. I was surprised, you know, that by the morning of the fifth day they could do this. I said, "I gotta get a picture of that." About halfway up we ran into four marines, including Staff Sergeant Louis Lowery, who was a photographer for the marines' magazine, *Leatherneck*. Lowery and the others said that the patrol had raised a flag at the summit and that he had photographed the flag raising, but I made up my mind that I wanted to get a shot of the flag anyway. There continued isolated fire, but mortar was not reaching us. At the northern end of the island a mile and a half away there was still heavy fighting. When I came to an area where I could see over a rise, I could see our flag fluttering. I clutched my throat. It was our flag. As I got closer I observed there were three marines kneeling beside a long pole, and one of them had a flag folded in the triangled, traditional manner. "What's doing, fellas?" "We're going to raise this larger flag so it can be seen by the troops all over the island," and they added that they were going to keep the first one as a souvenir. I moved around to where I could await what these fellas had told me they were going to do. I selected a position, and then I had to estimate how far back to get in order to get the full length of this pole swinging up. Because there were some chewed-up bushes in the foreground that might cut off the bottom half of these marines that were going to raise the flag, I grabbed a couple of rocks and a couple of old sandbags left from a Japanese outpost that had been blasted there, to stand on. This got me up a foot or two. Just about the time that I stood on top, Bill Genaust, a marine movie cameraman, came across and went to my right at arm's length and asked, "I'm not in your way, am I, Joe?" And I turned and said, "No Bill, that's fine—oh, there it goes Bill!" Bill had just time to swing his camera around to capture that wonderful, beautiful, extraordinary movie that shows the flag raising from the ground up. You notice it doesn't start with any preliminary footage. We had no signal beforehand. [Genaust was killed in action nine days after the flag raising.] The pole was a heavy iron or lead pipe probably twenty feet long. It came from either a heating system or water system for the Japanese outpost that was up there. It was originally the three marines I had met, but a couple of others saw what they were doing and could observe that it required more heft to lift it. One man kneeled down to hold it in position. When they got it into a little indentation in the ground—not very deep—three of the men held it there while one got a rope and tied it down three ways. Then they shoved a lot of rocks to keep it in position. Later, down below, I was told that it had raised a great cheer. I was more or less reporting an incident in the turn of the battle. Up until this point the news going back home from Iwo Jima was very sad. On Iwo Jima it was touch and go. Some of the advances were measured in a couple of feet. So this was a great boost to the people back home.

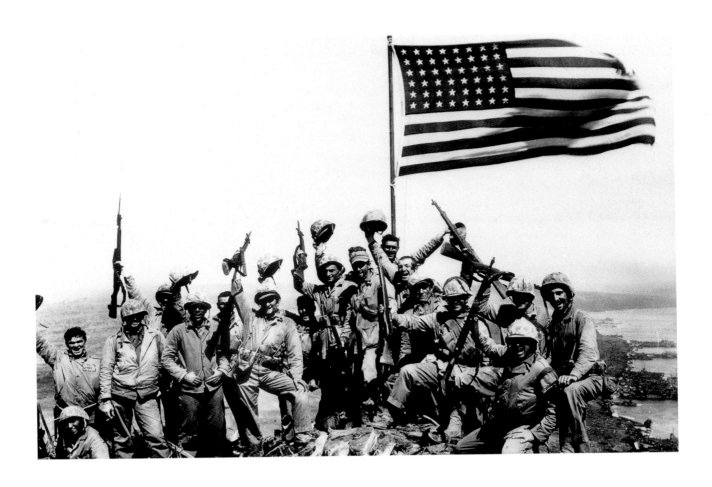

*Marines of the Twenty-eighth Regiment, Fifth Division, Cheering
the Flag Raising on Iwo,* February 23, 1945

I did make a second shot of three of the men holding the pole in place
waiting for the guy to come back with the rope as a backup. I knew that it
was a pretty static shot. In a situation like this you always shoot something
so that if the first two shots are no good, at least you'll come back with
something. And this time frankly I did pose a picture. I yelled to a number
of men, "I want to get a bunch of you raising your rifles and cheering."
It turned out to be a fairly good group picture, but it's more like a gradua-
tion picture. The first grab shot was number ten of the film pack of twelve.
Number eleven was the shot of the guys holding the pole. And for the con-
clusion of the pack, the group shot. When I had just arrived back in Guam,
two days after leaving Iwo and nine days after the picture had been taken,
I walked into the press headquarters and was greeted by a correspondent,
"Congratulations, Joe, on that flag-raising shot on Iwo." "Thanks," I said.
"It's a great picture, did you pose it?" All this time thinking he was talking
about the last photograph I had taken of the group of marines waving and
cheering, I said, "Sure." But then someone else came up with the flag-
raising picture and I saw it for the first time. "Gee," I said, "that's good
all right, but I didn't pose that one. I wish I could take credit for posing it
but I can't." Unfortunately a correspondent who had overheard only the
opening part of our conversation wrote that the shot was a phoney and
that I had posed it.

Ken Kesey on Top of the Furthur Bus, 1967

Back home, all of a sudden I was a "name" photographer. It took me a
while to get my balance. I was getting delayed reactions. My nerves were
coming to the surface. I would even come awake at night, "What was that
noise?" It was not until much, much later that the reaction came. So I
went in and talked to my doctor, and he said, "You have a mild case of
nervous exhaustion. You need a long vacation." So I went to the office and
asked for a leave of absence. They said I was entitled to six weeks, which
I appreciated, but I said I'd take three months and the rest of it would be
unpaid leave. So I hopped into my car and drove down to Los Angeles.
I had friends there and we jollied a bit. I continued on down to Mexico
City and then a couple of hundred miles west to a town that I had been
to before called Tequila. It is the place where tequila is manufactured.
I took some good photos of the people there. Of course I helped them in
testing the product. I was beginning to relax. After eight weeks in Mexico,
I returned to AP. They treated me fine. I was back to photo editing, but
I felt uncomfortable because there were people who had taken my place
while I was gone. So I thanked the AP and I resigned. One floor up was
the *San Francisco Chronicle*. The city editor, who I had known for a couple of
years, said, "How are you doing, Joe?" I said, "Fine, I just quit AP." He
offered me a job on the spot, which I ended up doing for thirty-five years.
I think I've shot some sensational photos during the thirty-five years there,
or the *Chronicle* wouldn't have continued paying me, but I'm known as the
Associated Press photographer because of the war.

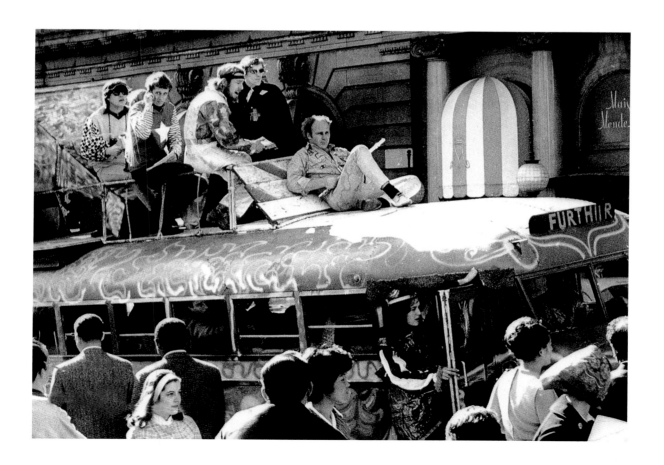

Jean-Philippe Charbonnier

I've covered wars. I've been in Vietnam. I've been in Nigeria. I've photographed insane asylums, childbirth, girls making love together. But actually, the more pictures you see of this sort of thing, the less interesting they are. Great photography can be subtle. Look at the work of Cartier-Bresson. I don't know if you know how Henri Cartier-Bresson worked with his Leicas. He figured out the exposure right away. He's got a meter in his head, and he would set the speed and the diaphragm right away and the distance. That is why some of his pictures are not that sharp, but there they are! It's better to have a picture that is not completely sharp but exists. They might not be as sharp as Gene Smith's, for example, because the moment that Henri shot goes by in an instant. Whew! It's gone! When I came to *Réalités* in 1950 I was mostly using a Rolleiflex, which is what they wanted me to use. I would go out on assignments with two Rolleis. One loaded with black-and-white film and the other with color. Plus very often I would bring my 4x5 master view camera with all the plates and of course a big tripod for it. I used it when I went around the world. It was horrible. I met a colleague, Eliot Elisofon, who was a great photographer for *Life* magazine, on that trip. I met him in Kyoto, Japan, and I saw how he was working. I was photographing the Ryoan-ji Temple with my 4x5 while he was working with small cameras, which his maga-

zine approved of. I wasn't supposed to go out with a Leica at all. It was considered too small. Besides, the colors the Leica lenses produced were no good, they said. Little by little as they eventually accepted the idea of looking at 35mm contact sheets, I did more and more small-size pictures. I quit using the Rolleiflex because there were only twelve views on each and there was no change of lenses. I explained this to my students at a photography class I taught some years ago at a graphic arts school. I taught them to keep things simple, one camera, one lens. I think it's mad the way some cameras are designed with all those things inside, with all those arrows and lights and bells. I told them while they were in my class it was absolutely forbidden to use a zoom lens. It doesn't make sense. Just like a motor drive. A camera is not meant to be a machine gun. It's the best way to miss a picture. I did print of course in the beginning, years ago. I always say without a good printer there is no picture. There are very good photographers who printed well—Boubat, Doisneau, Jeanloup Sieff, Smith, Weston, Ansel Adams. But it's a gift. Printing is just like cooking and other arts. It's not really interesting to me. Besides, it's dark as hell in there.

JEAN-PHILIPPE CHARBONNIER

Execution of a Collaborator, October 5, 1944

When I started photography I received a Leica Summar F2 from my mother's husband. The first time I used it decently was for the horrible story of the shooting of a man. In October 1944 I photographed on one roll of 35mm film the entire story of the execution of a collaborator in the small town of Vienne. He wasn't any kind of master spy. Just a simple fellow who had been some kind of errand boy or secretary for the Germans. Since the big-time collaborators often were tough to catch, the small fry often paid the price. Feelings against collaborators ran extremely high, especially in the early days of the Liberation. Five thousand townspeople gathered in the courtyard of the barracks at noon to watch the event. The condemned man received the traditional last glass of rum and a cigarette. By force of habit though, from years of tightly rationed tobacco, he stubbed out the cigarette and put the butt in his pocket after five or six puffs. A pointless act, since he would never have another opportunity to smoke again. He then was marched across the courtyard after being greeted by a priest. Because he was a traitor he was tied to a post with his back to the twelve-man firing squad. The order was given and the man was executed. I was deeply shocked and shaken by this demonstration of public justice. I deplore collaboration as much as anyone else, but this punishment seemed to me out of all proportion to the probably trivial crime committed by this man.

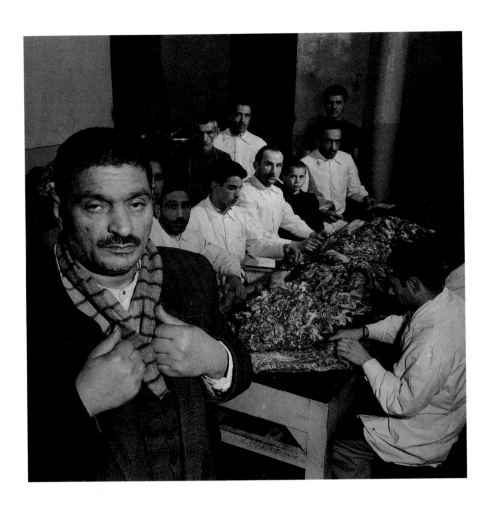

The Restaurateur, Teheran, Iran, 1952

To me exotic is a subway ticket away from my home. There is no need for me to buy a round-trip ticket to Japan. Paris is a gift from God. But I was working for a magazine [*Réalités*] that had the pretension of being international. There were seven main photographers. Edouard [Boubat] and I in particular were always sent abroad. Maybe because they were sure we would bring back something. Whatever the weather, whatever the people were like, we would bring a story back. You're not supposed to say, "I'm sorry, I had a problem because there were mosquitoes," or "I met a girl and we spent two weeks together without going out." The magazine never gave me or people like Boubat enough time to get inside of the places where we were sent. We could not wait for things to happen. Instead, we had to run after pictures all the time. For example, I did an around-the-world trip in four and a half months. I didn't even have the chance to blow my nose . . . it was something unbelievable. You know you have to arrive at this place, say Kuwait, for instance. You arrive there on a certain day, and you have to leave on that same day. Not the next day, but the very same day! Then you continue to the next location, and then to the next, and so on and so on. Instead of saying, "Well, I'm happy. I'm in Kuwait City. I don't know anything about this place. But anyway it's sunny, it's warm, it looks interesting. I'm looking forward to discovering the secrets of this place." So you spend the little time you have looking at your watch.

Ulan Bator, Outer Mongolia, 1955

I loved to do what I did for *Réalités*. But I didn't like the way I had to do it. We could have produced much better work if they had given us a little more time to think about what we were doing and produce it. What happens is that there is a moment that arrives when you don't see anything anymore. I remember when I was on a trip that lasted for three months to produce five or six stories. After shooting in Russia, Outer Mongolia—where I was the first Western photographer—and China, I arrived in Rangoon, Burma. I couldn't stand to see any more picturesque things. I couldn't stand to see any more monks in yellow. I couldn't stand to see any more temples. I was oversaturated with images. It was too much. I would never have put together such a devilish trip. It didn't make sense. If they told me, "You do this and then you take three days off and go to the beach for the girls or whatever you want to do," it would have been okay. I don't know why I speak about this. . . . I've had a wonderful professional life with a terrible stone in my shoe.

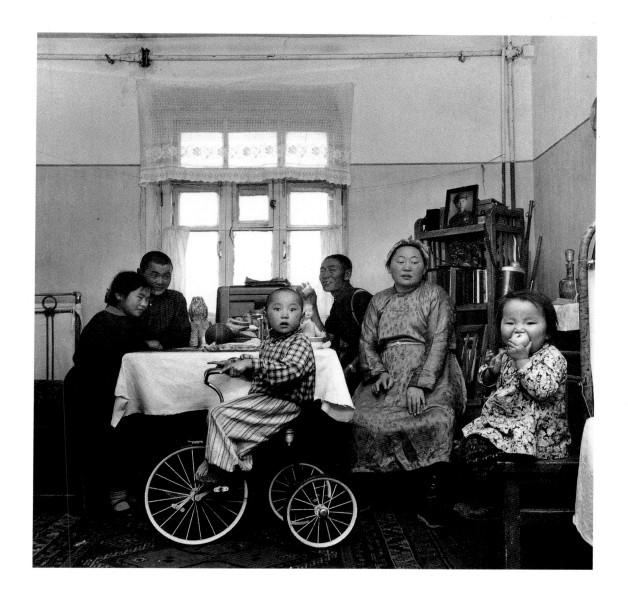

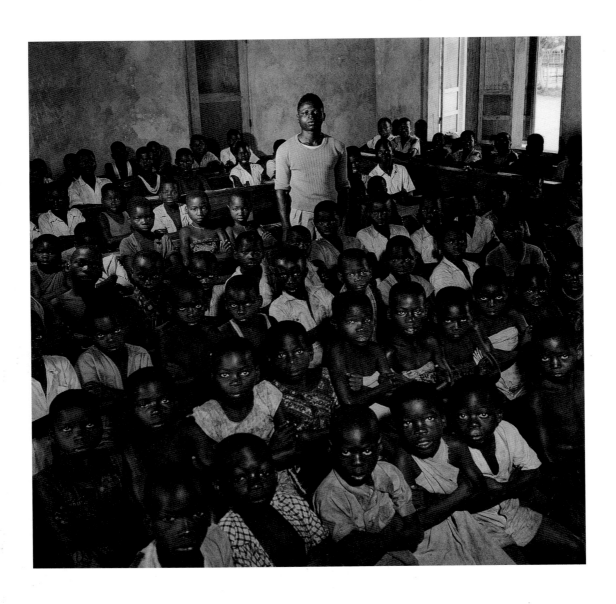

Classroom, Kintélé, French Equatorial Africa, 1951

I was so fascinated by the work of Eugene Smith, who I met once in Arles. The way it was done, the way it was printed, the lighting. They were so beautifully done. He was a fantastic technician. I remember I did two stories on the same subject that he did. One was of Dr. Schweitzer and the other was of a country doctor. But of course I didn't work the way he did. The climatic conditions of Lambarene, Gabon, in equatorial Africa, where Dr. Schweitzer was, were miserable. It's wet. There are mosquitoes everywhere. And here are these beautiful pictures of Smith's with beautiful light. You say this can't be true. I know he was there. I know that in his picture is Dr. Schweitzer. It's not an actor from the actor's studio. It's not Marlon Brando. But it has nothing to do with the real story down there, with the mosquitoes and the humidity. No, no, no. It's like the Spanish village series he did. It's fantastic staging, and I enjoy his work for that. To me it's fantastic photographic work. But it has nothing to do with common shots. It has nothing to do with Robert Capa's pictures of D day, for instance, or any of Henri Cartier-Bresson's shots.

Backstage at the Folies Bergère, Paris, 1960

One or two times a year I would shoot the fashion shows. I worked with
very famous models, including Bettina and Suzie Parker. I said then and
I still say today, "How can I tell these girls what to do?" They know better
than me. I'd sound completely stupid trying to direct them. Therefore I
can't do fashion photography. It's the same with shooting nudes. I've made
nude pictures before, but they were of girls who I lived with or my wife.
They happened to be nude. A nude photograph is just another photograph.
I don't undress the others either. I cannot say to a girl, "Good afternoon,
take off your clothes, sit down there, and we'll make pictures."

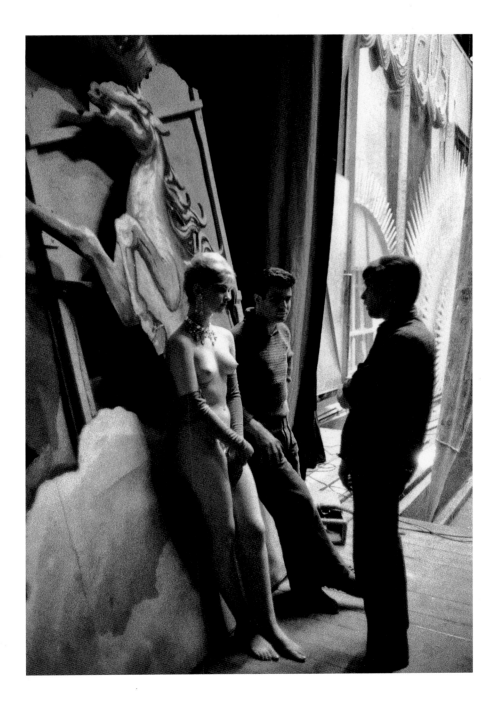

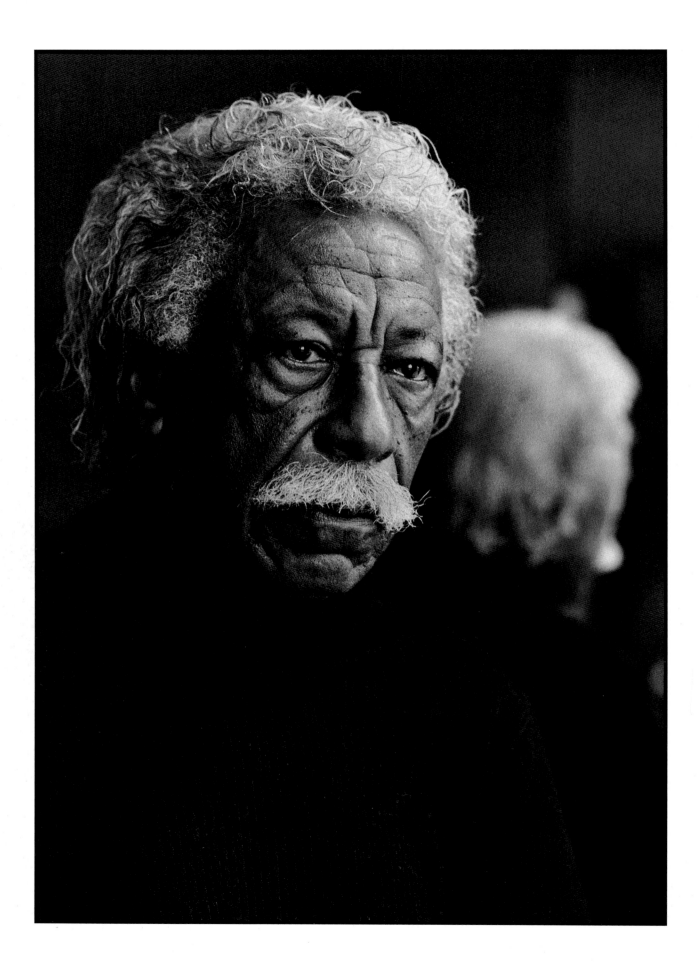

Gordon Parks

My interest in photography began while I was working on a train, the North Coast Limited, as a waiter in 1937–38. Up until then, I had never shot a photograph before in my life. The thing that probably set me off was watching this newsreel in a movie house, during a stopover in Chicago, of the American gunboat *Panay* being bombarded in the Yangtze River by the Japanese and watching it sink. The guy who filmed it, Norman Alley, jumped onstage to a standing ovation after the presentation. In the first place, I thought his part was rather glamorous, which struck an inner chord.

Possibly the most persuasive influence was the FSA photographs that I saw of Dorothea Lange, Walker Evans, Arthur Rothstein, Jack Delano, Carl Mydans, and John Vachon. I suppose it touched me that if they could reach out and make the public aware of how terrible this poverty was to the people who were on foot all over the land—farmers losing their homes and so on—that I could make the same stroke against racism that they were making against poverty. At that time the idea struck, but it didn't take over. It influenced me. My mind was all over the place. I was also seeing for the first time fashion photographs in these glamorous magazines that rich people were leaving on the train . . . beautiful women being photographed in Paris and London. I was this little kid from Kansas. You don't have time to think about the impossibility of it. The fact that you don't even have a camera. The fact that you couldn't afford to buy the camera. The fact that I probably couldn't use it after buying it. The hell with that. You let your imagination carry you. I'm a gambler. I learned you can't go any farther down than bottom, everything else is up—take a gamble. I bought a Voightlander Brilliant for $7.50 in a pawnshop in Seattle, Washington. The train had stopped there three days after I saw the newsreel in Chicago. I didn't know how to load it, neither did the guy in the pawnshop. But he did have some film on a shelf, and there was a customer in the shop at the time who was nice enough to say, "I'll load it for you." I have a tendency to think that he was some very well known photographer from out West.

Muslim Schoolchildren, 1963

One thing my mother taught me was that you don't use your blackness as a crutch for failure. "If a white boy can do it, you can do it better. Don't come in here telling me you didn't do this and you didn't do that because you are black and they didn't give you a chance. Go around them. There is always a way to go around them. Show them. Prove it to them. Make them come after you." Now where this woman got this philosophy from I don't know. I don't know if she even finished high school. I was the youngest of fifteen children, and she died when I was fourteen. She knew she was dying and tried to pour all her knowledge into me in a very short time, whereas she had a lifetime to give it to the others . . . certainly pouring in the love, a way to reason things out, a way to balance things out, a way to escape racism. I suppose as a kid I had been brought up with it in Fort Scott, Kansas. I couldn't even take my girlfriend to the corner drugstore and have a soda. It was for whites only. The grade school was segregated. The only reason they possibly didn't segregate the high school was that the town fathers couldn't raise enough money to build another high school. But we were told by our class adviser that we shouldn't worry about going to college. It didn't matter if we even finished high school because we were going to end up as porters and maids. That's the sort of atmosphere we were spawned in. Now I'm going to television and radio stations, stores, banks, and seeing black people and other minorities doing things that they never would have dreamt of doing when I was a young man. I've seen tremendous racial change. It's extremely difficult to dispute that. Yet, there still are these great depressed areas—Harlem, Watts, the south side of Chicago—which seem to be growing despite the changes. It's decadent. The south side of Chicago that I knew is not getting any better, it's gotten worse. The same thing in Harlem. So in one way I see enlightenment and change. In another way I see some kid up there who cannot appreciate the distance that I have come. He is still poor. He's still cold. He's still hungry, and he's still being discriminated against. He has no mother or father as I had to encourage me. He's lost. You can very easily displace the word "progress."

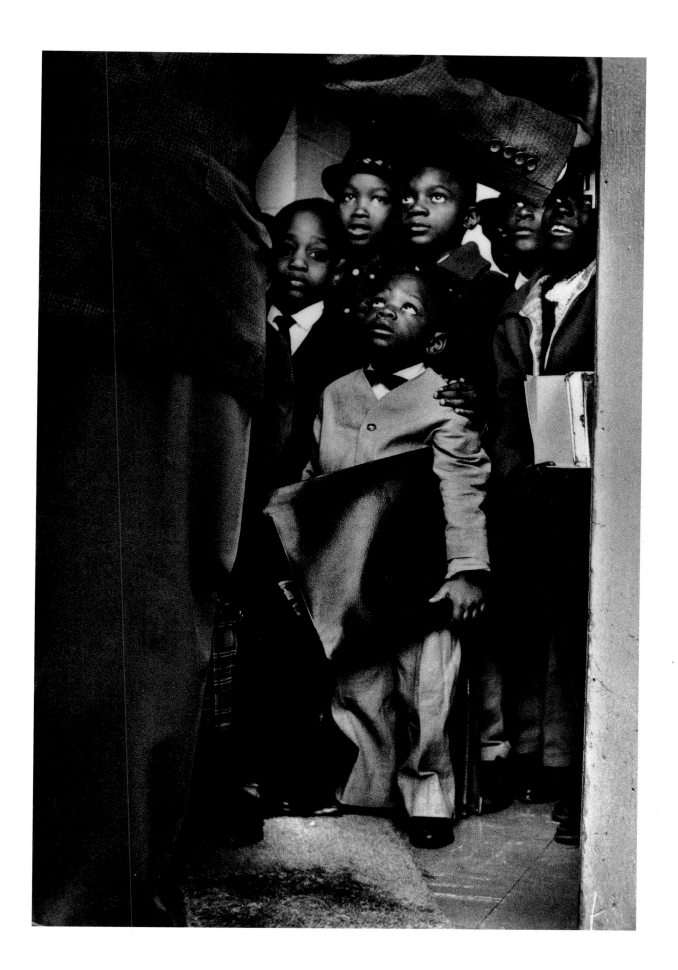

Ella Watson, American Gothic, Washington, D.C., 1942

Jack Delano of the Farm Security Administration, after seeing some of the work I had done on the south side of Chicago, encouraged me to come to the FSA, which I did in 1942. The first day I was in Washington, Roy Stryker sent me out. He had asked me, "What do you know about Washington?" "Well, it's the capital of the United States, it's where the President lives. . . ." I continued with mundane answers like that. So he gave me this assignment that seemed very strange. He told me, "Put your camera down and go buy yourself a topcoat at Julius Garfinckel's Department Store, go across to the restaurant to get some food, and go to the theater and see a movie and come back to the office." In each of these places I was refused in one way or another. Outright in the theater. Subtly at Julius Garfinckel's. They just couldn't find my size in a topcoat, and they didn't try. At the restaurant they refused me at the counter. I faced all that in one afternoon. Stryker had obviously given me the assignment to wake me up to the reality of the place. I suppose that in a strange sort of way racism in Washington, D.C., struck me harder than that I had suffered from as a child in Kansas.

I took Stryker's suggestion to talk to other black people who had spent their lives in Washington. I struck up a conversation with a black charwoman who was mopping the floor in the building. In the next hour she guided me through a lifetime of drudgery and despair. I asked her if I could photograph her. I placed her in front of an American flag with a mop in one hand and a broom in the other. I think this first photograph that I made for the Farm Security Administration became one of the most powerful photographs in all my repertoire.

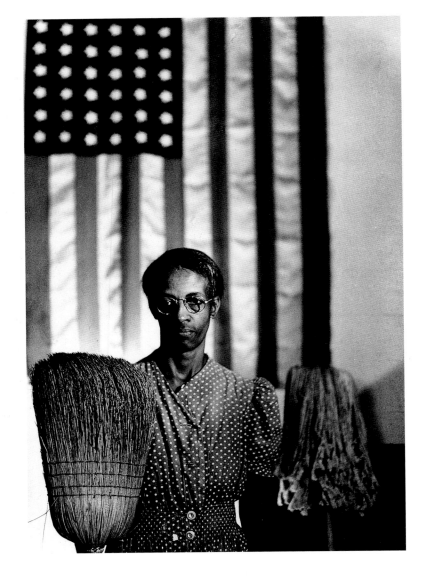

Red Jackson, Harlem Gang Leader, 1948

I walked into Wilson Hicks's office [at *Life* magazine] and he said, "How the hell did you get in here? What do you want in here?" Wilson was a very tough editor that a lot of people hated. I said, "I want to show you some pictures." I had gone up to somebody and asked, "Where's Mr. Hicks's office?" I knew I was going to get thrown out but then John Dille, who was editing documentary assignments, came into the office and saw some of the stuff I had done for the FSA. He was looking for a good strong documentary piece. So Wilson asked, "What do you want to do?" I proposed a story on a Harlem gang, not because I wanted to do it but simply because I felt I had to excite this man. I had to say something with my camera that none of the white photographers could do, such as to penetrate a Harlem gang. After being convinced by John Dille, Hicks said yes. After the story ran in *Life*, some readers sent money. It makes me feel good when I get letters to the effect that some image has encouraged people to do this or do that. In some instances it doesn't work out the way you hoped it would work out. *Life* magazine gave a substantial amount of money to move the Fontenelles, Red, the leader of this Harlem gang's family to a new home . . . a nice old house—away from Harlem—with a lawn, a new washing machine, a new stove, a new this and a new that, which people had donated. One day, the father comes home drunk, sets the place on fire, burns the house down, he dies in it, little Kenneth dies in it, and Mrs. Fontenelle comes back to Harlem and says, "I never want to see that place again in my life." At least in Harlem she had family that was alive. All that was left in that nice cute little home in Long Island was death.

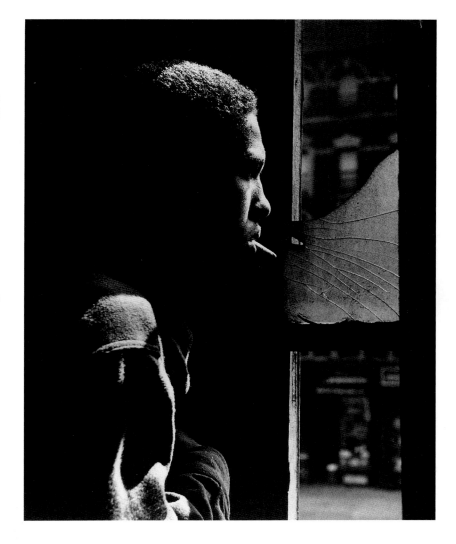

Ingrid Bergman, Stromboli, Italy, 1949

I had just been sent on my first fashion assignment to Paris. I had not joined the staff of *Life* yet; they were testing me, I guess. After I finished the fashions I sent them back to New York and they cabled me back that there was a wonderful love story on the island of Stromboli between Ingrid Bergman and Roberto Rossellini and to go there immediately and cover it. Roberto had become sort of a tyrant on the island and kicked all the news-people out because everybody was condemning Ingrid. . . . The whole world seemed to be against her for leaving her husband and daughter and going off with Rossellini. She was pregnant at the time too. The film was falling apart. . . . Roberto was angry at all the newspeople. They had to have some coverage, and they had to have somebody they could trust. Ingrid thought she could trust me. She had seen my pictures of the Harlem gang series in *Life* and thought they were sensitive, so that's why I was invited. I was taking a portrait of her on one side of the island, and these three women came along dressed in black. They were curious about me and Ingrid and what we were doing. They just paused a moment, and I took advantage of that moment. I think the picture is symbolic of what Ingrid and Roberto felt the whole world was thinking.

Muhammad Ali after the Henry Cooper Fight in London,
England, 1966

I gave some advice to a young black man who wanted to be a photographer. He asked, "How the hell did you do it way back then when there was nobody to help you? You went to *Vogue,* you went to *Life,* you were the first black director in Hollywood. . . ." "You really want to know how I did it? By forgetting that I was an African American. I was just an individual out to do a job. I could not be hampered by racism and what racism does to people. I refused to accept it. I ignored it. I walked around it. As my dad used to say, 'Waltz around it and foxtrot on their backs' [laughing]. If you are going to let bigotry destroy you, the people who have set it all up will be happy because this is what they wanted to happen. If somebody sees your work and they don't hire you, don't let race become an excuse for your failure where actually it wasn't for that reason. All right. How many white boys would have loved to have worked with *Life* magazine when I began there in 1948? Millions would have liked to have been *Life* photographers. That was the goal. How dare I even dream?"

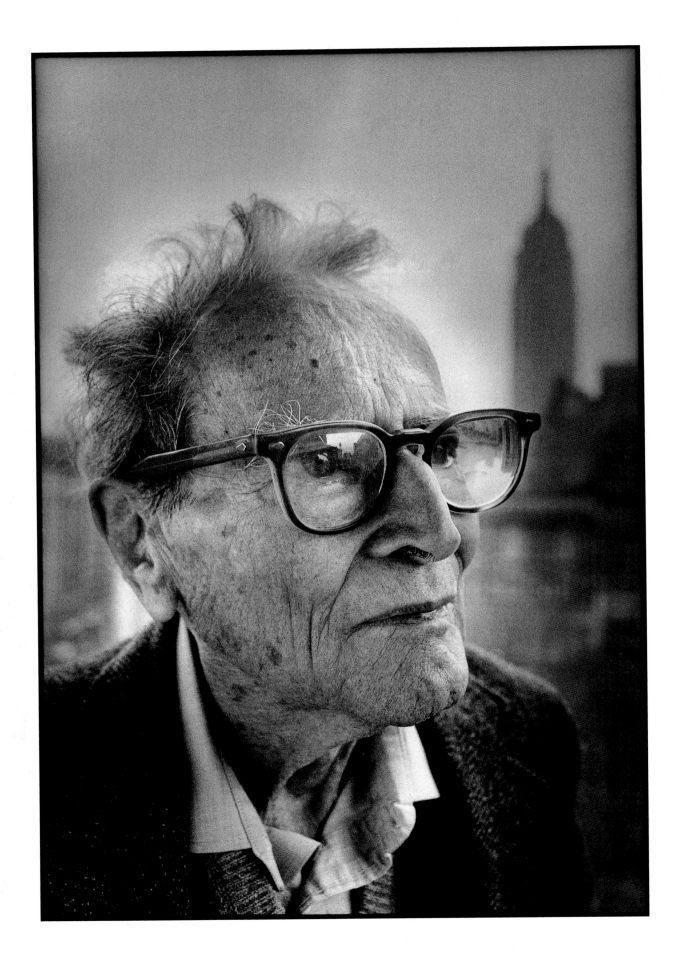

Andreas Feininger

The camera arrests time, so to speak. In other words it gives us time to study what we saw when we made the photograph. What you have in the form of a picture can really be studied, the details can be examined, you can get to the root of whatever the subject is. You can think about it. When you make the photo, all you have time to think about is your exposure and sharpness and composition. I've always liked simplicity. Cut out what you don't need. I was at the Bauhaus only a short time, and I didn't see eye to eye with the people there. I found that people like Walter Peterhans's and [Lázsló] Moholy-Nagy's attitude toward photography was too intellectual and abstract. If it looks interesting, I shoot it. When I began doing photography professionally I photographed architecture. I originally wanted to be an architect. From architecture I came into photography, because I couldn't find work as an architect. When I went to architects looking for work, they usually showed me pictures of what they had done. The number-one architect in Stockholm, where I was living at the time, showed me pictures of buildings that I liked very much, and he asked, "How do you like them?" And I said, "Very interesting, but your pictures are lousy." So he asked me if I could do better, and I said yes. So he said go ahead and do it. He loved the photos I made, which he showed to all his colleagues, and I soon was shooting for them as well. Because when the war broke out in 1939 between the Soviet Union and Finland, the Swedish government prohibited foreigners from using cameras. They thought they might spy. That ended my career in Sweden. But I found New York was a fascinating place to photograph.

Midtown Manhattan Seen from Weehawken, New Jersey, 1942

I think it is a good photograph because it shows New York undistorted—a city that I am fascinated with. It was shot with a super-telephoto lens, a 40-inch lens on a 4x5, and the proportions are those of New York, with the church on the right side of the frame in the foreground. The skyscrapers, which are quite a bit behind, appear much larger because, of course, in real life they are actually so much larger. These are the natural proportions. But you get this on film only if you shoot from very far away and with a super-telephoto lens. The closer you get, the bigger the church would be and the smaller the skyscrapers would be. The photograph ends up becoming the ordinary postcard-type view of Manhattan. I searched across the Hudson River until I found a place in Weehawken, New Jersey, where I got a very good view of this particular part of the waterfront. You know, if you use a lens of this very long focal length, it's very sensitive to vibration. Gravity will always be pulling it down, so naturally you would get an unsharp picture. So I constructed a special tripod where the lens is supported both front and back. I call it a five-pod, because it has five legs. I attached two additional legs to a conventional tripod that extend out, supporting the front and back of the camera and lens. Therefore there are five legs that only hit the ground at three points. If you hit it at five points you never would be able to achieve a steady balance. I made the camera, which consisted of two boxes that slide inside each other for focusing. I made them light-tight by lining the inside with velvet.

Jewish Shop, Stotting, 1940

In the Lower East Side I loved the Hebrew characters on the shops. They're graphically so interesting I think. It's all gone now. It was so beautiful there. The interesting neighborhoods to shoot in are too dangerous. You might get robbed, your camera would be taken away. These streets are totally unsafe. And the ones that are safe are very dull. It's the same here or in Hong Kong or Berlin . . . no difference. Graphically I think *Jewish Shop, Stotting*, is just about perfect, with all these elements coming together, and then it has a very moving woman's touch. The woman in the window sits under her lamp and just works and works and works. *Stotting* is misspelled; it should be *stopfen*, which is a Yiddish word meaning repair, repairing cheap things . . . you *stopf* socks, for instance. There she sits working her life away and never getting anywhere. The whole thing to me is a tragic composition.

Signal Hill Oil Field near Long Beach, California, 1948

I photographed the oil fields near Long Beach. When I got there, all I saw was an immense oil field. The towers close to me were very, very high. Because of the perspective, the ones that were farther away got smaller and smaller. That's when I got out the 40-inch lens. Look at the sharpness. It was a Dallmeyer, which is a very famous English lens. The derricks in the distance were compressed, and the scene looked like a man-made forest.

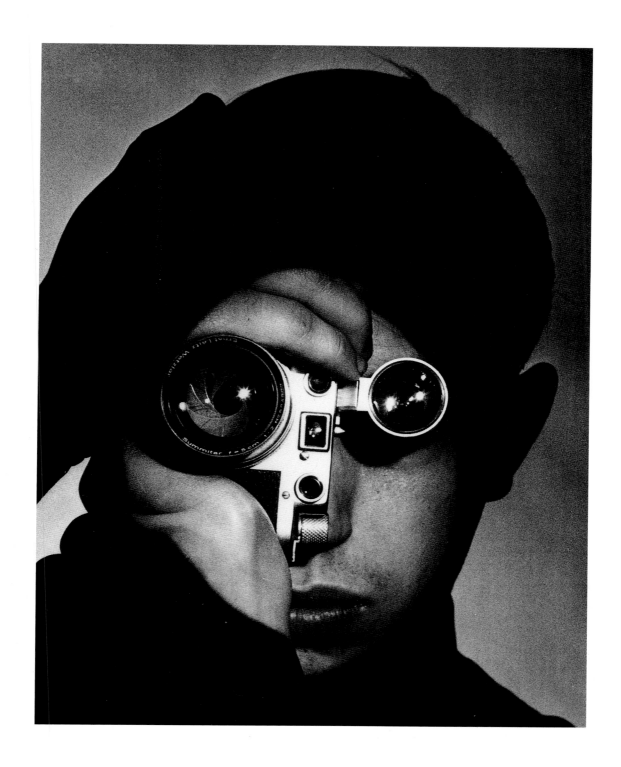

The Photojournalist, 1951

This actually was shot for an assignment. Dennis Stock had won one of *Life*'s contests for young photographers. He was playing around with his Leica, and when he held it up to his eye for a moment I saw the possibilities. I adjusted the light in the studio and took the photo. The reaction from the editors was that it was one of the strongest photographs that they had ever seen but that it would scare people. So they didn't use it. Since then it has been used on the covers of at least ten magazines.

U.S. Navy Helicopter Taking Off at Night, 1949

This was a rescue helicopter. Small lightbulbs had been put into the tips of the rotors. They thought it would make that thing more visible at night. For instance, more useful in rescue operations at sea. They had invited the press for a demonstration. I was not there for this first attempt. The picture that everybody got—there were probably a dozen photographers there— was something that looked like an overexposed Christmas tree with lights. It was a total mess. The helicopter had just gone up and down, up and down, several times. You never saw the spiral. Wilson Hicks, the *Life* photo editor, showed me that picture and asked if I could do better than that. I said, "Of course I can." So he said, "Okay, do it." So I talked to the people and the pilot there. Obviously it was going to be a double exposure. To create the pattern in the sky of the rotors would have to be a time exposure, naturally. The helicopter on the ground had to be a short exposure, or it would be overexposed. So we had the light directed on the helicopter for just a few moments and then the pilot did exactly what I had asked him to do, go straight up, not too high, slip forward and down, and then fly straight over my head. And because of the direction I was shooting I was able to get the moon in as well. He did it three times, because I never knew quite what I got. You can't look through the ground glass of the 4x5 during the exposure. The second time one of the bulbs burned out during the ascent, creating an uneven pattern, and then another bulb burned out halfway through the third try. Fortunately as it turned out we had gotten the shot on the first attempt.

Eve Arnold

I had six weeks of training with Alexey Brodovitch at the New School for Social Research in New York. That was all the instruction I ever had in photography. He was responsible in a sense, certainly with me, for trying to get away from the hidebound studio work with a large-format camera that was fashionable. For my first assignment I went to Harlem to photograph the fashion shows there. I asked a woman named Rose Morgan what was happening in fashion in Harlem, and she said, "Miss Arnold, there are 300 fashion shows a year in Harlem—in churches and in bars and in restaurants." It was really incredible. This was 1950. . . . It was a protest against the white-dominated "shmata" trade in New York. When Brodovitch saw the stuff, he said, "Don't do any more class assignments, just go back to Harlem and do that story." He referred to this work as documentary fashion because of the application of documentary techniques. It became my first published story. It was published in *Picture Post* in Britain. It was on the strength of this story that Magnum Photos took me on. I decided early on that I had to streamline everything so I could work and move around easily. I think it elicits more from the people you're trying to photograph. You can travel, you can carry the equipment yourself, you don't become a big production. I'm not a technical freak. There are people who love technique and love the equipment and they get together and talk about lenses. I think that's wonderful, if that's what you want. I would like to know who it was that I photographed. I would like to know something about that person that means something . . . that I haven't encroached on him . . . that my lights didn't tell me it was a great photograph because it was lit beautifully. I want to know who "Uncle Joe" is underneath. The only way I can achieve that is by not putting myself forward. You can do so much more that way. I work with a minimum amount of equipment— usually three Nikon bodies and three separate lenses, usually a 35mm, 50mm, and 105mm. I don't use lights, I don't use tripods, I don't use motor drives. Everything that I need on most trips I can get in one bag that I can carry. It also means that I didn't get a bad back until quite late.

Marlene Dietrich, Recording Session, New York, 1952

I photographed Marlene Dietrich in New York when she was recording songs she had sung to Allied troops during World War II. She was the most professional person I ever met in my life. She was so diligent, I felt she brought the same energy as a ditchdigger who had a boss behind him with whips. She was driven, she was funny, and she was very clever. She arrived this rainy night with Jean Gabin and a little funny man who was introduced as a friend from Hollywood. It was her astrologer, who had said that this was the night to make the recordings. She was singing the songs that she made famous: "Lili Marlene," "Miss Otis Regrets," that whole series. Here we were in this drafty, dirty, dark soundstage and I was shooting with a Rolleicord with the ambient light and she wasn't quite sure she wanted to be there at all with me. She was used to that whole big studio glamour setup with everything front-lit. In those circumstances she would say, "Hey, the key light is fine but what about the fill?" Leo Lerman, picture editor at *Vogue,* a buddy of hers and a friend of mine, later told me that she called him at six o'clock in the morning when we got through the recording session and said, "That Arnold woman was here all night." He said, "Why did you let her stay?" She said, "She did it with such authority it never occurred to me to send her home."

Roy Cohn and Joseph McCarthy, House Committee on Un-American Activities, Washington, D.C., 1954

I was sent to the senator's secretary to be vetted. My train had been late coming into Washington so she quickly sent me along to the Senate hearing room where McCarthy held up the hearing just to meet one free-lance photographer—his cohorts Cohn and Schine had just come back from Europe where they had been lambasted by the European press and he was looking for some good publicity. "My dear, who do you work for?" I said, "*Vogue, Esquire, Fortune. . . .*" He said, "Well that's fine." It was true, I had had maybe one assignment from each, but I was doing this one for myself. I went through the entire morning—we broke for lunch, then he had a press conference. As I came over with my camera to photograph him, he put his hand on my shoulder and said, "My dear, are you getting everything you need?" I thought he was loathsome, so I put my hand up to remove his hand and then luckily my brain was quicker than my hand so I ended up holding hands with him for a moment. Then I said, "Excuse me, Senator, I have to get back to work." There were thirty reporters there, and they looked at me like I was something that came out from under a rock. When we went down to the dining room to have lunch nobody would talk to me.

Marilyn Going Over Lines for a Difficult Scene, Set of The Misfits, 1960

Although she seemed uncertain, her understanding of what would make her a movie star was so great. The need also was so great. The intelligence was there too. She created Marilyn. She created that character. It wasn't the movies that did it, she did it. She had much more control with a still camera than in the movies. We would discuss what we were going to do, and then we would play. We used to laugh a lot. It was great. I think insofar as she trusted any photographer, she trusted me. With Marilyn we started out as two young women beginning their careers. Neither one of us knew what we were doing, and that was a bond between us. Secondly, I was not a threat to her. Male photographers are always bragging about going to bed with their subjects. I had six sessions with her. The shortest was two hours, which was a press event, and the longest was two months on the set of *The Misfits*. Her enemy was that she couldn't sleep, so she would take sleeping tablets. I saw an enormous change in her over the ten years that I photographed her. In that time she had gone from a beginner to a world figure, and it had taken its toll. She created "Marilyn Monroe," but it was very hard on her. To my knowledge, as long as she could fantasize about being a movie star she was fine. It was when the fantasy became the reality that it was hard. In a way, I think it was part of what killed her.

Malcolm X Collecting Money for the Black Muslims,
Washington, D.C., 1960

The whole segregation thing was an explosive issue. I read a book, *The Black Muslim in America,* and it was a real eye-opener. I suggested this story to *Life* and they seemed very happy. I came in highly recommended by a black reporter-writer, Louis Lomax. It was at a time when Malcolm had decided he wanted to go public, so he was anxious for the story. Malcolm invited me to dinner at a restaurant he ran on 125th Street. We talked and apparently he liked what he encountered because I got invited to Chicago. The Black Muslims wanted to get away from whites, so they set up their own shops and factories to make their own clothing, and schools and universities; all this they started in Chicago. It was an incredible story and a very dangerous one. The night that I had dinner with Malcolm and he decided I was okay I went to a meeting of African nationalists where a woman started screaming "white bitch" at me. It was early summer and I remember having on a woolen sweater. As I went through the crowd, people stuck burning cigarettes in my back. Wool smolders, it doesn't burn, so I didn't catch on fire. When I got back to the *Life* darkroom to leave my film, I took my sweater off and discovered it was covered with holes. It was that kind of story. When I went to Chicago to work I got a call every morning at the hotel at eight o'clock, "Get the hell out of town before it's too late." It may have been the Black Muslims. It may have been the faction that killed him in the end. I don't know. It occurred to me that I ought to call the *Life* office and tell them that I might be in trouble, but I figured they'd take me off the story so I never told them.

Retired Worker, Gwelin, China, 1979

During the course of two trips I traveled altogether 40,000 miles in China. The Chinese gave me a small room at the Peking Hotel where I could store things. I brought 300 rolls of Kodachrome each trip, enough film to last me for three months. There is a myth that black and white is art and color is commerce. If you get a really fine photographer, he can use any medium, he can make the colors sing just as he can do the same with black and white. I shoot for form rather than color. It is true that black and white is more of an abstraction and you have to get involved with it and bring your imagination into play. That's wonderful. But if you use more of a kind of monochromatic color, there's no reason why it shouldn't look equally wonderful.

Marc Riboud

If photography is a profession, it is a tough one nowadays. For me it is a passion, closer to an obsession. I have often dreamt of being a precursor of Erich Salomon, with a small camera, hiding behind a curtain when Bonaparte crowned himself emperor, or even behind a tree—a big one—during one of his battles.

In their times Daguerre and Nadar had to be craftsmen to make the photographs we admire now. Today a camera is such a simple tool that it takes two minutes for anyone to learn how to use it. Therefore a major threat is facing us: billions of photographers are shooting billions of photographs, to the delight of millions of shareholders. The consequence: photographers tried desperately to differentiate themselves from this horde of snapshooters invading their field. So they decided to name themselves "artists" while Picasso called himself a worker-painter. They declared that photography should leave the street to the barbarians roaming there, so they could concentrate on their own personal world and reach the sacred level of creation. Sorry, this is caricature. I love caricatures! I also love the barbarians—many of them—as well as the intellectual artists—few of them.

For me photography is not an intellectual process. It is a visual one. I agree with Walker Evans's definition of the photographer: "A joyous sensualist for the simple reason that the eye traffics in feelings not in thoughts. He is a voyeur by nature, a reporter, a tinker, and a spy." The world we live in is submerged by thoughts, comments, and concepts of all sorts. We forget that our language is based on the eye and for the *pleasure* of the eye. We are involved in a sensual business. The eye is made to see and not to think.

While shooting, if we think too much, we miss the birdie. A good photograph is a surprise. How could we plan a surprise? We just have to be ready. René Char, a French poet, advised us "to foresee as a strategist and to act as a primitive." We should be proud to act as primitives. Anybody can become a professional. It is more difficult to act like a primitive.

There are different ways of seeing. I have mine. For me to look at and to photograph a beautiful face or a misty landscape is like listening to music. It helps me to live. After forty years have I changed my way of seeing? I don't think so. Rarely one changes. I do different things, the same way. When asked which picture is my best one, I answer, "I will shoot it tomorrow." And I keep trying to change my way of seeing. In vain. If taste for life diminishes, the photographs fade because photography is savoring life in $1/100$s of a second.

Paris, 1953

When I was seven years old I was riding my bicycle past a couple on a motorbike as they were embracing and kissing. They stopped me and asked, "Can you take a picture of us with our camera?" I had never held a camera before. So I took it, clicked the scene and quickly rode off. This was my very first photograph but of course I never saw it. Strangely now, whenever I find myself among tourists, there is always one of them asking me to take a picture of his group in front of a monument. As I don't know how to handle an automatic camera, he teaches me how to use it and how to choose the good angle. I obey and do my best.

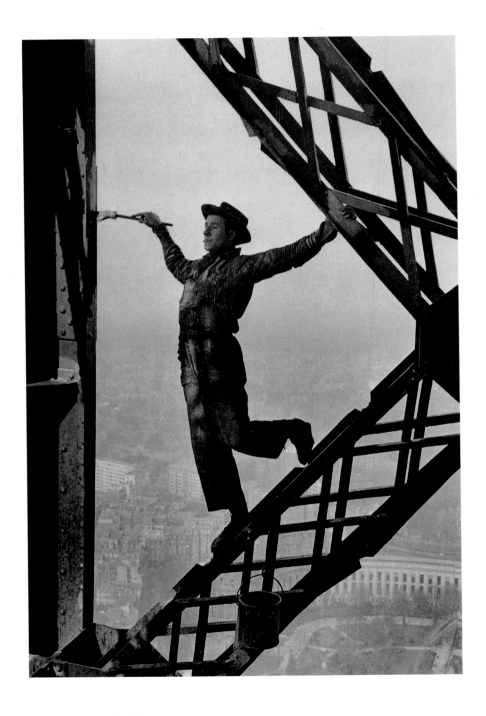

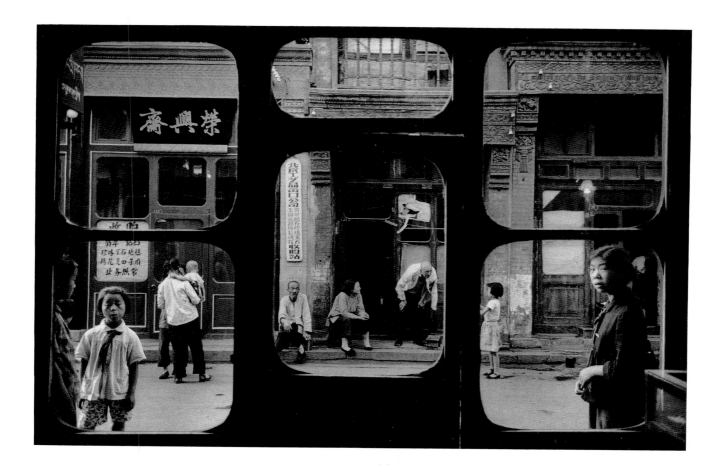

Beijing, 1965

I have traveled all over the world, but I am not a globetrotter. Sometimes I think I am not good at traveling. I am rather a rambler. I travel slowly. When I decided to go to India in 1954, it took me six months just to get to Calcutta and I stayed there for one year. My stays in China took up another year of my life. I am often reluctant to leave a place when I get there. And I can feel at home as much in Shanghai or Saigon as in Lyons where I was born.

I am often asked how frequently I go to China. Yes, I have been often to China. No, I don't speak a word of Chinese. Yes, I like to photograph where life is intense with fast changes. Yes, it is difficult to photograph people who look like us and cities that look like ours. No, my only interest is not exoticism. But I prefer people who keep their own culture.

There is a fashionable trend to become a miner in order to photograph miners or a Muslim to photograph Arabs or a lama to enter Tibet. I don't believe in that. We better remain what we are. There is no point fooling ourselves; for the peasant in front of us, the Leicas over our shoulders may represent ten years' income.

Pakistan, 1956

My advice about equipment? A good pair of shoes comes first, as it is faster
to walk up nearer to the subject than to change lenses. Light cameras are
better. Let us avoid everything that requires thinking and leads to hesitation.
I usually carry two cameras, one Leica M6 and one R6. As for lenses, a
35mm, a 50mm, and sometimes a zoom. As for films, TRI-X and TMAX
3200. I prefer black and white. It's already a simplification, isn't that what
we are all trying to do? I don't like automations, which are by definition
the average, and the average is equivalent to mediocrity. But I even enjoy
shooting with throwaway cameras, especially underwater and panoramic
ones. It's a good way to train one's eye.

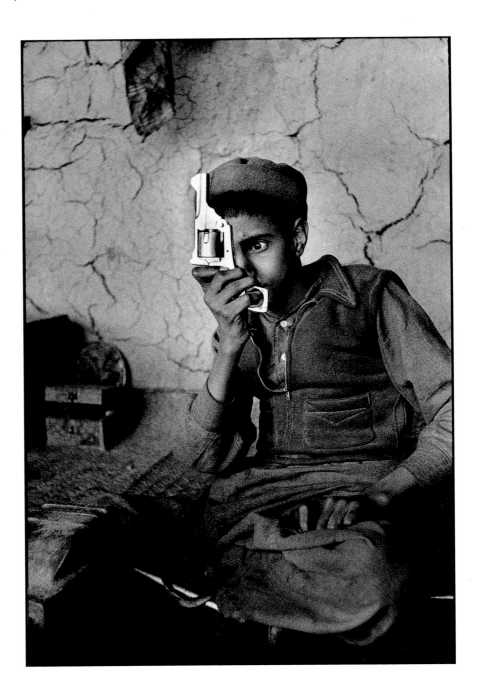

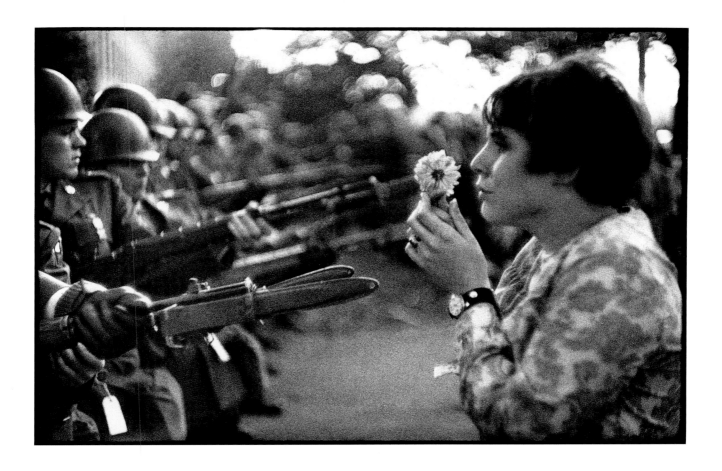

Washington, D.C., 1967

I am sensitive to the beauty of the world and of people. I try to avoid violence and monsters. And what a pleasure to discover rhymes and rhythms in my viewfinder. My contact sheets reveal that I have been carried away by many causes. I don't regret it. Life would be sad indeed without dreaming to change it. And to change one's life first. After so many disillusions only one cause seems to be still worthwhile: culture. And it is an international cause.

Iran, 1979

What we are looking for can only be found in life and reality. Pure creation, spontaneous generation, I don't believe in it. I remember those notices over train windows when I was a child: "It is dangerous to lean out." A friend of mine unscrewed one of them to hang over his bed. But I always thought we should adopt the opposite motto: "It is compulsory to lean out of the window." It is this obsession to photograph life, intense life, that keeps me going. It is a mania, a virus as strong as my reflex of independence.

Edouard Boubat

My work in photography started just after the war, in 1946. In fact, I never learned photography formally. I just had a camera. I had gone to the Estienne school to learn how to print books. It was a graphic arts school. I have to say that I am lucky because I have always made a living from my pleasure, which is photography. Because I know war . . . because I know the horror, I don't want to add to it. You see too much . . . you watch television and every day you are invaded with death. After the war, we felt the need to celebrate life, and for me photography was the means to achieve this. I have been mesmerized by the light ever since. The artistic director Bertie Gilou saw a small exhibition of mine in Paris at the La Hune bookshop, which was one of the few places to exhibit photography at the time. It was a group show that included the work of Brassaï, Doisneau, and Izis. The editor of *Réalités* said, "I like your pictures. Come and see me." When I began in photography, everybody had a darkroom in their kitchen or their bathroom—wherever we could find the space and running water. At that time we didn't think of ourselves as being "professional" photographers. I am not a professional, I am not an amateur, but yet I am both. Henri Cartier-Bresson developed his rolls in his shower. But when I started with *Réalités*, the magazine took care of the printing, which allowed me to concentrate on taking photographs. I was told, "Edouard, you go to a very good laboratory on the rue de la Comète." There I met my friend Pierre Gassmann. For us at *Réalités* it was wonderful. It is the same relationship between a conductor and an orchestra. So Pierre and I work in the same way. Pierre has always said, "There are never bad negatives. There are only bad printers." In the 1960s magazines preferred color, so it became necessary to often work in color, especially on later assignments for *Réalités*, but I have always preferred the subtleness of black and white.

Première Neige, Jardin du Luxembourg, *Paris*, 1955

It was the first snow of the season, and during the first snow it's always magic. Also the composition works well. You will never find the same. Just once. It's photography. Just one time and no repeat. Once it's gone . . . there is no repetition. With painting you can do it again but not with photography. Photographers are lucky. I have several friends who are painters, but they stay in their studio. I love music, I love painting, but it's photography that lets me come out of myself. Myself, yes I stay there, but my studio is all the world. I must be on the ground, I can't stay inside all day. Photography is a combination of skill and harmony with time, light, and shade. Our studio is the world. I let the light do everything by itself. My life is the photography. I work for photography and photography works for me. My life is not separate. It's the same for all artists. Photography consumes me, but I consume the photography too.

Sunflowers, 1987

Fifty miles south of Paris in Île-de-France was this beautiful field of sun-flowers. I was walking in the countryside. The sunflowers are alive and looking around. I wasn't thinking of anything in particular at the time, it was only a question of beauty. You want to talk about a photograph but sometimes there is not too much to say. It's just to go and be patient and receive. The picture speaks for itself. There is something to the saying that a picture is worth a thousand words.

Paris, 1952

Every picture has its own story. I like the picture of the little girls. I met them by chance. Twenty years after I took the photograph, I met a woman who told me, "Mr. Boubat, you took a picture in front of my shop." She told me that one of the girls was the daughter of the former owner and had become Miss France because she was very beautiful, but later she became a homeless person living on the street. It's a terrible story, but I think it is true. I don't know if it was the girl on the left or the right. All pictures continue their story . . . the subjects become older. You capture a moment, but life continues and nobody knows what happens later. But there is the contrary to that sad story. Many people come to my exhibitions and say, "That's me twenty years ago" or "Those are my parents." Maybe they're wrong, it's a kind of dream, just their imagination. . . . "Oh, that's my mother, I recognize her dress." Then the picture continues its life. And it's a nice story. And people are so happy. "That's me. Look how beautiful I was." I did the portrait of the French writer Jean Genet. Then he saw his picture years later and said, "How handsome I was." Sure, he was so young. And time goes on. Time goes by. But that moment is frozen. Now he's dead. But you see the photograph and he is alive. That's the magic of the picture. You believe what you see. But you can touch only the present. You know Shakespeare's Macbeth: "Life's but a walking shadow, a poor player that struts and frets his hour upon the stage. . . ." The poor actor . . . it's me, it's you, too. We are the poor shadows.

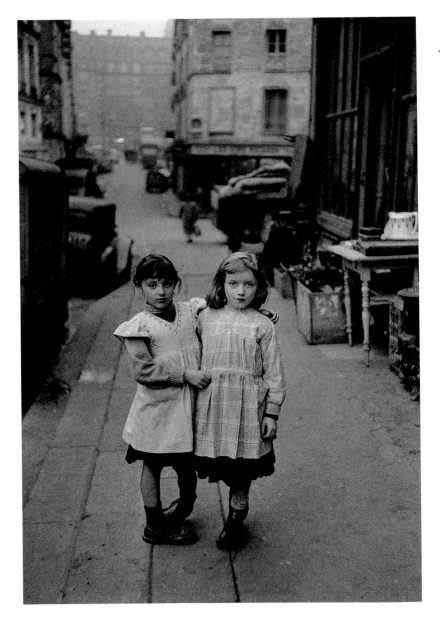

Saint-Germain-des-Prés, Paris, 1953

Here in France, to this day, dogs are still allowed in cafés. I was just passing by the terrace and saw them. I was like a thief. This photograph, like all my photographs, is about meetings and about *coup de foudre,* love at first sight. The dog is sitting at the table like a friend. It was just like that, no mise-en-scène. I never set up pictures like that. I didn't change anything, it was by chance.

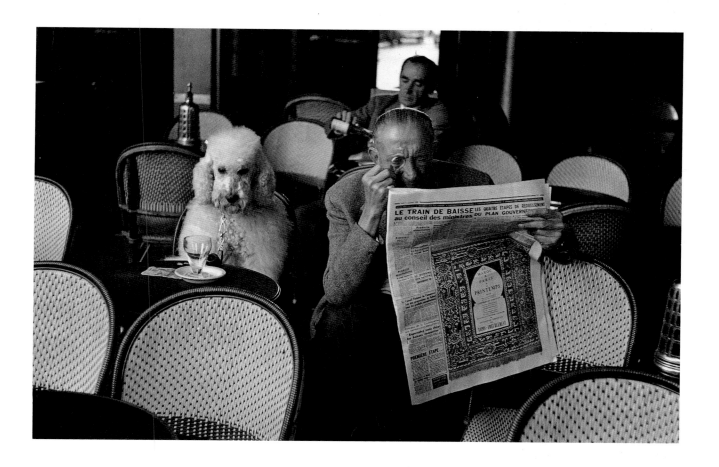

Cinema, Festival d'Alger, 1969

I photographed a great festival celebrating Africa on an assignment for *Réalités*. Many people from all over Africa came for this festival of movies. The photo was taken while the people were watching the movies at this outdoor theater. The light is very interesting because the people are lit by the projector light hitting the screen. I am fascinated by the many faces. A woman is wearing a mask. I don't think too much when I make a photograph. I just take a picture of something. The scene was like that. There's not too much thinking. It's done without mind. The mind is there before the picture and afterward. But at the very moment, the real moment, there is no mind. Like in the art of archery, at the very moment the archer releases the arrow there is no mind and you are not separate from the target. With photography you have many things to think about and do afterward—you put it in a magazine, a book, a gallery, but for myself the best moment is during the taking of the picture. It's the same thing when you pick some flowers or when you draw something. It's a question of energy. As you travel, sometimes opportunities are offered to you as a gift. You can't possibly know in advance what you're going to find. But you must be open to it and you must be prepared to receive this gift . . . to have your equipment and knowledge ready to accept it. When you are in front of a landscape or you do a portrait, for a very short moment you become one with what you photograph. I remove myself so that I can let appear what is more than me. If I don't remove myself, all I'm going to show is Boubat. Somebody once said to me that it's not a matter of looking, it is a matter of seeing.

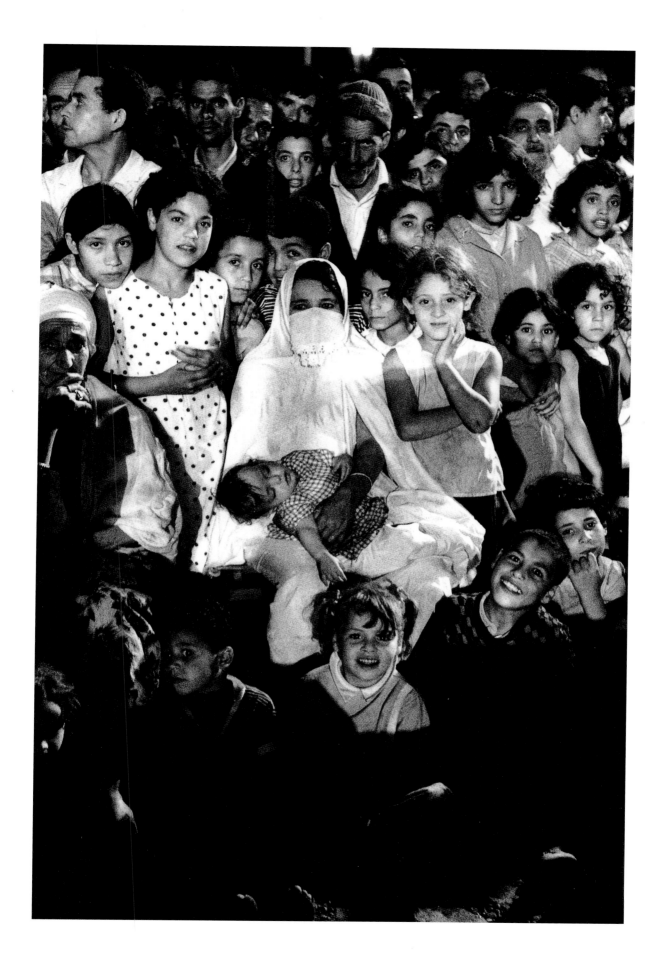

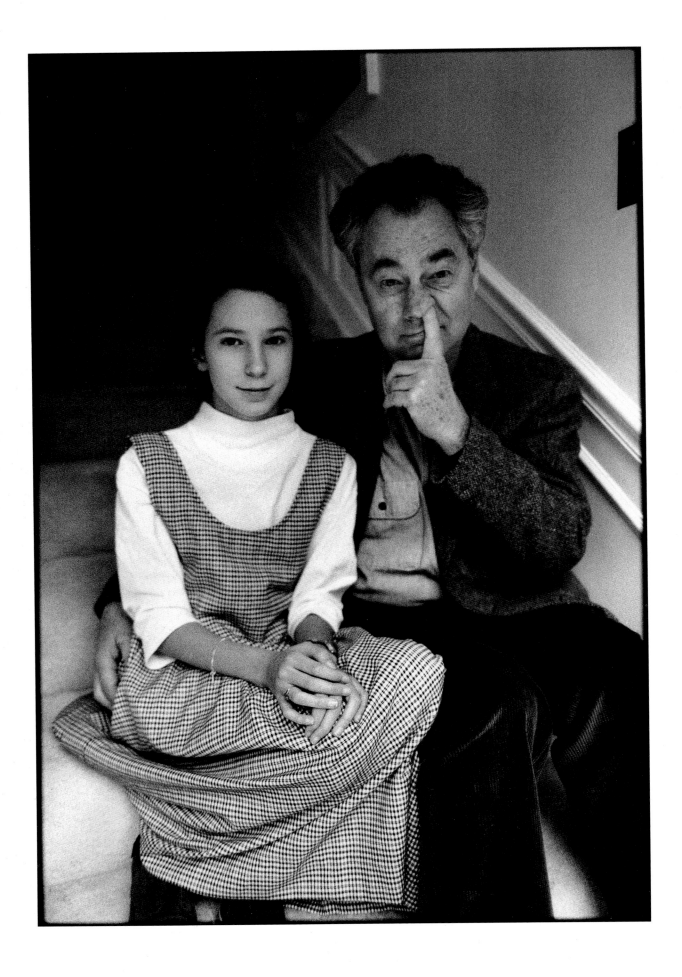

Elliott Erwitt

I often have a camera with me, particularly if I have nothing to do. Most of my work, the photos that appear in my books, was very rarely shot on assignment or pictures done for commerce. Generally I use a normal lens on my Leica. Most of my colleagues, who are not only assignment photographers but interested in what they see—which is a distinction—often carry a camera around. That's how you take pictures. You can't take pictures without a camera. . . . Cartier-Bresson and Gjon Mili are among my favorite photographers. I don't know why, but Mili does not seem to have stuck in the pantheon of photographers. I think he is one of the most important photographers that ever was, and also one of the great personalities of photography. He with [Harold] Edgerton developed one of the most important discoveries in photography—the strobe—but he was not just a technician, he was a great photographer and immensely important to photography. Many of my colleagues, like Sebastião Salgado, are doing wonderful work. But we seem to be in a big "star fucking" phase. Famous people in outrageous poses. You get a formula, and then you stick to the formula. Fine, I like that, it's very amusing, but it's formula; when you've seen three or four pictures, you've seen them. There's no discovery, there's a lot of cleverness, and that's okay, it's good for magazines and that's where you see it, but the more subtle, interesting stuff you don't see in popular publications. I'd like to see more photographers shoot duller things and make them interesting. I don't mean like wilting lilies or flower arrangements, but human stuff. Stuff that doesn't jump out at you. Life is not only misery and hysteria, it's also everything in between.

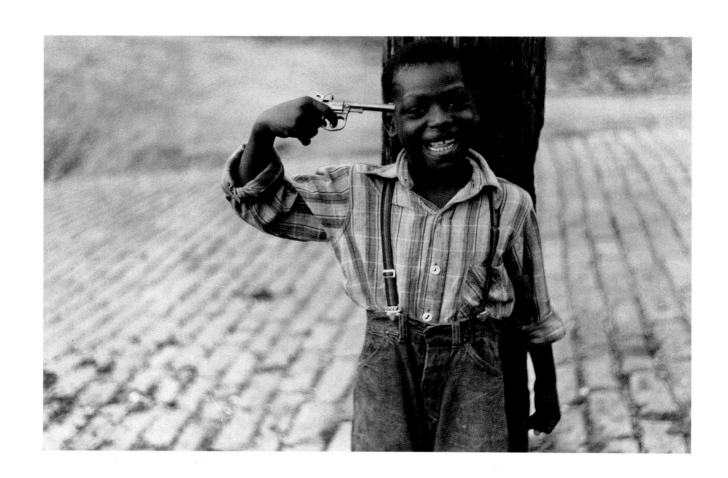

Pittsburgh, 1950

The picture that I keep coming back to more and more, which has a lot to do with me and my attitude and my point of view, is of the little black boy with the gun to his head. It's a picture that for me has the elements . . . that speak of me as a photographer. The photograph is funny and tragic at the same time. If you look beyond the actual image, it symbolizes something.

Las Vegas, Nevada, 1954

I suppose a big break is when you win the lottery. . . . I don't know that I ever won the lottery. I won a prize in a *Life* magazine photo contest while I was in the army in Europe. Having won the prize was pretty good because it gave me money that I didn't have so I could buy a car. Also, I was treated with slightly more respect than before as a private first class. I thought that winning a prize with *Life* magazine might be helpful when I got out of the army—to go to *Life* and say, "Well, here I am fellas!" It didn't work that way. But I was fortunate to meet people that were helpful. Edward Steichen, Robert Capa, Roy Stryker . . . they encouraged me. Some of them gave me work and saw to it that I was working. I should point out that in those days you usually didn't get to keep your negatives for jobs, you were working for others. This is something that was changed largely by Magnum Photos, by Robert Capa and myself, if I do say so myself. We were blackballed. We didn't work, we fought tooth and nail for our rights and so on. But before then you might as well have been a plumber. You did your work, and it wasn't your work, it was someone else's work.

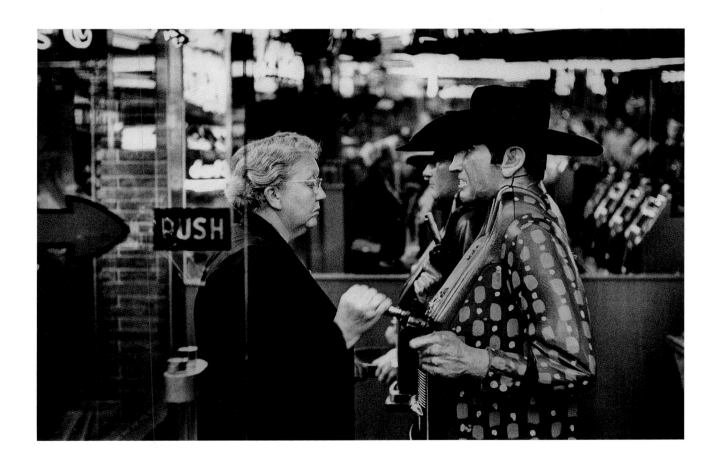

Muscle Beach, Venice, California, 1955

I go to the beach whenever I have the opportunity. Early childhood memories of a month at the beach each summer might have something to do with it. There's not much to do there except get some sun, which is passive, so I take a few snaps. In my book *On the Beach,* a great many of the photographs are taken at East Hampton and Amagansett, places that are close to my house at the beach. Saint Louis might be a bad place for a beach lover, but New York has beaches all around. My feeling about life on the West Coast is that it should be avoided. I would say that especially in southern California it's a good place for oranges but not for people. We moved there in 1941, but I was dying to get out of that place. I went to Hollywood High School and City College there, so I lived there from 1941 until 1945–46. Southern California is not my cup of tea. My tolerance for Los Angeles or Hollywood now is about three days; the fourth day is unbearable. I left for good when I was seventeen, but I kept going back because my mother lived there until she moved to San Francisco, a more decent part of California.

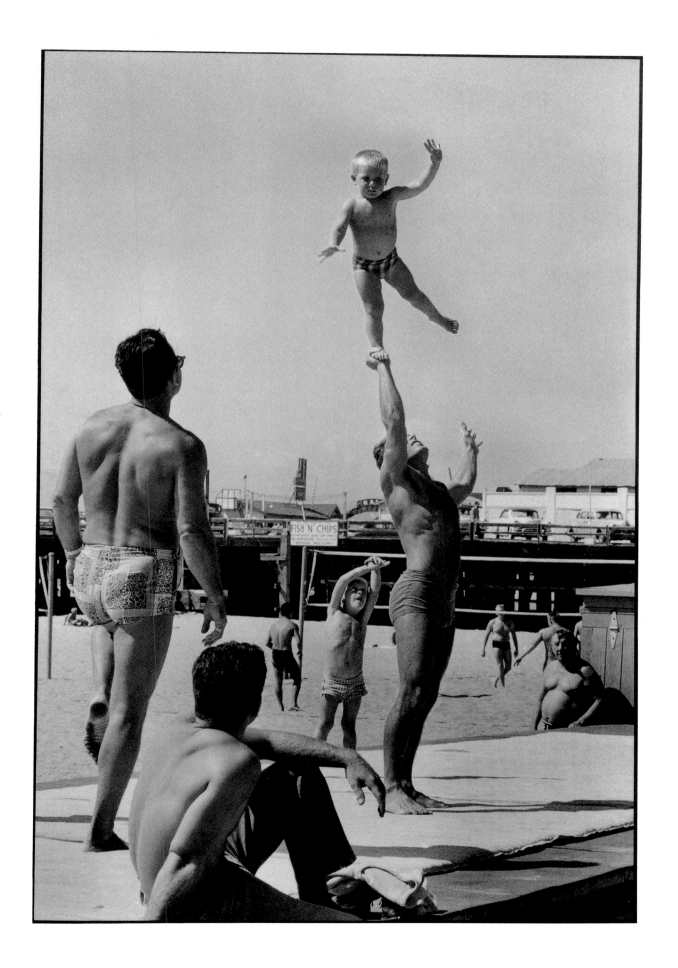

South Carolina, 1962

I like dogs, and you find them everywhere. I don't especially care for cats. Live and let live, though. They're less interesting than dogs, and from the point of view of photography they're also smaller, which is an important fact. Cockroaches, for instance, I wouldn't particularly be interested in taking pictures of, though I understand that they have quite a personality. Dogs have a sense of humor. They're very close to human beings in that respect and they very often acquire the characteristics of their owners. Depending on if the owner has a sense of humor, their dog will get one too. However, I would not think that a German shepherd or a Rottweiler would have too much of a sense of humor . . . they're not bred for that. Dogs don't start out looking like their masters. It's a process. Very often they acquire each other's habits and characteristics, particularly if the association is a close one. However, to start out with, you certainly don't find seven pit bulls in a Park Avenue apartment or Yorkshire terriers in the back of a southern farmer's pickup truck.

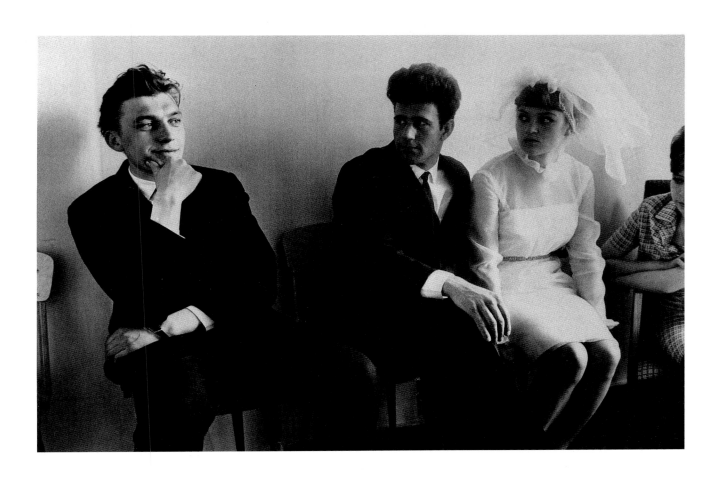

Bratsk, Siberia, 1967

I was doing a magazine story about the hydroelectric dam in Bratsk, which at that time was the largest in the world, but when you're in a place you want to look around as well so I walked into this wedding palace. You can read anything you want into it. I think that if you explain pictures it's like explaining jokes, or as a friend of mine used to say, "It's like dissecting a frog; once it's dissected it's dead." If it hits you, fine. If it doesn't, that's fine too. A picture has more than content, it has also a position, a style, and so forth, so if you get something out of it, it's good enough; if you get something beyond that, it's even better.

Mary Ellen Mark

I think your whole life, I mean all the experiences you've had combined, has an effect on you and makes you the kind of person that you are as an adult. They certainly express themselves in your work, whether you're a musician or a photographer or a painter or whatever. When I was a child I went on a field trip to a mental hospital. It was incredible. Also, my father was in and out of mental hospitals. It must have led to my interest in mental hospitals. I'm interested in the guy that doesn't have all the breaks in life and the people who live on the edge. They don't depress me. I'm not saying that their lives are wonderful, but they have so many incredible qualities. I don't photograph them because I feel sorry for them. I photograph them because they have a certain passion and humanity that is really interesting to me. I would like my pictures to be a voice for them. But that doesn't mean that I don't enjoy shooting people that have more fortunate lives than they do. I just like to approach things in a way that I can do it honestly. Photography is about seeing the world in your own peculiar and personal way. It's selfish, maybe, but I love being involved in work that lets me feel that I can come close to people and that I'm not just functioning as a public relations agent for somebody.

I remember the first time I went out on the street with a camera with the idea of making pictures—not just taking pictures of friends but really making pictures—how much I loved it. It's so wonderful to be able to go out and photograph something that you care about. The first big break that I had was for *Look* magazine. I was hired to do a photograph of Federico Fellini, and from there I did a piece on heroin addicts. Once I had these two big photographic spreads I was considered reliable, which led to working for other magazines, including *Life*. I have a lot of respect for magazines. I really use magazines as a way of building a body of work. It's a lot like a grant when I'm given an assignment that I feel I can relate to. I try not to take long assignments unless they're ones that are really interesting to me. I approach every assignment with a real passion. I want it to be great. I want it to be part of my work. I want to have work that has a real value to it. Sometimes it can be hard looking at the tough side of life. It has to take some toll. But at least I can feel that I've made pictures of some things that get beyond the surface. It's important.

Marlon Brando during the Filming of Apocalypse Now,
Philippines, 1977

I used to work on movies a lot. It was the first commercial work that I
did in the late sixties. I enjoyed doing stills on films like *Carnal Knowledge,
Apocalypse Now, The Day of the Locust,* and *One Flew Over the Cuckoo's Nest.* But
things started to change in the early eighties. It became totally controlled.
Shots started to be done in a studio setup off the set. It became much more
like commercial work and less like personal work. When I photographed
celebrities in the late sixties and early seventies I could really make personal
images. I could approach celebrities like I could approach anybody and try
and make a photograph that said something personal about them . . . that
had some depth. To make great photographs of people you need intimacy.
Everybody's so concerned now about image. It's not that I want to take a
picture of someone famous that's going to make them look bad. . . . I'm
not interested in that at all. But I would like to take a photograph that
somehow reaches something inside and that isn't so controlled and isn't so
over-art-directed and overstyled.

"Rat" and Mike with a Gun, Seattle, Washington, 1983

In 1983 I was assigned to illustrate a story on street kids in Seattle for *Life*.
After doing the assignment I thought it would make a fantastic film, so I
suggested it to my husband, filmmaker Martin Bell. He's so used to me
telling him that everything will make a fantastic film that he didn't believe
me until he saw the photograph I did of a kid roller-skating down the hall-
way of an abandoned building and thought that it would make a great film-
making image. We raised the money to make the documentary *Streetwise*.
We all put in some money. The writer on the piece for *Life* who worked as
a producer on the film, Cheryl McCall, got some money from Willie Nelson.
We still keep in contact with some of the kids in the film. Tiny still has a
tough life with drugs. Every once in a while Rat calls. He's in and out of
jail for petty crimes. Mike seems to have a better prognosis. Dewayne died.
Lulu was killed in a street fight. One guy's a security guard. They tell you
that they have broken free . . . but you never know. It's hard. It's difficult
to escape your destiny. It is sad. But it's a fact. Not all life is a bed of roses.
It's very, very difficult for people to escape the patterns that their life has
set out to be. It's very difficult to change once you get on a track. A lot
depends on the bed that you're born in . . . a lot. Society is set up in a
way that makes it tough to be disadvantaged.

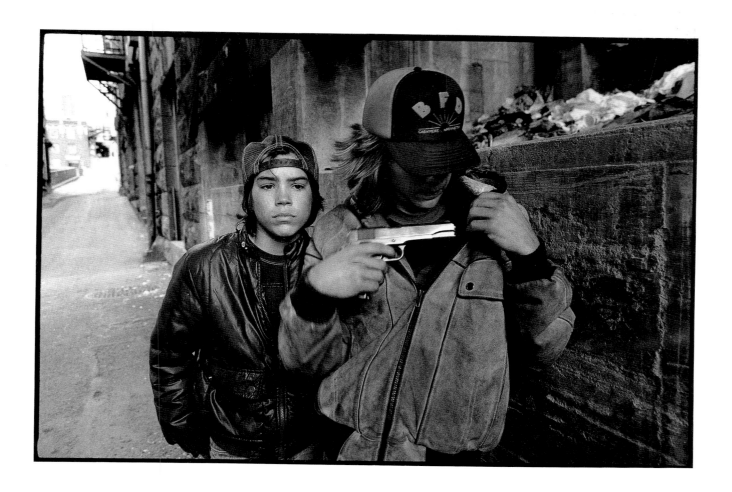

Hydrocephalic Girl with Her Sister, Il Cottolengo Hospital, Turin, Italy, 1990

I went to the children's section of a hospital in Turin, which is run by nuns, and I saw this little girl. I only took like four frames . . . it was really fast. Her little sister just happened to be there visiting. I think what really makes this picture is that strange little monkey doll. Those are elements you can't predict. Reality is so amazing. You can never art-direct reality, it just brings itself to you. You can never do anything better than what's real.

Twin Brothers Tulsi and Basant, Great Famous Circus, Calcutta, India, 1989

I love the circus, it has everything that I'm interested in: a sense of irony, humor, strangeness, and edginess. It's a beautiful art form. That's a totally documentary picture. The brothers are waiting to go on. They were there. They were holding the puppy. Reality is so much more interesting than fiction—than what you can think of for a picture.

Gypsy Camp, Barcelona, Spain, 1987

I think that my pictures that are successful have a real edge to them and that they're symbolic of other things. What I try to do is to go beyond the preliminary image and to evoke other feelings. They should make you think about other things. They should evoke certain memories. They should have a certain symbolism that touches you. I know my pictures have a real signature on them, and in some ways I pay a real price for that. But I wouldn't change it for anything. I feel very strongly about that. If my pictures had less of a signature I probably would work constantly. But I would prefer to have a signature. A magazine is not going to hire me to photograph just anything. People typecast me. They don't think I can do any other kind of work. To shoot almost exclusively in black and white was a very conscious decision that I made about ten years ago. I can shoot in color, but it's just not my look . . . it's not my way. I'm not saying that color photography is bad. There are some great color photographers, like Joel Meyerowitz. His work goes beyond color. In his work there's a mixing of content and color. That's why they work. He sees in color and thinks in color. I think in black and white.

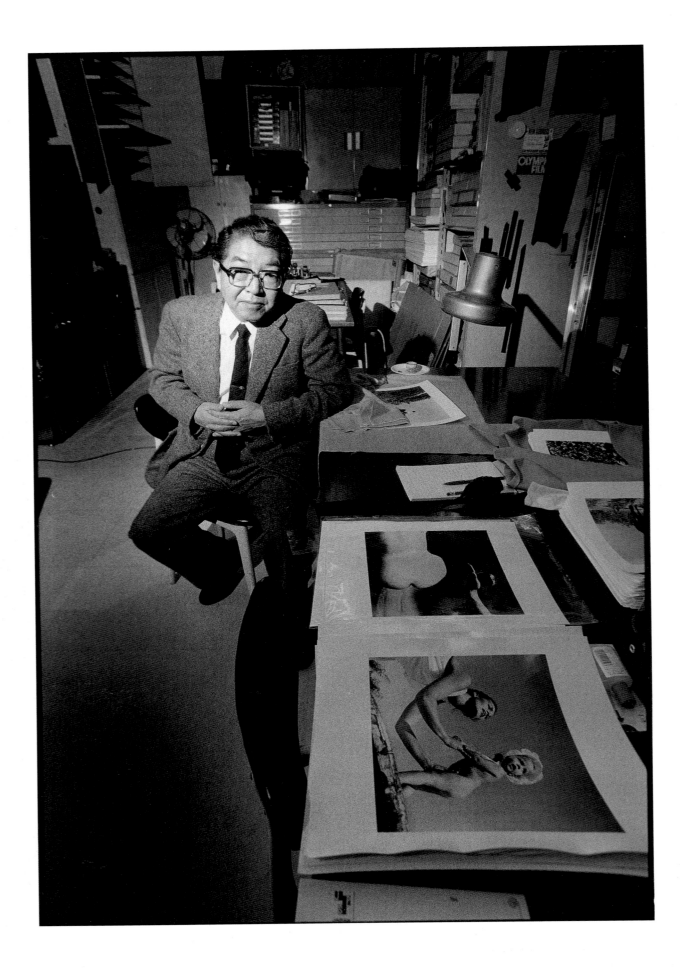

Eikoh Hosoe

In the early 1950s, when I was a high school student in Tokyo, I first got seriously involved with photography. My father was an amateur photographer, and he let me experiment with his camera, an old Thorntonflex. He also had some darkroom equipment. Besides photography, I was also interested in learning English conversation—not through high school classes but from native speakers. I was very fortunate . . . a classmate of mine had an elder brother who worked at the gate of a compound for families of American servicemen in Tokyo, called Grant Heights. I was able to gain access to the camp through him. Every time I went to Grant Heights I had my camera with me. I was very curious to know about the American way of life. Inside the camp was another world compared to the outside world. I took many pictures of children playing. The next time I came back to the compound I brought small pictures of what I had taken the previous time and gave them to the children. Even though it was a large camp, the children had their favorite play spots, so it was easy to find the ones I photographed. The children then brought me to their parents' houses and introduced me. My English conversation greatly improved, as did my photographic skills. Everything that had anything to do with photography, magazines such as *Look* and *Life*, photo exhibitions, fascinated me. In 1953 I went to an Edward Weston exhibition at the American Cultural Center in Tokyo that deeply moved me. I knew that photography would be a part of me for the rest of my life.

Ei-Q, Artist/My Mentor, Urawa, 1953

When I began taking pictures in the early fifties, the mainstream in the photographic climate was a sort of "candid" photography or "social realism." It was deeply related to the social conflicts of the postwar years. Hundreds and thousands of homeless and jobless men and women with children flooded the streets, along with ex-soldiers returning from the battlefields of China, the Pacific, and Southeast Asian countries—all with much anxiety and slight hope for the future. Social life had improved to some extent by the early days of the fifties, but people continued to suffer from political problems such as labor strikes, and daily problems such as food, housing, energy shortages, and unemployment. Photography was a strong weapon for pursuing these social conflicts. It can be the same now, but there was a tendency then to disregard a personal vision in photography, in terms of the relationship between the individual—the photographer—and society, especially for those photographers working for the magazines and newspapers. Ten years after the end of the war, in the mid-fifties, a few young photographers who belonged to the new generation began to think of photography in more personal terms. VIVO, a group of six young freelance photographers—Ikko Narahara, Shomei Tomatsu, Kikuji Kawada, Akira Saito, Akira Tanno, and myself— was founded in 1959 so as to pursue photography more personally and seriously. Throughout the sixties, the Japanese economy expanded enormously. Many new photographers emerged and got involved in advertising and commercial photography. During the late sixties—the height of the political crisis of the student reform movement—Japan continued to enjoy economic growth, but with the by-product of environmental pollution. Many documentary photographers worked very positively to examine the conflict personally and socially. Eugene Smith's Minimata series is one example. Industrial pollution was reduced as a result.

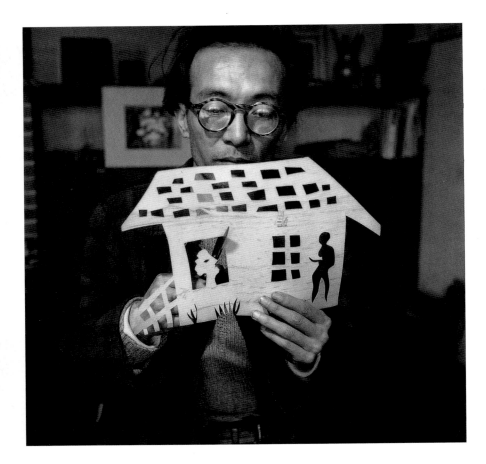

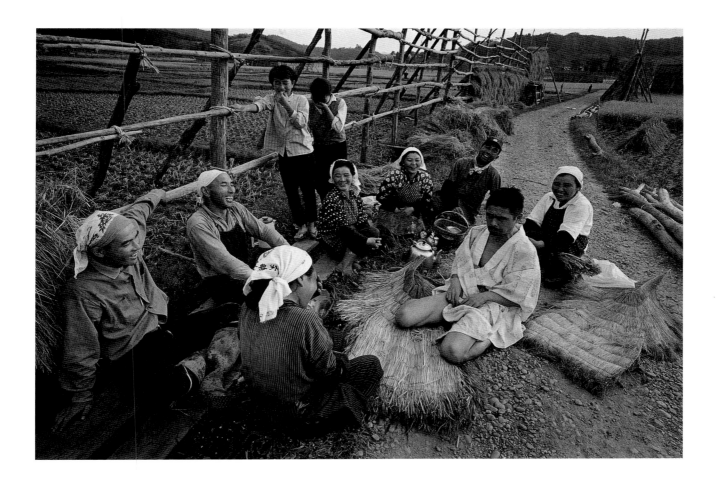

Kamaitachi #13, 1965

Learning how to express his or her own vision or identity is an important theme for a photographer. Series such as Kamaitachi perhaps express a desire to pursue my own identity. Kamaitachi, for instance, is a record of my memories as a child during the war years, when I was evacuated from Tokyo to Yamagata, where my mother was born. At the same time, I also wanted to do a subjective documentary on Tatsumi Hijikata, a founder of Butoh dance. Kamaitachi is an invisible legendary animal that attacks people. *Kama* means "sickle," and *itachi* means "weasel." In other words, a Kamaitachi is a weasel with sharp teeth as sharp as a sickle. Hijikata, my model for this series, and myself descended upon the little village of Tohoku, where Hijikata was born and the homeland of the Kamaitachi. We were very warmly received by the villagers despite the fact that we acted as the legendary invisible animal and appeared without warning.

The Cosmos of Gaudi, Sagrada Familia, Barcelona, Spain, 1977

In order to express a specific theme—such as the work of Gaudi—a single photograph is not enough, so for me a series is inevitable. This method of creating a series might look like a so-called photo story that would have appeared in *Look* or *Life,* but it is not. A total collection of photographs called a series works as if it is a whole building, and yet each piece of the building must be appreciated as a perfect work of art. The Cosmos of Gaudi series is my hypothesis that Gaudi may have tried to approach another kind of Zen spirit on the opposite side of the earth as seen from Japan.

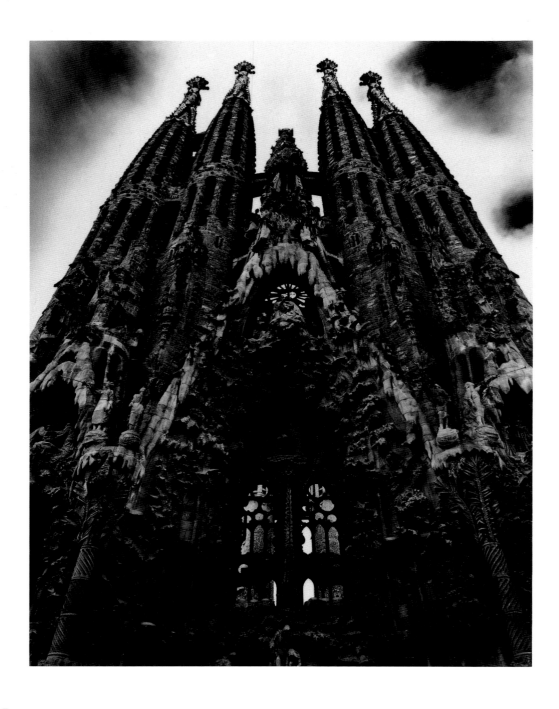

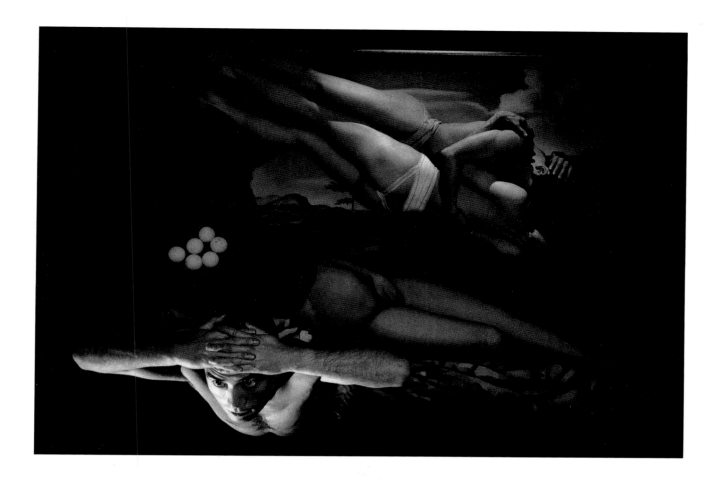

Ordeal by Roses (Barakei #16), 1961

I was fortunate to be able to have the famous author Yukio Mishima as my
model. He served as a great inspiration. He understood that he was my
subject matter and therefore did not tell me how he wanted to be photo-
graphed. The concept behind the Ordeal by Roses series was life and death,
through the subjective documentary of Yukio Mishima. Ordeal by Roses
consists of five parts. "Prelude," part 1, represents a number of variations on
a constant theme. Part 2, "The Citizen's Daily Round," tells of the madness
of the solid, worthy, average citizen. In part 3, "The Laughing Clock or the
Idle Witness," the model is required to change completely and become a
scoffer and a witness. Part 4, "Diverse Desecrations": plunging into the midst
of ancient artistic styles, sacred and sensual alike, he kicks them about, he is
born from them as a child from the womb, and he is buried in them as a
corpse, until eventually these blasphemous sports create in him the illusion
that his body has become transparent. Part 5, "Ordeal by Roses," is the
protracted torment of his excursion. Now the symbol of the rose with its
cruel thorns emerges to the fore, and he is confronted with torture and
extinction infinitely delayed. So the collection draws to its close, with death,
and ascension to a dark sun.

Witnesses of the End of the Twentieth Century, 1992

The series Before Awakening: Toward the End of the Twentieth Century is based on three techniques: the solarization that Man Ray used, the Fotograms that Moholy-Nagy did, and a Photo-Dessin that Ei-Q, my teacher in my youth, taught me. I named the combined technique Luna Rossagraph. When I was a very young photographer, I was curious about many technical aspects of photography—what kind of camera, film, developer, f-stop, and so on—a master photographer would use to yield such a beautiful print. I came to realize that printing is much more than a technical question. For instance, take Eugène Atget. His prints, printed by Berenice Abbott (who was a disciple of Atget and at one time Man Ray's technical assistant), are very warm . . . warmhearted, I should say. Well-known French printer Pierre Gassmann has printed the Atget negative—his print shows every detail that the negative could yield, so it can be said to be a good print. The New York Museum of Modern Art, which has a bunch of Atget's prints and negatives in its collection, assigned a group of Chicago printers to make albumen prints [the same technique that Atget often used]. Here are four different prints of an Atget image printed by four different printers. Atget's own print is not good from the viewpoint of technique; maybe he didn't use warm water—maybe it was winter time—or perhaps he didn't use enough hypo. Maybe he didn't have the proper facilities to wash the prints perfectly—but you feel part of Atget in the print. Berenice Abbott, in her print from Atget's negative, showed her love and her respect for Atget. Her prints are very warm—she put her heart into the developer, so to speak. The Museum of Modern Art print is beautiful, but I don't feel any irregularity of a human being—it's too perfect, and the print by Pierre Gassmann is beautiful but it's cold. I feel a certain distance between Atget's and his print. Atget's print is his. Maybe Atget loses some detail in the shadow area. The Museum of Modern Art prints show full detail in the shadow area. But I recall the famous words of Ansel Adams, "Photographers are, in a sense, composers and the negatives are their scores." And printing is a performance! So here are four great performances. Atget was a performer himself, just playing his own score. So in my case, I don't think I'm the best printer—in fact my son Kenji is better and he knows my aesthetic taste—but I respect the way the performer treats his score.

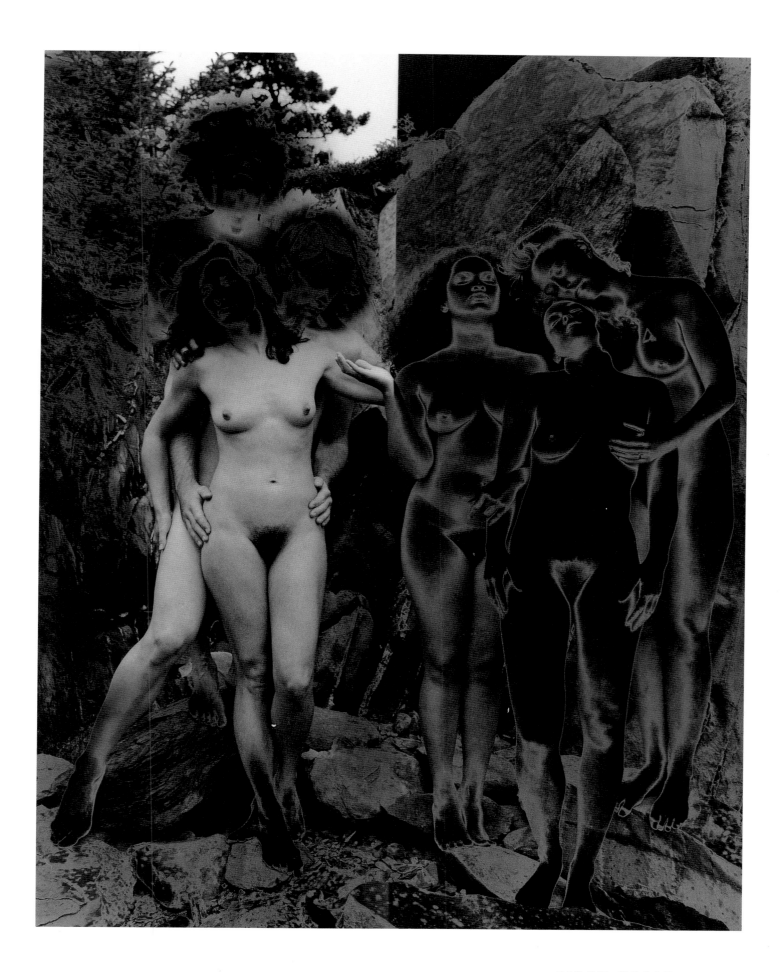

Jeanloup Sieff

My first camera was a gift for my fourteenth birthday. It was a black plastic Photax. I didn't even ask for it. As I got into it, I read books on how to develop film and enlarge prints. Girlfriends and landscapes were the subjects of my early photographs. I've never lost interest in those subjects. I continue my childhood. When I was a child I was mad about movies . . . all the classical movies. I have been more aesthetically influenced by Antonioni, Rossellini, Renoir, and Orson Welles than by other photographers. The Russian director Sergei Eisenstein's use of the wide angle in his movies was inspiring. I've heard that he used cocaine. When you take coke—I've never taken coke—it makes the diaphragms of the eyes smaller, and Eisenstein, I read in an interview, often used wide angle in his movies because it gave him the same aspect and feeling he had when he was on cocaine. I wasn't doing it because I thought I wanted to do something like Eisenstein, but I was influenced by it. In reality, everything in life you are influenced by: movies, painting, writers, music. We're like a sponge: everything you learn, everything you like, you take in. Whatever you do in life, you use what you have absorbed. I'm not speaking about a direct formal influence, except for a few painters. In 1961 or 1962 I discovered Andrew Wyeth, who had a direct influence on my landscapes.

For me, each photograph I make is the translation of an emotion, whatever kind of emotion it is. It can be an aesthetic emotion. A human one. An intellectual one. It can be a reaction to the light only, since photography is shadow and light. Everything is of interest to be photographed. It depends how, at which moment. So for me there are not categories in photography except for the "good ones" and the "bad ones." Let's take an example, Irving Penn—fashion, landscape, portrait, still life, everything. He's a photographer. He's making photographs of what interests him. Everything can be interesting depending on the quality of the one who is looking at it. The eye is looking at the subject. In other words, what is important is not the subject but the eye, the way it is seen by the photographer. There are food and car photographers. They exist. Some are very good with cars and some are very good with food. And some are just doing a job like working in a bank, and they stop at five o'clock. They're using photographic knowledge and photographic technology, but to me they are not photographers. You *can* have an emotion with a car. A photograph is related to an emotion. Yesterday I photographed fashion. Today I did a portrait. Tomorrow I'm going to do a landscape in the country. Sometimes the nude is a landscape, sometimes it is a portrait. Every day I do different kinds of things, but always something that I'm interested in.

Harper's Bazaar, *Palm Beach*, 1964

I never speak about clothes with the editors of a fashion magazine. I'm interested in shadow and light, shapes. I don't care about the dress. I discuss other things such as project ideas. When I started doing fashion in Europe I hated the makeup and the rigid poses of the models. When I was in New York working for *Bazaar* in the sixties, again it was very heavy makeup. But you couldn't take it off because pages and pages of advertising were sold to enormous makeup companies. But still at times I would try to have the makeup taken off, and at other times I would try to exaggerate it. I used to do some color for fashion and advertising clients but never for myself. I don't see in color. I see in black and white. I feel more responsible for it. I do the prints in my darkroom. For me, color is often very unexotic. Very often I look at a photograph and I think that it would have been very nice in black and white because the subject was fantastic but the color was too strong and it weakened the image. You can do some very nice things in color but black and white goes to the senses with shapes and lines and expressions.

Alfred Hitchcock with Ina, Harper's Bazaar, 1962

I went to Hollywood for *Bazaar*. I told them in a meeting that I wanted to do a parody about how the people who live there become part of the movies. So I went there one week before everybody to look around. I went to Universal Studios and I saw the set of *Pyscho*. I asked if Mr. Hitchcock was around. I thought it would be a nice shot to use him with a girl. And they told me, "No, Mr. Hitchcock is in San Francisco. He is editing *The Birds* and he is very busy, but we'll try." Then the press agent called me and said, "Mr. Hitchcock can come for two hours, tell us when." I said, "Okay, tomorrow morning at seven A.M." And he was there. Everybody was ready, of course. He came over to me and asked what I wanted him to do. I told him we were doing a parody of his world, and I wanted him to go behind a girl pretending he wanted to strangle her and she would act very afraid and in the background would be the house in *Psycho*. "Oh, that's a very nice idea," he said. "I love to strangle nice girls in the morning before breakfast." And at nine A.M. he left and took his flight back to San Francisco.

An English Bottom, Paris, 1969

Sometimes the face is not interesting when the body is. Sometimes the face is a distraction. Photos are often more timeless when you don't know who the subject is.

Death Valley, California, 1977

For many years I wanted to go to Death Valley. I was fascinated by the name of the place. And I like the desert. I like open spaces. I like to breathe. The photograph with the bush in front, the cracked earth, and the mountain in the back I like very much. . . . It's a *belle* photograph. I remember it was warm and sunny. I miss the sunshine. I like the optimistic bush in the dry land; it means that hope still exists.

Somme Military Cemetery, 1992

I suppose everywhere on earth you have places where awful things have happened. . . . People have always been killing each other, but the First World War was unique: 10,000 people killed in a night just to move fifty meters. Then the next day back fifty meters and 10,000 more killed. Just unbelievable butchery. In the battle of Verdun in 1916 it was one million and a half—in a few months—dead, both sides, French and German. Twenty years old, eighteen years old. A whole generation of men, dead. The battle-field was 600 kilometers long for four years . . . back and forth, back and forth the troops went. Besides Verdun there are many other places such as Champagne and the Somme region in the north of France where you still can see many old fortifications and trenches. You can still see things there, but I'm photographing less physical memories and more abstract memories. This project is something that I've been fascinated with since I was a very young boy of twelve or thirteen. I had many books about the First World War. I went to the places where Blaise Cendrars, the French writer, and Ernst Junger, a German writer, were writing about in their diaries of the war. In my photograph of a cornfield with the Somme Military Cemetery in the extreme background, the cemetery is a small part of the large landscape. If you don't know the history behind the place, you simply think that you are sitting in front of a cornfield. But if you read the diaries of Cendrars or Junger, you know there are 20,000 people under the ground there. If there is a feeling of peace in my photographs it is because I believe that life is stronger than the stupidity of the world. The best is to forget and to try and live. Oscar Wilde wrote, "Death and vulgarity are the only things one cannot explain."

Helmut Newton

I started taking pictures when I was twelve years old. I had gone into a German version of a Woolworth's store and bought a camera. I don't know why I did it. I mean there was no great motivation. I just bought it like a kid buys some toys. Then I just kept on photographing. And I just got to love it more and more. Yva [a well-known Berlin fashion photographer] was my master. I met her through my mother. I had made myself be thrown out of school. I hated school and I was a horrible scholar. But my mother was very supportive and through a family relationship found me an apprentice-ship—in those days it was not an assistant, it was an apprenticeship. The parents had to pay the master. That was a true apprenticeship, like you would learn carpentry or what-ever. Whatever trade you had in Germany, you had to have years of apprenticeship. It was a very good system. After six months Yva called my mother and said, "I'm so happy with your son's work that you don't have to pay. We'll give him a little pocket money to show our apprecia-tion." She was a wonderful lady. She was later killed in Auschwitz. Photography was more developed in Berlin than anywhere else. It was the cradle of modern photojournal-ism. When I was a kid of fourteen I made a self-portrait of myself with a hat and gloves, a kid's idea of being a foreign correspondent. But I started being very interested in fashion pho-tography from the very beginning.

I don't know why. Yva was a fash-ion photographer, but even before I worked for her, while I was still in school, I would dress up my girl-friends and pose them like I saw in the fashion magazines my mother would receive. There was a German *Vogue* at that time. I was surrounded by photography, especially propa-ganda pictures. When you look at many of my pictures—the big nudes, for instance—they have a kind of fascist classic imagery. My real muse is my wife. . . . We've been together since 1948. June truly is somebody that is important to me not only as my wife but as somebody very important to me in my work. She has always had a great awareness of things. You know, my wife said, "In looking at your pictures you cannot deny your youth in Berlin," and she's right.

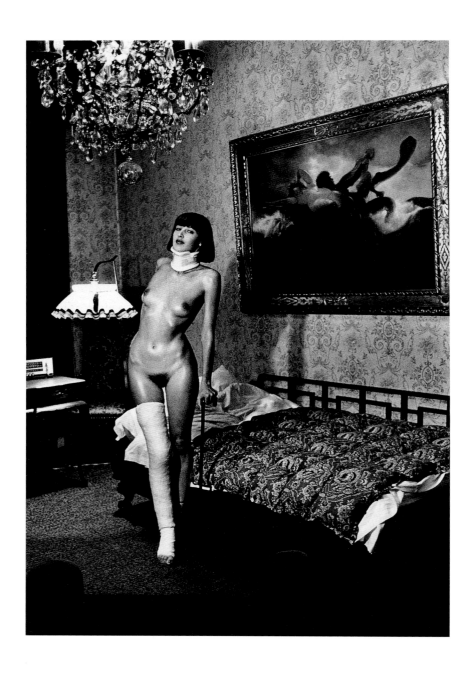

Jenny Kapitän, Pension Dorian, Berlin, 1977

The photograph of Jenny Kapitän in Berlin comes from my memories of watching Erich von Stroheim on screen. In *Grand Illusion* he wears a neck brace. I see things. . . . I have a pile of newspaper clippings. I'm very interested in the paparazzi. I'm very interested in daily news pictures. I am the most down-to-earth, realistic person you'll ever meet. I don't have any fantasies. I just keep my eyes open and my antennas up and I see what goes on around me. My ideas come much from daily happenings, what I read in the newspaper, what I see when I go out, and a lot of it comes from literary references from stories I've read. Ever since antiquity people have been writing about, painting, and drawing sexual acts.

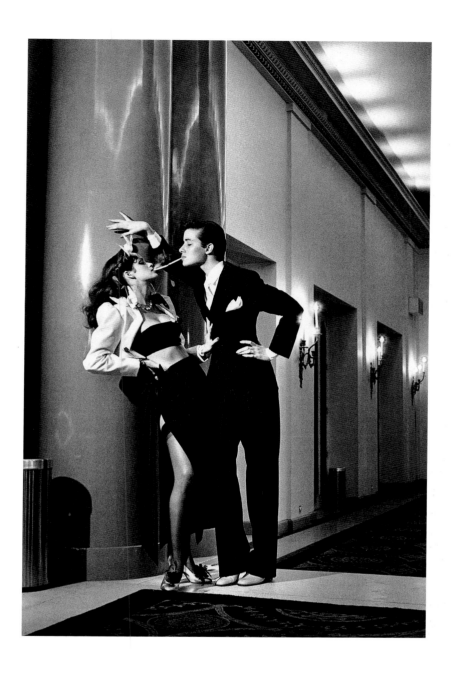

Woman into Man, Paris, 1979

When I was a kid in school and I used to photograph my girlfriends in my room, I used a tungsten photo flood with a 100-watt globe. I often still do the same kind of thing when I need light. I also shoot very little film. When I used to work with Grace Coddington a lot for American *Vogue* and shot 6x6 sometimes I wouldn't even finish a roll of 120 film. I would say, "Let's go to the next dress." Grace once said, "Helmut, you shot six pictures," and I responded, "But you only need one." Some photographers burn rolls and rolls of film and make a hundred prints. Look at the cost. And who's got the patience to look at all that film? I wouldn't want to edit it. The maximum I do as a rule is twenty-four frames. That approach is from the old school where I was brought up. Shooting lots and lots of film with a motor drive is an insecurity. What are you going to get?

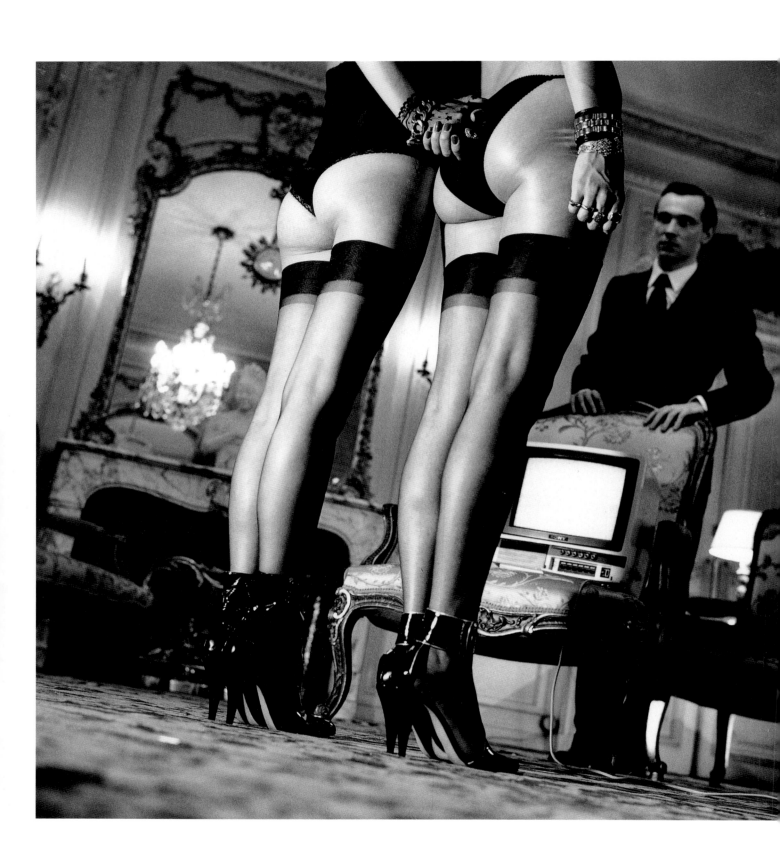

Two Pairs of Legs in Black Stockings, Paris, 1979

It's very strange. When I do a book signing I find that there are more women buying my books than men. They're buying it for their husbands or boyfriends or for themselves. When I give lectures I've found that I have a lot of women fans. An enormous amount. Most are young. I don't know why this is, but I'm very delighted. I've gotten a lot of flack, of course, as well. I say I'm a feminist, which is true, you know. Would I be spending my life photographing a subject that I hate? It is a lot of bullshit, just a waste of time to argue.

Woman Examining Man, Saint-Tropez, 1975

When I started at French *Vogue* in 1961, the art director started the same day. In the old days the art directors were a power on a magazine. Nowadays they just glue down the pictures. The real power is the commercial side of the magazine. They don't have the same artistic sense. I find that advertising photography is much more creative today than editorial. In the good old days editorial was the creative thing. We all became known through our editorial work. We made our name through editorial work. Over the last ten years editorial photography has not broken any new ground. It's commercial crap, catalog photography. American magazines are very advertiser-conscious. They're absolutely petrified to lose one reader. The photography done in advertising is much more creative.

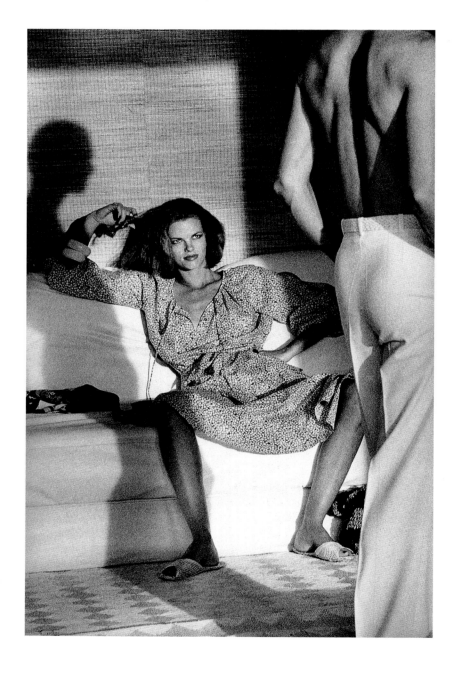

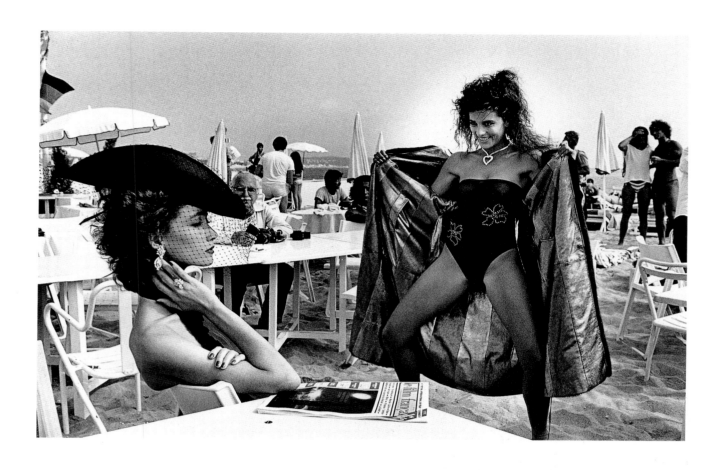

French Vogue, *Cannes. Hat: Jean Barthet. Coat: Revillon.*
Bathing Suit: Yvan & Marzia, 1981

Any photographer who says he's not a voyeur is either stupid or a liar. . . .
I think somehow you have to be mentally and sexually interested in your
subject. It's a whole big love affair. . . . I like content. I don't get a hard-on
or anything like that. You can't work under those conditions. Anyway, I'm
an old guy now. But the thing is this. Women are a subject that I think is
fascinating. My wife has said that while I'm working, "Somebody could drop
dead next to Helmut and he wouldn't know it." I'm totally focused. She
said to me on a shoot, "People are getting hungry." I said, "I don't give a
shit if they're hungry or not, we've got work to do." I've found that in any
kind of photographic session, as soon as people, including myself, sit down
and get some food in their stomachs, forget it. Afterward all the spirit is
gone from everybody, including the photographer. I don't mind nibbling
as I go along, and everybody should nibble. I work very fast. We start at a
reasonable time. Nothing like dawn. Maybe 9:30 or 10:00 A.M. But then
we have lunch at 4:00 P.M. when we're all through. Everybody sits down
and they're all dying of hunger. But so what? People never remember
the discomfort they go through, but they remember bad pictures.

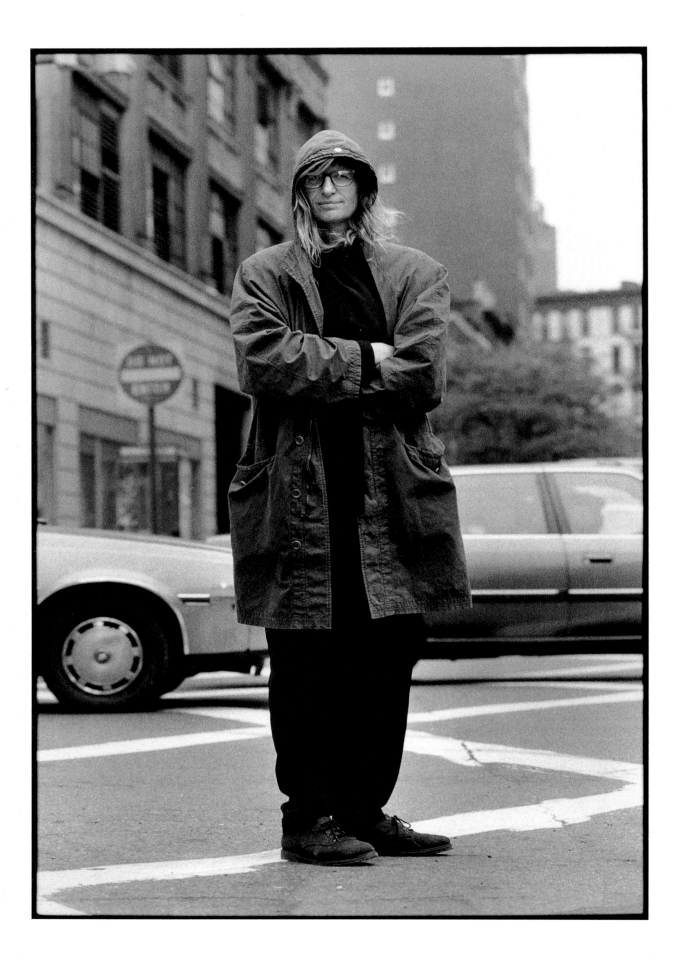

Annie Leibovitz

I was twenty when I started at *Rolling Stone*. I was very lucky because I was among a group of people, even though we were very young, that knew that what we were doing mattered. There was a sense instilled at a very young age that this was important. We had this sort of arrogance that nobody else "got it" but us. There was no place else where popular culture was being done. . . . I know it's so hard to get a break into any place to get published. But it's more about making good photographs than getting published. I know it is very hard, but if young photographers can self-motivate themselves, if they can give themselves a project of photographing someone that is close to them in some way, they could do intimate work. Sometimes photographers overlook the thing that is right in front of them, it just seems too obvious. The people we know the best, we tend to say, "Get out of the way so I can get this picture." If someone spends time on someone that is close and really develops a story and then brings that work into a magazine, I think people would be very interested. I know it's like the chicken-and-egg theory—you want the work, but you have to develop that work before. We have seen Sally Mann. Her work is so strong because she knows those people. Nan Goldin's work is really her friends and herself. Cindy Sherman is herself. That's the work we're interested in. The stuff that means something. We sometimes don't realize that the work that is possibly our strongest work is intimate and right in front of us.

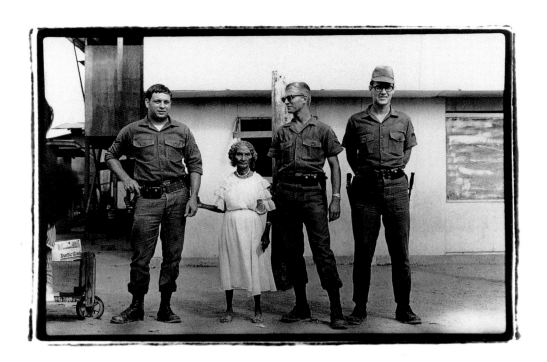

American Soldiers and the Queen of the Negritos, Clark Air Force Base, the Philippines, 1968

When I was at the San Francisco Art Institute, my father was stationed at Clark Air Force Base in the Philippines. I'm a military brat. My parents were worried sick that they had left me in California to go to school when they went to the Philippines. They tried to get me to go to the University of the Philippines, and I just said, "I don't want to go there." So they insisted that between my first and second year at the San Francisco Art Institute I spend the summer with them in the Philippines. My mother happened to be going to Japan for part of that time to do a study program. She took me and my younger brothers and sisters along. When you're in Japan you buy a Seiko watch, you buy a camera, you climb Mount Fuji, and do all those sorts of things. I got a Minolta SRT101. The camera was not exactly an unknown object in my family. There were a lot of family snapshots and 8mm films. But this was the most sophisticated camera that I had owned up to this point. When we went back to the Philippines I used the base hobby shop to print and started taking pictures with this new camera. I started to take photography seriously. This is when I shot the photograph of Mary, Queen of the Negritos. It's really based on "Everyone come over here and lean up against the car." When I came back to the States, I took a night class in photography while I was still a painting major. Being eighteen, nineteen years old, it was a very confusing time. There was the Vietnam War. My father was in the service. He was going in and out of Vietnam. There I was in the middle of San Francisco hippieland going to the San Francisco Art Institute, where all the teachers were drunk and the painting department was filled with very angry abstract painters. Rrrrraggghh! Everybody was using red. I wasn't ready for abstraction. I really wanted some reality somewhere. The photographers and the photography students were much more approachable, friendlier. There was much more of a camaraderie.

Louis Armstrong, Queens, New York, 1971

At the San Francisco Art Institute the kind of work that I was taught was Robert Frank, Cartier-Bresson. Mary Ellen Mark and I could have gone the same route. If anybody would have told me I was going to be a portrait photographer, I would have laughed in their face. I wasn't into the portrait, but I was asked to do them for the covers of *Rolling Stone.* I was interested in environmental studies. Now I've managed to combine the two and tell stories in the portraits. I remember looking at the early issues of *People* and seeing that they took the subjects and made them change their clothes three times and they did it all in two hours. There was no depth to it at all. Part of the problem was that nobody had the money to send you out for a month to do "the photo essay" like the old days of *Life* magazine. So in a certain sense the condensed portrait was less offensive to me. It was saying this was posed, this is done. It's more illustrative.

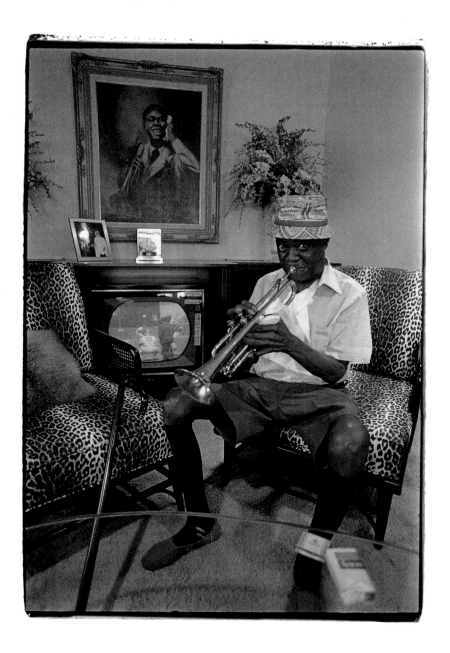

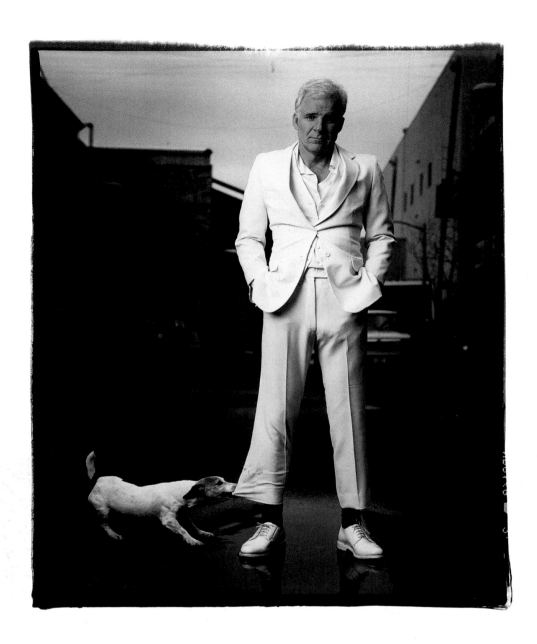

Steve Martin, Studio City, California, 1995

One of the things that I discovered quite by accident, this style shooting strobe with ambient light outside, came about because of the problem with *Rolling Stone* magazine being able to have the picture survive on the rag print paper from the ink when *Rolling Stone* went to color. I had never shot color before. I lied, "Oh yeah, no problem" [hyperventilating]. One of my first color covers was Marvin Gaye in Los Angeles. It was done on his hilltop in Topanga Canyon with a sunset behind him, and it was natural light and no strobe involved. When it finally printed in the magazine, all you saw was the sunset, you never saw Marvin Gaye. He was completely silhouetted. I knew that things had to be lit up.

John Lennon and Yoko Ono, New York, 1980

I think I am actually a photographer that likes to look at things and watch them happen more than I am a person who can set things up and direct people to do things. I think I do all right, but I don't enjoy it as much. I think that with respect to watching somebody do something, or seeing how they approach something, that's where the idea came of asking somebody to do something, play a role, to be part of something, was more comfortable for me too. It gave them something to do and I could watch and react to it. The shootings that I like the most are when I can do couples like John and Yoko because they could take care of themselves. I was really fascinated for a period when I was working with *Rolling Stone* with the whole graphics of the cover and what worked on the cover. I had been with the magazine for ten years at that point and grown with it and I knew what worked. It had to be simple with a strong sense of composition, an uncomplicated presentation that gave you all the information. I remember their album *Double Fantasy* had just come out, and I was very jealous of the cover photograph, which was of John and Yoko exchanging a simple kiss. I don't know if you remember 1980, but romance was dead, and I was really taken by the kiss and I wanted to do something around that kind of idea. I thought of a simple embrace. The positions were taken from my life. I would think about how people would curl up with each other. I asked them both to pose nude. John had no problem with it, but Yoko at the last minute didn't want to take her pants off, she was going to only take her shirt off. I was sort of disappointed and said, "Oh, just leave everything on," which ended up making it very strong with just John being naked. I love when there are several meanings going on . . . that's the fun of it. I think everyone can take out of it what they want.

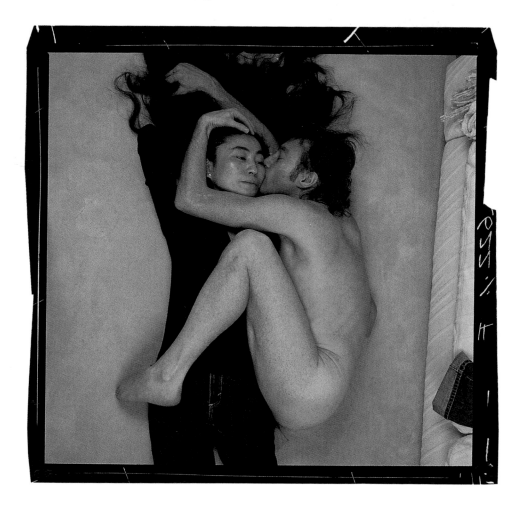

The Goldmans at Ron's Grave, Los Angeles, California, 1994

It was almost as if I was born to do the O. J. Simpson story. The whole celebrity aspect of it. The Los Angelesness of it. The kind of bowing-down celebrity worship. Doors opened up that I had no idea were going to open up. The first day I was there around the courthouse I got credentials to actually be around the pressroom. There was one floor for print press, but they seemed to make an exception for me. One thing that really did help was my show at the Los Angeles County Museum of Art, and there had been a lot of publicity. Even Gil Garcetti, the DA, had gone to see the show. Judge Ito had gone to see the show. When I got there Judge Ito had said he wanted to meet me. The first day I was there I was taken back into his chambers, and I talked to him about what I was out there to do. It turned out he was a fan of my work. Judge Ito is a photography nut. I was trying to get him to sit for a portrait but he said he just couldn't do it. He said [slapping her forehead to demonstrate his reaction], "Ah, I can't believe I am saying no to you. I just can't." But what he did do was get me a seat in the courtroom. I told him I couldn't get a seat and he said, "Well, this is my court and I'll get you a seat in the courtroom." The courtroom work wasn't that great but what the courtroom position allowed me to do was to meet people. Everything fanned out from there. I could talk to Shapiro and Marcia Clark during breaks. These people would not answer their phones in their offices, but you could reach them at the courthouse. I could stop people and talk to them in the halls. The Goldmans weren't answering calls. I basically had become friends with the Browns. I liked the Browns tremendously. They called the Goldmans. Finally the Goldmans got back to me and I went to go meet them at their house, and one of the cameramen who worked for ABC who became a friend of mine at the courtroom told me, "I don't know how you can get this, but where Ron is buried there are these trees and it's on this hill and it would be incredible if you could get them to go out to the site." That stuck in my head. I thought there is no way I can get them to go to the cemetery, but they had finally agreed to let me do a family picture of them. I went out to see them, and the light was gone. I just shot in their kitchen. I said, "To do this right I really wish I could do this during the daytime." And then as I was leaving, Mr. Goldman said, "Are you running a picture of Nicole?" I said, "No, but when I shot the Browns there was a picture of Nicole in the living room." He said, "We'd like to have Ron in this picture somehow. We'd like to put a portrait of Ron in this family shot." I saw the opening there, and I said, "Would you consider going to the grave?" He thought about it and there was a slight pause and he said, "Yeah, we'll go." So we went out I think the following Sunday. I met them at their house and followed them to the cemetery— it was a very difficult thing to do—but it was done with the idea that Ron should be in the photograph, that Ron shouldn't be forgotten.

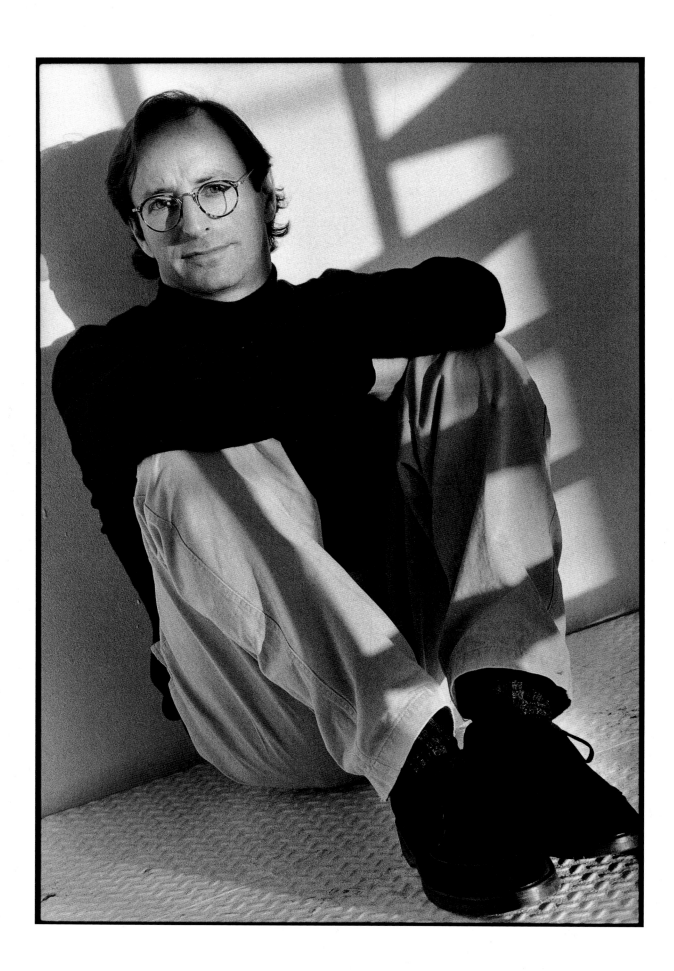

Herb Ritts

I was a sales rep for my father's furniture company when I literally fell into photography. I had a Miranda camera and started taking pictures of roommates and friends, and the one that put me in a place that got me published was Richard Gere. We had taken some pictures at the beginning of his film career just prior to his movie debut in *Days of Heaven*. Richard mentioned to the publicist that he really liked my photos and that they should be considered with all the real photographers that were shooting him. The photographs ended up in *Vogue, Esquire,* and *Mademoiselle,* all in one month, and then a month or two later one ended up on the cover of *L'Uomo Vogue* in Italy. I had never even heard of that magazine. In fact, I never had even looked at *Vogue* or the other fashion magazines. I had no clue. I would get these checks in the mail and realize that my photographs had been published. The photos were taken at a gas station in San Bernardino. We were there to fix a flat tire, and I said, "This looks good," so we took some shots. *Mademoiselle* got so much fan mail from Richard's picture that the art director tracked me down and called me out of the blue: "Can you shoot Brooke Shields for us in a few days?" So I said, "Great." I just went down to shoot her on a soundstage during a movie shoot with my camera and did a double-page spread. While things happened on one front with personalities, I continued taking pictures of friends. One of them was Matt Collins, who in the late seven-

ties was a top male model with a very refined look. He moved out here and rented a room in a house that I had bought. I had my camera and he needed some headshots for his acting. At one point I went to a furniture show in New York for my folks and I had a little paper sack of around fifteen of my pictures. I was staying with a friend of mine who was a model named Michael Holder. Every morning his girlfriend, Lisette, would scurry out past me sleeping on the couch. I never really met her, but apparently he showed her this little bag of pictures, because three weeks later these big red trunks arrived at my home from Italy containing all these men's clothes— Versace, Armani, Missoni. It turns out she was from *Harper's Italia* and wanted me to shoot the whole men's collection because she really liked my pictures. I didn't even know she had seen them. I grabbed Matt Collins, and we went down to the beach in Santa Monica and shot twenty pages of the fall collection under the pier. So they sent me a copy of the magazine and more clothes. That sort of started it. Eventually Franca Sozzani, the editor of *Lei* magazine at the time, who is now the head of all Italian Condé Nast, started sending clothes. She's the one who basically started Bruce Weber, Steve Meisel, and me. She would send us clothes, usually with no editors. It doesn't happen like that anymore. Then it was much more wild, much more free in terms of what you could do.

Versace Dress, Back View, El Mirage, 1990

I think today especially in the American magazines, except for *Bazaar* now and then, it's gotten very commercial. It isn't like when you look back in *Vogue* or *Bazaar* in the fifties, sixties, and seventies, when Avedon and Penn and everyone else could really create interesting fashion pictures. There are exceptions, but in terms of fashion magazines it's very limited. It's unfortunate but it's bound to commercial interests or administrations that are not very creative. A lot of the good advertising work is a lot better than the editorial, which is sad. Helmut Newton comes up with great ideas. Whether magazines like *Vogue* print it or not is another story. I really admire Helmut. He's one of my favorites because he always takes a chance in whatever he does. Through the years he's done what he's wanted to do, whether it's published or not.
I don't know if there is anybody in particular whose work I can look at and say, "That's my influence." There are a lot of people I like: Man Ray, Weston, Edward Curtis. I like Joel-Peter Witkin. He has his very own style, and I find his images quite interesting, though some of his pictures are hard to digest. If you talk to him and study his work and see how he does it, it's all pretty amazing how he comes up with what he does. I admire his process.
For young photographers I think the basic thing is to go out there and start taking pictures and honing their eyes at something they find of interest in terms of subject matter and lighting. It's not about worrying about school and technical aspects so much as about finding a subject that really gets you emotionally involved. If you love shooting cars, if you like being commercial and slick, if you are into rusty junkyards, fine. It's what makes sense to you. There are a thousand ways to see something.
Photography is not really about getting bogged down in having the best camera and not really looking at a picture. I sometimes use movie lights or strobes if I have to, but pretty much I like to just go for a picture. I don't sit there and Polaroid it, Polaroid it, Polaroid it. It's not my style. I don't like to be bound so heavily by anything technical. I like to go for the moment.

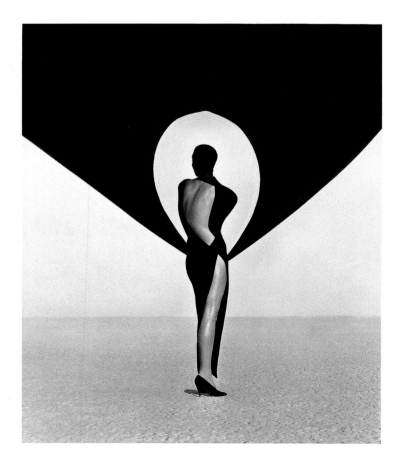

Masai Woman and Child, Africa, 1993

I went on a safari and I was very taken with Africa. I decided to go back
to do a book because it had all the elements of something that attracts me.
I was inspired by it . . . not only the exotic nature of the people and the
animals but the terrain as well. The sense of texture is something that I very
much like and enjoy. The whole book is done in natural light. A lot of pic-
tures were taken in Tanzania. I wanted to take my eye and go somewhere
that was a challenge and see dawn to dusk what I could do. "Okay, here it
is. Here's a camera. Go." You're "on" the whole time. Everything is fair
game. You're not dealing with personalities or dresses. It's whatever you
come across. A lot of people I photographed had never been photographed
before but were completely open to it. I didn't style anything—just the way
they were. More and more I enjoy this sort of challenge. A lot of it has to
do with what you get inspired by, so it's a truer kind of a feel.

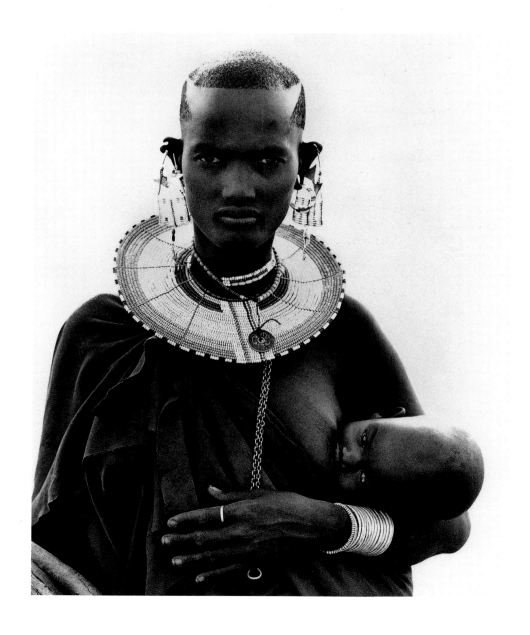

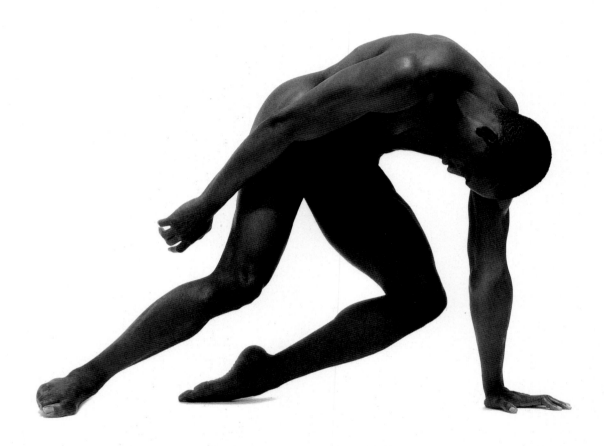

Bill T. Jones, Los Angeles, 1995

I love shooting nudes because they're so classical, timeless. When you look at painting or sculpture through the centuries it's always been there. It's almost so simple, yet to make something from that is always a challenge. I love the line, what you can get from it. I don't think there is a different approach to shooting a male or a female nude. I think it's actually what the person who is modeling or who is the subject does for you. How they can project. How they can outwardly move, their physicality. It's about how the person combines their mentality and physicality.

Djimon with Octopus, Hollywood, 1989

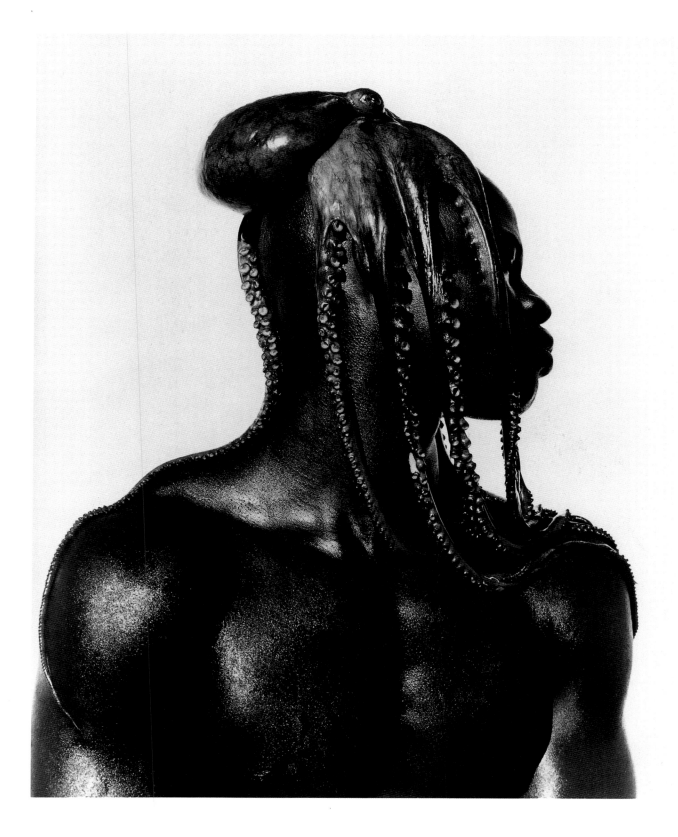

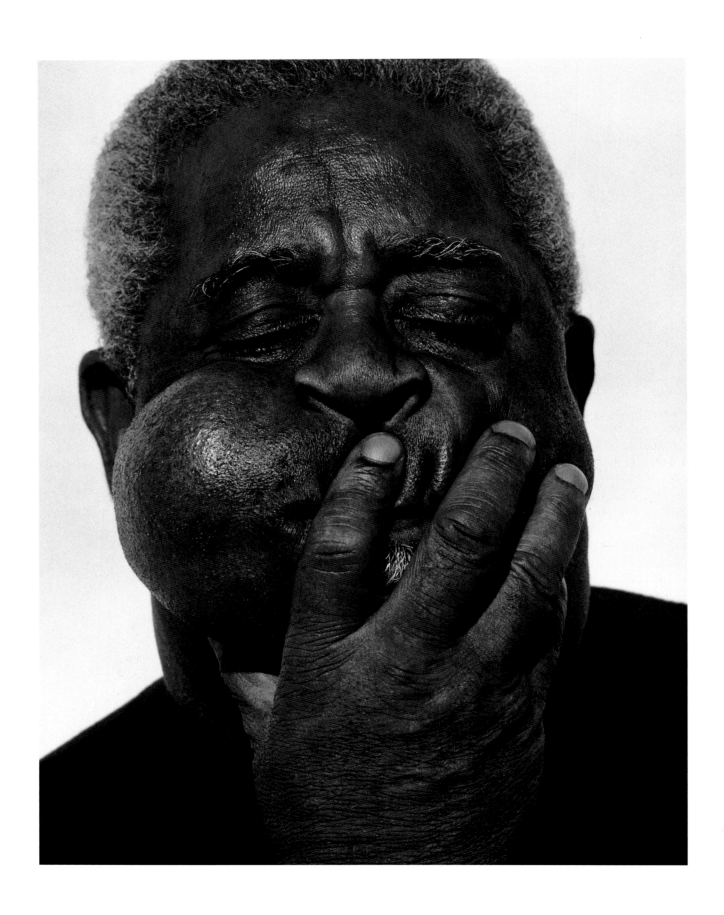

Dizzy Gillespie, Paris, 1989

Some people are very shy and you have to walk them through a session. Sometimes that quality is just what you want and you don't try and change it. I never try and overdo something with hair and makeup where you lose the soul of the person. I think it's very important to still have that person be that person. You have to respect what each person's about. Sometimes you can push to get something, but you have to know your limits and how to do it and make the people feel comfortable. I love the shot of Dizzy. It was for the Gap. I enjoyed working with him a lot, but it took a little time to get the shot. I wanted to get a shot of him with his cheeks popping out the way they did when he played the horn, but without the horn to make it more abstract. I asked him if he wouldn't mind putting his finger over his mouth and blowing out his cheeks. He said, "No, I only do that for kids, I can't do that for pictures." But at the very end of the session he did, and I grabbed the one camera that we hadn't packed away yet and got the shot.

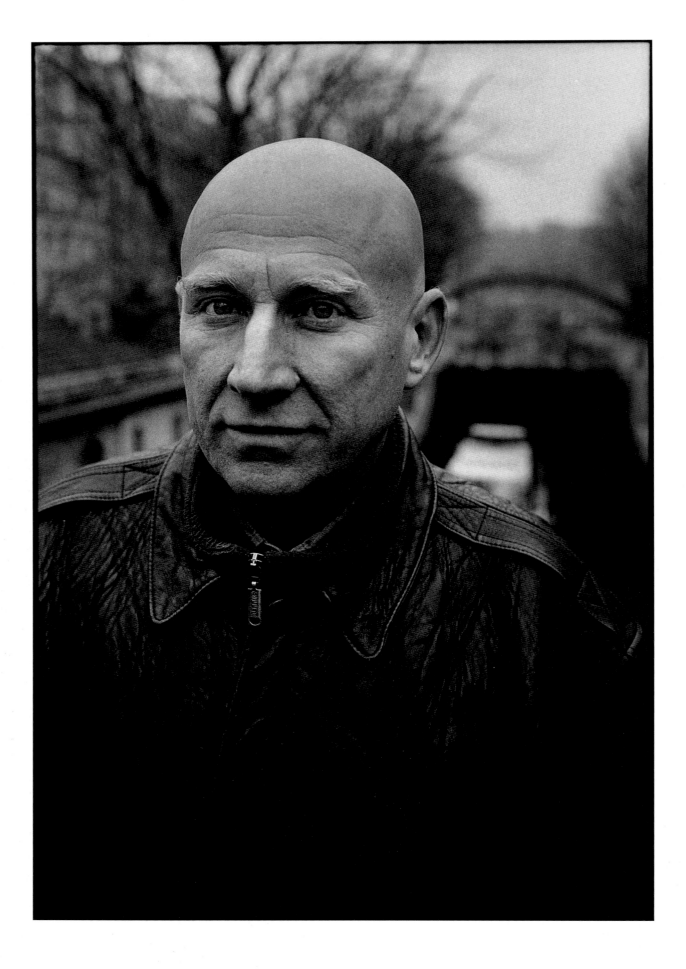

Sebastião Salgado

What is photography? It's the way of thinking of a photographer. I'm sure you're not interested in the pictures that I do one by one. You're interested in the concept—my concept of life—the way that I interfere in the reality of a situation to get my pictures. One's life's experiences are inside one's photographs. My study of economics has played a very important role in the creation of my photographs. I have had the opportunity to go a little more deeply inside my subjects' lives. My study of economic relations around the world as well as my study of sociology and a little bit of anthropology have probably given me a good capacity for analysis. When I began to photograph after years of this study, it had a great effect. I try with my pictures to raise the question, to provoke a debate so we can discuss problems together to come up with solutions. I don't believe in a quick solution to these problems. But humanity is just one humanity. We must create solutions for the human race. It's important for people not to have a problem with their conscience because they're living well. I have a nice car, a nice home, my kids go to good schools, I like to eat well. It's not a crime. But we must care about others too. We must save ourselves. The human specimen. We are in very big danger. But we can change things. You can say that this is a little bit idealistic—but it's what I trust. I believe to just sit will achieve nothing.

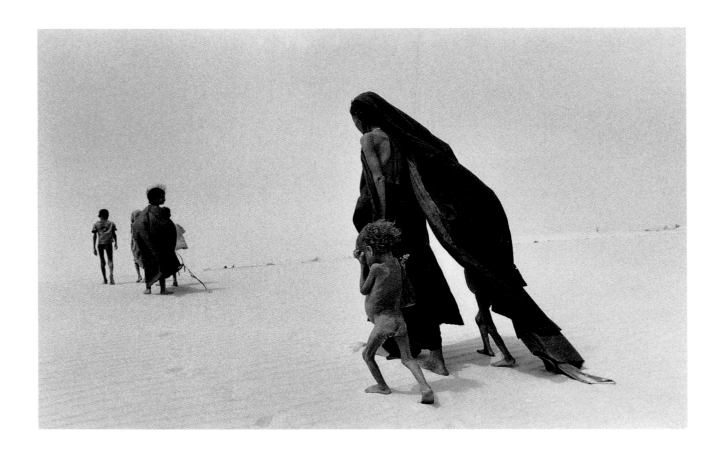

Walking on What Used to Be Lake Faguibine, Mali, 1985

The photographs that I do in places like the Sahel I do because I trust that with these pictures we can discuss problems—huge problems. When I do a traveling exhibition of my photographs, I don't prefer the pictures go to a museum rather than a trade union. What's important is that people see the images and discuss them. They're looking inside the lives of their fellow man. What I want in my pictures is not that they'll look like art objects. They are journalist pictures. All my pictures. No exceptions. They are published in the press. If afterward they go to a museum or gallery, I want them to go there to create a debate or discussion. If a person wants to buy my picture, that's fantastic. The money will help fund my projects. Altogether, I spent fifteen months in the Sahel. Nobody sends you for that length of time for a story.

The Outskirts of Guatemala City, Guatemala, 1978

What is rich? Sometimes people say, "Sebastião, you take pictures of such misery." I take pictures of people that have less material goods than others. Misery is human, misery is the spirit. Misery is not lack of material things. Some people have more goods than others. The people from Bangladesh have a rich culture, they have very good painters, musicians, writers, photographers. . . . Here is not better than there. Here we have more material goods. They have thousands of years of evolution. I've met people in New York and in other so-called modern societies that are more poor than the person in the Sahel that's starving. You see there that they are starving but they have hope and they are not alone. They are part of a group. Sometimes here you see a person that is lost on the street. I can see that their hope is gone. The person is alone. What happens because of the economic choices we have made is that the families and the communities are beginning to disintegrate because we are beginning to be urbans. You come alone to live in a town, then you bring some others of your family. Then sometimes they arrive and the job is not there. They have to do another type of work. They lose their dignity. Values change. The pyramid structure where you have an older person as the counselor of the family, the many levels of the family that hold all this together, this kind of thing disappears when you come to the big town. What becomes important is who is the consumer and who has the money to guide the family. This kind of power has changed the structure.

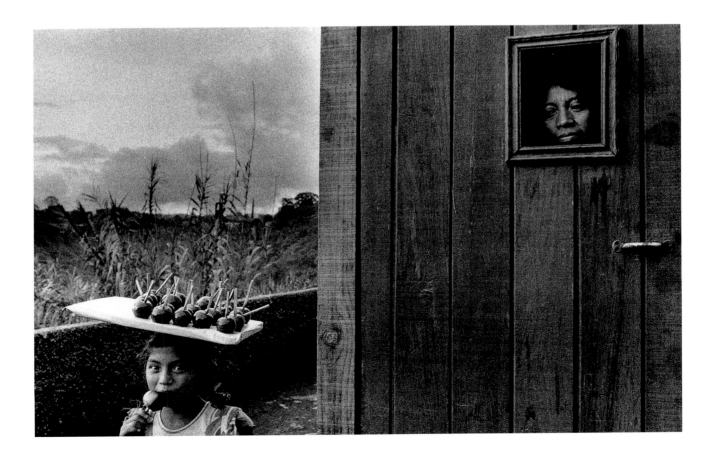

Serra Pelada Mine, Brazil, 1986

You know the big problem is that the question is put quite differently there than it is here. Because there, the importance is put on trying to survive, to stay alive. Many children die of starvation and malnutrition. They smell glue to escape the feelings of hunger. Kids are killed in the streets because they become bandits. The people that live there think more about these problems than about a tree. The thought is, if you cut a tree and you give employment and food to people, that's okay because humans are more important than trees. If you protect the trees to protect the humans, that means that solutions to the problems of survival must be reached first. There is huge pressure on Brazil not to cut the Amazon because it's needed to filter the world's carbon dioxide. The more carbon dioxide created in the Northern Hemisphere, the more filters needed in the Southern Hemisphere. We need to reduce emissions here and help the people there if we want to protect the forest. We can't think more about what "they" must do. It's a global solution. If we don't get global solutions for our problems, the people in the underdeveloped countries will continue to flee to the more developed countries, which creates problems in those countries. We need to bring development and investment to every country around the world. The rate of population growth needs to decrease. The population that we have in the world has doubled in the last fifty years from 3 billion to 6 billion. The way of living for all has to become better. We can say, "Oh well, but the way we've developed here in the United States, France, Germany, and Japan is not the ideal way." Of course it's not the ideal way, but it is a way. And it's the way the underdeveloped countries must evolve. It's better than living in complete abandonment and going back to the Stone Age. We must accept the patterns of development and be more honest with the countries that supply the raw material because the price of the raw material coming from the Third World has been decreasing for years, and the price of sophisticated technology is going higher and higher. We also need to transfer education, technical information, better mining and agriculture techniques. Show the poorer countries how to produce enough food for their people to eat. We can transfer this type of technology. In the end, to transfer real investment, money to create jobs. The Amazon is being destroyed because there are millions of people there who need to survive.

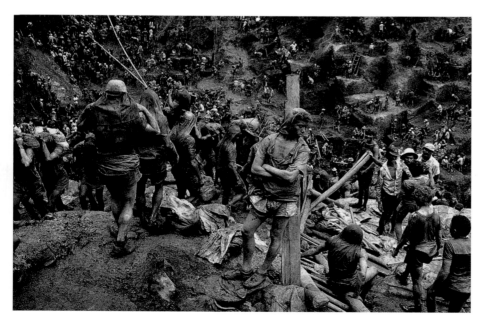

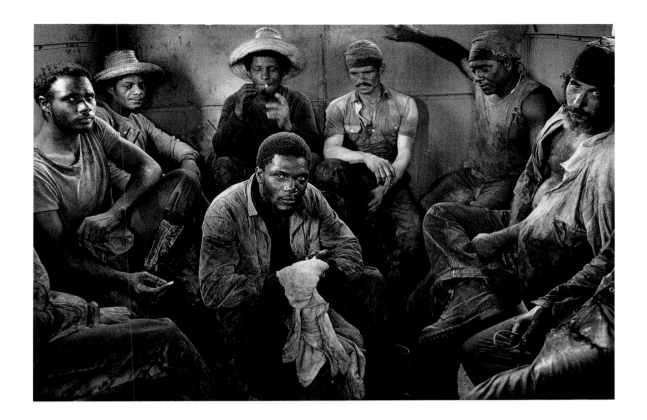

The End of the Day for Sugarcane Cutters, Cuba, 1988

With the arrival of all the new technology, the way things are produced in the world will completely change. I wanted to document manual labor, a method of work that is disappearing. I did photos about the end of the traditional industrial era. For example, I shot in car factories in India, the former Soviet Union, and China where they produce cars like they did in the United States many years ago. The age of electronics is changing the world rapidly. I included in this portrait people that work in oil fields, who work in agriculture, in the mines of Brazil, in construction. Machines have displaced a lot of people. When you see that a few machines can produce what took thousands of peasants to produce before, when you see the concentration of people in towns, when you see this individuality and concentration of revenues, you realize that we are living in a revolution as big as when we jumped from the Middle Ages to the modern age in the fifteenth century. The big difference is now we are close to 6 billion people and have ultrasophisicated communications. Because we are living inside this revolution, we don't pay attention to it. When you travel a lot and go to many different points on the planet, you begin to link a lot of this together. Five, ten percent of the society controls the whole society. We are going toward a huge bureaucracy, a financial bureaucracy that controls the world. It's not the government. France has become a state completely owned by insurance companies, banks, and other big business. This is happening all over the world. The big enterprises control the government, the army, they control all sorts of things. What's important for this kind of bureaucracy is free trade, so proceeds can come from any part of the world. We have arrived in the society that we chose to live in one hundred years ago. We have a celebration of capital.

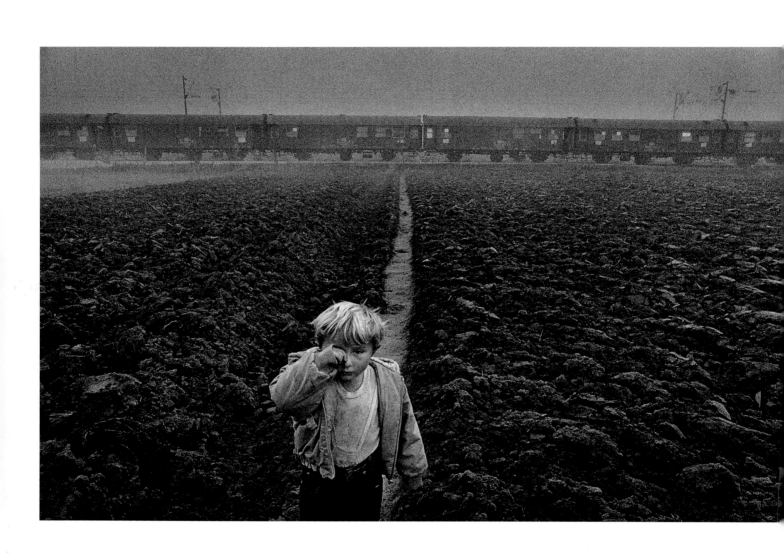

Refugee, Former Yugoslavia, 1994

All things change, and the way you see the world changes also. I thought of evolution just in one sense, that we as a specimen were going to be better. After Rwanda, I saw that evolution could be evolution in another sense, toward the end, toward destruction. I worked for the first time with the Rwandan people in the beginning of May 1994 at the Tanzanian border in the refugee camps. I went to Rwanda two times more, and each time I saw the same people, the same Utu and Tutsi people, adapting themselves to another condition. The people had completely adapted themselves to the violence, death, and destruction. I saw the same thing in Bosnia. For example, when the conflict began it was so difficult to get a child to school when your neighbor is shooting at you. For a mother it was difficult knowing that school was going on and it was necessary for the child to go, but that by putting the kid out in the streets it was possible that he could get shot down. He was going under cars, behind walls, to arrive at school. The family would be desperate. Then when you come to see this family two months later, the family had adapted to this way of life. Six months later it was normal, "Bye, mother, I'm going to school." "Okay, kid. See you later." And bullets were flying by when he would cross the streets. I saw that we are an animal with a great capacity for adaptation. We can adapt ourselves to any condition in life. A violent life. A soft life. A beautiful life. But I'm not sure we are a specimen that will stay here forever. Begin to imagine dinosaurs that lived 100 million years ago and lasted as a species for millions of years. They disappeared for some reason. We can also go. Today we have the AIDS virus. If we have three or four viruses that cross at the same moment we probably will be gone altogether. The sea around Jakarta, Indonesia, is poisoned. The underground water in São Paulo, Brazil, the reservoir, is so polluted, the city has to get drinking water from eighty kilometers distant. I've worked a lot in Bombay, and you see the pollution level there. If you break our very fragile equilibrium—crossing these problems with the problem with the ozone— there is a big risk for us.

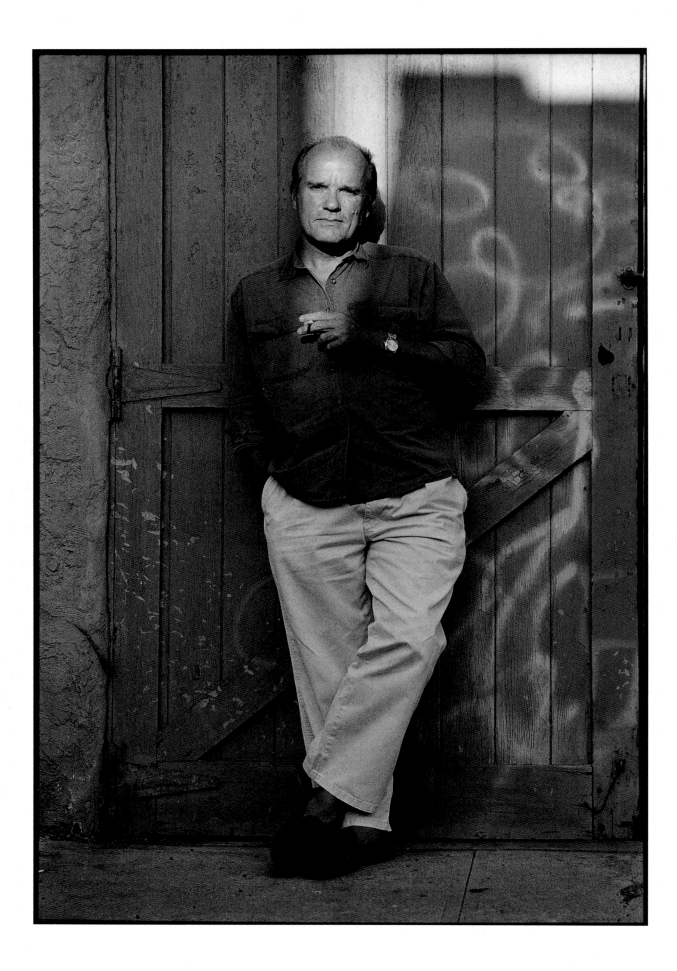

Peter Lindbergh

I began my photo career as an assistant in 1972 and 1973. I enjoyed it very much, but in the beginning I had no clue about anything. Hans Lux, the photographer who showed me what studio photography was all about, was a friend of a friend and was looking for an assistant. Hans showed me Balcar strobes in his studio and I remember being totally astonished that somebody used lights in that way. I was so innocent I said, "What are you doing with all that flashing?" Everything was very casual. He would walk in flippers around the studio, which had a pinball machine. I was able to arrange things and make a first Polaroid, and Hans would say, "Okay, move it around a little bit." So very quickly I got confidence in myself. At that time I was just starting to be an artist. I had exhibitions and interesting things going on, but I felt it wasn't really what I wanted to do all my life. I started out in a painting class in Germany, and that evolved into what is called today "concept art." At the end I was working with computers, which could calculate all the possibilities. I figured out that you didn't have to paint these things or hang them on the wall, you just had to make a computer listing of how many elements, combinations, and possibilities existed, and that got too intellectual for me. I wanted to work with my hands and meet people every day. During my last six months with Hans I built a little studio—a loft in Düsseldorf—with the money

I made working with him. I bought Balcar power packs and lights. I wanted to be an advertising photographer. It was the only thing I knew. While I was an assistant, my wife was working for an agent who was a representative for Helmut Newton, so she had good contacts and then she opened up her own agency with another girl. They took my first little pictures with their photographers— they had photographers like John Bishop from London and people like that—and slowly I got advertising jobs. One of my first campaigns was for Samson, the tobacco where you roll the cigarettes yourself. We went to Amsterdam. We went up to people on the street who were rolling cigarettes and just shot them. We got a release, they got some money, and we came back with some really great pictures. The style was totally reportage. I felt that staged pictures just looked stupid. After four years or so I got a call from a German art director, Willy Fleckhaus, who had been the art director for *Twen*, the German version of *Nova* in England. After *Twen* magazine had closed, he called up one day and said, "Your pictures are very editorial. Do you want to work for me and do stories? I have ten pages for you to do for a magazine *Moda & Vonen*"—which means fashion and living—"with Kenzo," a big designer in Paris. This was 1977 when I was still in Germany. It was a great experience to work with Fleckhaus, who was a kind of German Brodovitch.

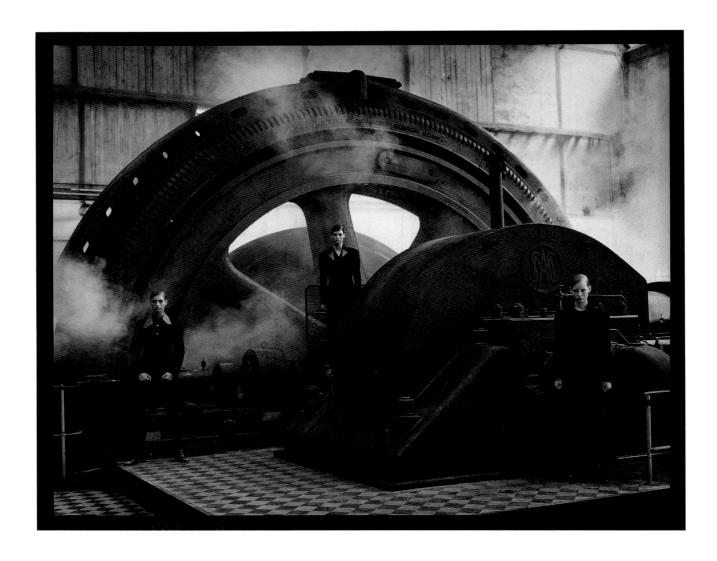

Comme des Garçons (Catalog), 1988

I was born in 1944—a year before the end of the war. I was a totally happy kid. But when we played it was in front of brick factories with chimneys always pouring out smoke. Every morning my mother had to brush off the outside windows, there was that much dust and dirt. The factory shots are among my personal favorites for their intensity and because they show my roots. Where I come from looks like that. The most incredible machines. I come from Duisburg in the Ruhr. It's like Pittsburgh, heavy industries. The Comme des Garçons photo came from that. As a child, we played around places like this all the time. The big machine with the smoke was in Nancy, France. Comme des Garçons was totally free. We didn't even have concept discussions. Rei would just say, "This is what I'm working on and you make the pictures." Rei Kawakubo really started these art catalogs. After three or four years every company had their catalogs.

Kristin McMenamy, Marrakech, Morocco, French Vogue, 1990

I had a short period where I shot with an 8x10 camera, but it's too complicated, you get so involved in the technique it takes a lot of energy away from the actual picture and generally it's too slow. But it was a great experience. Now I shoot with Nikons and a Pentax 6x7. When I'm in the studio I do everything with HMIs. I haven't touched a flash for ten years. Outside of the studio I've been doing more and more reportage-style work. I have the camera around my neck and a few rolls of film in my pocket and I just walk around with the model. You don't have the feeling of fashion pictures anymore.

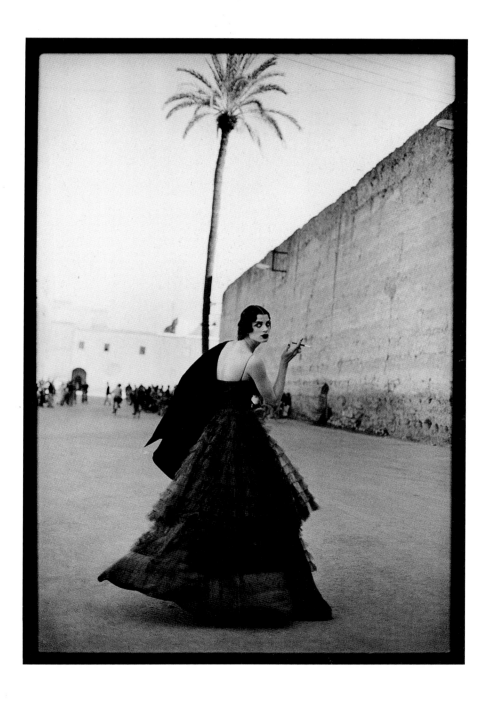

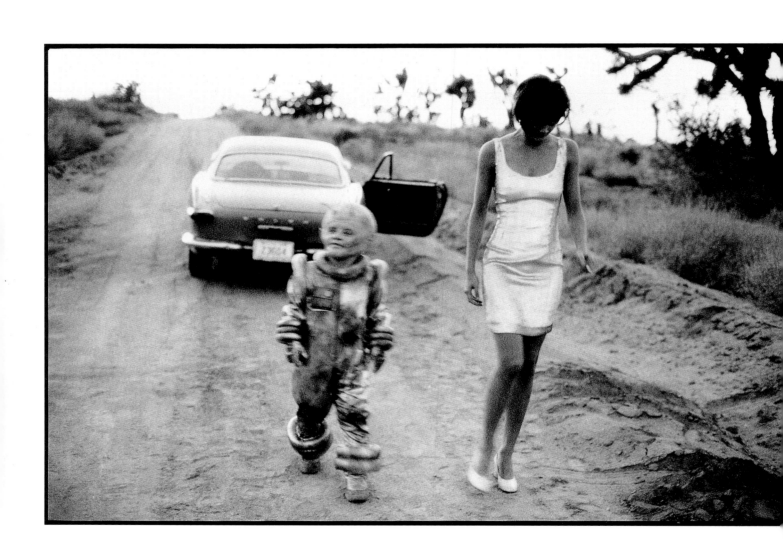

Italian Vogue, *March 1990, Fashion: Versace*

I got the idea for the story when I was at the dentist and there was a UFO magazine in the waiting room and I really got into it. The army caught something, a pilot disappeared, these kind of stories were in the magazine. I wanted to do a story like that so I called Franca Sozzani, the editor of Italian *Vogue,* and she was totally excited about the idea. We got this woman who was a midget to play the part of a male ET. I wanted to do a love story with them. The story is that the ET crashed a UFO in a dry lake. We got all these pieces of airplanes from this little airport in the Mojave Desert, collected from planes that they blow up for movies, and we spread them around simulating a crashed spacecraft. The story opens with a picture of the St. James Club on Sunset Boulevard with UFOs airbrushed in. The next picture is Helena Christensen discovering this "little man" just sitting there. Then she brings him to her trailer home in the desert. In the last picture you see Helena from the back and the Martian turns around crying and says "Bye" and goes into infinity. This is where I'm kind of a special fashion photographer. The editors say to one kind of fashion photographer, "There are ten pictures to do with the new skirt length." So they get to the story from that point, from the clothes. I come more from the photography, and they find the fashion for the story. I get more to my editorial fashion story from the story and then the fashion editor finds the clothes to match it. . . . She lives in a trailer home . . . you can fit an evening dress in if you want, you can do quite a few different things. You still show clothes— they're fashion pictures—but it doesn't come from the new wave—now the hippie look or the miniskirt or the print. You can't always do stories like this. It's a luxury thing to do that kind of approach to fashion photography. So if you will only do this, magazines get cross with you. You'll lose your influence with the magazine. You have to do a little of both.

Linda Evangelista and Hugh Grant, New York, 1992

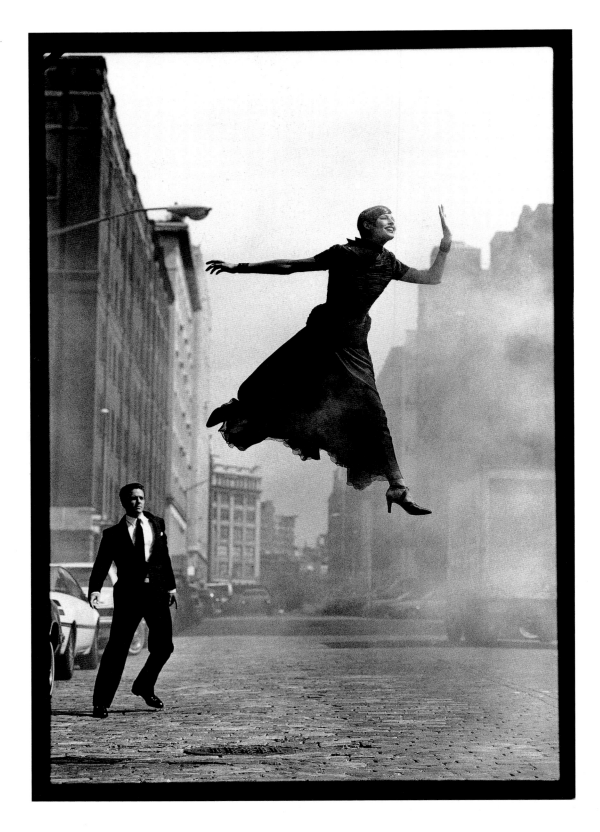

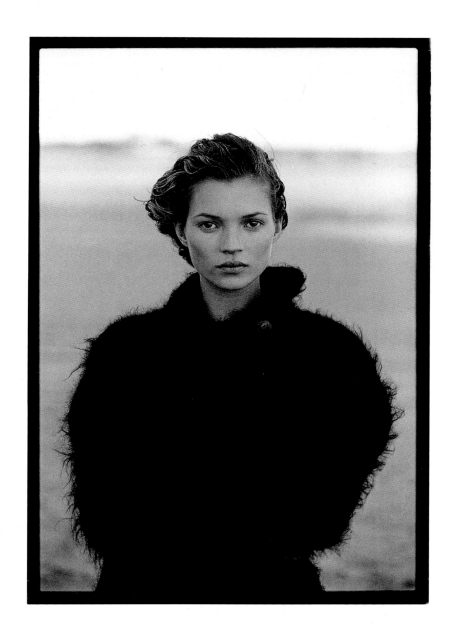

Kate Moss, Harper's Bazaar, *Arles, France*, 1994

In every period—every decade—a woman has a certain expression, a certain image. The supermodels have dominated a certain look for a number of years. In the 1970s when I began, I couldn't match my mind with American *Vogue*'s image of a woman—the perfect makeup, the perfect hair, always in the most beautiful apartment, wearing the perfect fashion. I had no interest in the really done kind of a woman. That is not my feeling of a woman. I never made women ugly, but I didn't overly make them up. I go for the personality, not for the beauty. In terms of clothes, fashion is of course important, but a woman should wear a dress, not the other way around. As long as the clothes are okay, there is no problem. If the clothes are wrong, it's very difficult to do the picture. I think that in photographing models or women or whatever, what interests me most is the face, the personality.

Selected Bibliography

Abbott, Berenice. *The World of Atget.* New York: Paragon Books, 1979.

Adams, Ansel. *Ansel Adams: An Autobiography.* Boston: New York Graphic Society, 1985.

Aperture Foundation. *Aperture Masters of Photography: Manuel Alvarez Bravo.* New York: Aperture, 1997.

———. *India: A Celebration of Independence 1947 to 1997.* Essay by Victor Anant. New York: Aperture, 1997.

———. *Martin Munkacsi: An Aperture Monograph.* New York: Aperture, 1992.

———. *Aperture Masters of Photography: Henri Cartier-Bresson.* New York: Aperture, 1987.

Arnold, Eve. *In Retrospect.* New York: Alfred A. Knopf, 1996.

———. *Women to Women.* Tokyo: Japan Professional Photographic Society, in conjunction with Inge Morath, 1996.

———. *The Great British.* New York: Alfred A. Knopf, 1991.

———. *All in a Day's Work.* New York: Bantam Books, 1989.

———. *Private View: Mikail Baryshnikov American Ballet Theatre.* New York: Bantam Books, 1989.

———. *Marilyn Monroe: An Appreciation.* New York: Alfred A. Knopf, 1987.

———. *In America.* New York: Alfred A. Knopf, 1983.

———. *In China.* New York: Alfred A. Knopf, 1980.

———. *Flashback! The 50s.* New York: Alfred A. Knopf, 1978.

———. *The Unretouched Woman.* New York: Alfred A. Knopf, 1976.

Bendavid-Val, Leah. *National Geographic: The Photographs.* Washington, D.C.: National Geographic, 1994.

Boubat, Edouard. *It's a Wonderful Life.* New York: St. Martin's Press, 1997.

Brown, Joseph Epes, ed. *The North American Indians: Photographs by Edward S. Curtis.* New York: Aperture, 1972.

Brown, Turner, and Elaine Partnow. *Macmillan Biographical Encyclopedia of Photographic Artists and Innovators.* New York: Macmillan, 1983.

Bush, Martin. *The Photographs of Gordon Parks.* Wichita, Kan.: Wichita State University, 1983.

Capa, Robert. *Photographs.* New York: Alfred A. Knopf, 1985.

Cartier-Bresson, Henri. *The Decisive Moment.* New York: Simon and Schuster, 1952.

Charbonnier, Jean-Philippe. *Jean-Philippe Charbonnier—Photographs.* Paris: Musée d'Art Moderne de la Ville de Paris, 1983.

Conner, Ken, and Debra Heimerdinger. *Horace Bristol: An American View.* San Francisco: Chronicle Books, 1996.

Danziger, James, and Barnaby Conrad III. *Interviews with Master Photographers.* New York: Paddington Press, 1977.

Deedes-Vincke, Patrick. *Paris: The City and Its Photographers.* Boston: Bulfinch Press, 1992.

Eisenstaedt, Alfred. *Eisenstaedt Remembrances.* Edited by Doris C. O'Neil. Boston: Bulfinch Press, 1991.

———. *Eisenstaedt on Eisenstaedt.* New York: Abbeville Press, 1985.

Erwitt, Elliott. *Between the Sexes.* 1994.

———. *The Angel Tree: A Christmas Celebration.* New York: Harry N. Abrams, 1993.

———. *Elliott Erwitt: To the Dogs.* New York: DAP, 1992.

———. *Elliott Erwitt: On the Beach.* New York: W. W. Norton, 1991.

———. *Elliott Erwitt: Personal Exposures.* Tokyo: PPS, 1988.

———. *Recent Developments.* New York: Simon & Schuster, 1978.

———. *Elliott Erwitt: The Private Experience.* New York: T. Y. Crowell, 1974.

———. *Son of Bitch.* New York: Viking/Compass, 1974.

———. *Observations on American Architecture.* New York: Viking Press, 1972.

Feininger, Andreas. *Andreas Feininger: Photographer.* New York: Harry N. Abrams, 1986.

———. *Total Photography.* New York: Amphoto, 1982.

———. *Industrial America.* New York: Dover Publications, 1981.

———. *Feininger's Chicago.* New York: Dover Publications, 1980.

———. *Feininger's Hamburg.* Düsseldorf: Econ Verlag, 1980.

———. *New York in the Forties.* New York: Dover Publications 1978.

———. *Light and Lighting in Photography.* New York: Amphoto, 1976.

———. *Roots of Art.* New York: Viking Press, 1975. Reissued as *Nature and Art.* New York: Dover Publications, 1983.

———. *The Perfect Photograph.* New York: Amphoto, 1974.

———. *Andreas Feininger.* Text by Ralph Hattersley. Dobbs Ferry, N.Y.: Morgan and Morgan, 1973.

———. *Photographic Seeing.* Englewood Cliffs, N.J.: Prentice-Hall, 1973.

———. *Principles of Composition in Photography.* New York: Amphoto, 1973.

———. *The Color Photo Book.* New York: Prentice-Hall, 1969.

———. *Forms of Nature and Life.* New York: Viking Press, 1966.

———. *New York.* Text by Kate Simon. New York: Viking Press, 1964.

———. *The World Through My Eyes.* New York: Crown Publishers, 1963.

———. *Maids, Madonnas, and Witches.* Text by Henry Miller and J. Bon. New York: Harry N. Abrams, 1961.

———. *Changing America.* Text by Patricia Dyett. New York: Crown Publishers, 1955.

———. *The Face of New York.* Text by Susan E. Lyman. New York: Crown Publishers, 1954.

———. *Feininger on Photography.* New York: Ziff-Davis, 1949. Reprint, New York: Crown Publishers, 1953.

Fiedler, Jeannine, ed. *Photography at the Bauhaus.* Cambridge, Mass.: The MIT Press, 1990.

Foresta, Merry A., and William F. Stapp. *Irving Penn, Master Images: The Collections of the National Museum of American Art and the National Portrait Gallery.* Washington, D.C.: Smithsonian Press, 1990.

Frank, Robert. *The Americans.* New York: Pantheon, 1986.

Fulton, Marianne. *Mary Ellen Mark, 25 Years.* Boston: Bulfinch Press, 1992.

Galassi, Peter. *American Photography 1890–1965 from the Museum of Modern Art, New York.* New York: The Museum of Modern Art, 1995.

Gernsheim, Helmut. *A Concise History of*

Photography. New York: Dover Publications, 1986.

Goldberg, Vicki. *The Power of Photography: How Photographs Changed Our Lives*. New York: Abbeville Press, 1991.

———. *Margaret-Bourke White*. New York: Harper and Row, 1986.

Greenough, Sarah. *Paul Strand: An American Vision*. New York: Aperture, 1990.

Hambourg, Maria Morris, and Christopher Phillips. *The New Vision: Photography Between the World Wars*. New York: Museum of Modern Art and Harry N. Abrams, 1989.

Harrison, Martin. *Appearances: Fashion Photography since 1945*. New York: Rizzoli, 1991.

Hill, Paul, and Thomas Cooper. *Dialogue with Photography*. Manchester, England: Cornerhouse Publications, 1994.

Horvat, Frank. *Entre Vues*. Paris: Editions Natan, 1990.

Hosoe, Eikoh. *Eikoh Hosoe: META*. New York: International Center of Photography, 1991.

———. *Photography: The World of Eikoh Hosoe*. Ito, Japan: Ikeda Museum of 20th Century Art, 1988.

———. *Eikoh Hosoe: Untitled #42*. Carmel, Calif.: Friends of Photography, 1986.

———. *Barakei (Ordeal by Roses)*. New ed. New York: Aperture, 1984.

———. *The Cosmos of Gaudi*. Tokyo: Shueisha, 1984.

———. *Human Body*. Tokyo: Nihon Geijutsu Shuppan, 1982.

———. *Kamaitachi*. Tokyo: Gendai Shichosha, 1969.

———. *Man and Woman*. Tokyo: Camera Art Publications, 1961.

Hughes, Jim. *W. Eugene Smith: Shadow and Substance: The Life and Work of an American Photographer*. New York: McGraw-Hill, 1989.

Hunter, Peter. *Erich Salomon*. New York: Aperture, 1978.

Johnson, Brooks. *Photography Speaks II*. New York: Aperture/Chrysler Museum of Art, 1995.

———. *Photography Speaks*. New York: Aperture/Chrysler Museum of Art, 1989.

Kismaric, Carole, and Marvin Heiferman. *Talking Pictures: People Speak about the Photographs That Speak to Them*. San Francisco: Chronicle Books, 1994.

Lacayo, Richard, and George Russell. *Eyewitness: 150 Years of Photojournalism*. New York: Time Books, 1995.

Leibovitz, Annie. *Photographs: Annie Leibovitz, 1970–1990*. New York: HarperPerennial, 1991.

Lemagny, Jean-Claude, Alain Sayag, and Agnés de Gouvion Saint-Cyr. *Twentieth Century French Photography*. New York: Rizzoli, 1988.

Life: The First 50 Years, 1936–1986. Boston: Little, Brown, 1986.

Lindbergh, Peter. *Ten Women by Peter Lindbergh*. Munich: Schirmer/Mosel, 1996.

Mark, Mary Ellen. *Streetwise*. New York: Aperture, 1988.

Marling, Karal Ann, and John Wetenhall. *Iwo Jima: Monuments, Memories, and the America Hero*. Cambridge, Mass.: Harvard University Press, 1991.

Museum of Photographic Arts. *Revelaciónes: The Art of Manuel Alvarez Bravo*. Albuquerque: University of New Mexico Press, 1992.

Mydans, Carl. *Carl Mydans, Photojournalist*. New York: Harry N. Abrams, 1985.

Naef, Weston. *The J. Paul Getty Museum Handbook of the Photographs Collection*. Malibu, Calif.: J. Paul Getty Museum, 1995.

Newhall, Beaumont. *The History of Photography, from 1839 to the Present*. New York: Museum of Modern Art, 1982.

Newhall, Nancy. *The Daybooks of Edward Weston*. 2 vols. New York: Aperture, 1973.

Newton, Helmut. *Archives de nuit*. Munich: Schirmer/Mosel, 1993.

———. *Helmut Newton: Private Property*. New York: W. W. Norton, 1990.

———. *Portraits*. Munich: Schirmer/Mosel, 1987.

Norman, Dorothy. *Alfred Stieglitz: An American Seer*. New York: Aperture, 1990.

Parks, Gordon. *Half Past Autumn*. Boston: Bulfinch Press, 1997.

———. *Arias in Silence*. Boston: Bulfinch Press, 1994.

———. *Voices in the Mirror*. New York: Doubleday, 1990.

———. *The Learning Tree*. New York: Harper and Row, 1963.

Riboud, Marc. *Marc Riboud: Photographs at Home and Abroad*. New York: Harry N. Abrams, 1988.

Ritts, Herb. *Herb Ritts: Work*. Boston: Bulfinch Press, 1996.

———. *Africa*. Boston: Bulfinch Press, 1994.

———. *Notorious*. Boston: Bulfinch Press, 1992.

Rosenblum, Naomi. *A World History of Photography*. New York: Abbeville Press, 1989.

Salgado, Sebastião. *Terra: Struggle of the Landless*. London: Phaidon Press Limited, 1997.

———. *Workers*. New York: Aperture, 1993.

———. *An Uncertain Grace*. Essays by Eduardo Galeano and Fred Ritchin. New York: Aperture, 1990.

Sieff, Jeanloup. *Jeanloup Sieff: 40 Years of Photography*. Cologne, Germany: Evergreen, 1996.

Sobieszek, Robert A. *The Art of Persuasion: A History of Advertising Photography*. New York: Harry N. Abrams, 1988.

———. *Masterpieces of Photography from the George Eastman House Collections*. New York: Abbeville Press, 1985.

Sontag, Susan. *On Photography*. New York: Noonday Press, 1989.

Szarkowski, John. *Looking at Photographs*. New York: Museum of Modern Art, 1976.

Tokyo Metropolitan Museum of Photography. *Innovation in Japanese Photography in the 1960s*. Tokyo: Tokyo Metropolitan Culture Foundation, 1991.

———. *Japanese Photography in the 1970s: Memories Frozen in Time*. Tokyo: Tokyo Metropolitan Culture Foundation, 1991.

———. *The Rise of Japanese Photography*. Tokyo: Tokyo Metropolitan Culture Foundation, 1991.

Biographical Notes

Eve Arnold
born 1913

Born in Philadelphia to Russian immigrant parents, Arnold established herself in the 1950s with sensitive human interest stories for *Look* and *Life* magazines. Her photo essays and celebrity profiles reveal Arnold's ability to put her subjects at ease. A feeling of intimacy permeates her work; she avoids building barriers, both physical and psychological, by working with a minimum of photographic equipment and shooting most often under ambient light conditions. Her only formal instruction in photography was six weeks of training with Alexey Brodovitch at the New School for Social Research in New York, where for a class assignment Arnold went to Harlem to photograph the fashion shows. "In a sense it was a protest against the white-dominated 'shmata' trade in New York," she said of this photo-essay, which ran in *Picture Post* in Britain. On the strength of this, her first published story, she was invited to join the photo agency Magnum. She has produced several books, including the award-winning *In China*. Published in 1980, the culmination of two three-month, 40,000-mile journeys crisscrossing the world's most populous country, this book revealed the aspirations of a people emerging from decades of Maoist suppression. In addition to her books and magazine work she has photographed "specials" on thirty-one films, including *The Bible, The Man Who Would Be King, Under the Volcano, A Man for All Seasons, The Great Train Robbery,* and *The Misfits,* for which she spent two months on the set with Marilyn Monroe. Among her numerous awards and accolades she was named Master Photographer, an honor awarded by the International Center of Photography in 1995. In that same year, Arnold was named a Fellow of the Royal Photographic Society.

Edouard Boubat
born 1923

While he never studied photography formally, Edouard Boubat spent the years 1938 to 1942 at the Ecole Estienne in Paris studying book printing, design, and typography, which gave him an eye for simplicity in line and composition. He taught himself how to use the camera and to print, converting his bathroom into a darkroom. As World War II ended, Boubat, like so many of his fellow camera-wielding countrymen, emerged from the rubble (though fortunately much of his beloved Paris was spared) to fill the pages of magazines and books of a war-weary Europe with much-needed images of hope, humor, and compassion. Boubat's personal celebration of joie de vivre has for more than half a century extended not only outside the Paris city limits but far beyond the borders of his native France. Traveling the world from Brazil to Vietnam to Sweden to Kenya, mostly on assignment for the French monthly *Réalités,* Boubat has carried his own aura of tranquillity with him, calmly crossing international borders and transcending language barriers. While his message is often subtle, it has not gone unnoticed, even from the beginning of his career; he received the Kodak Prize at the Bibliothèque Nationale exhibition in Paris in 1947 and participated in a 1951 group show with Brassaï, Robert Doisneau, Facchetti, and Izis at the famed La Hune Gallery in Paris. *Réalités* artistic director Bertie Gilou saw Boubat's work at this show and invited Boubat to join the publication, to which he contributed until 1965. Among his other awards are the Grand Prix du Livre from the Arles Photo Festival in 1977, and in 1984 the Grand Prix National de la Photographie. The poet Jacques Prévert, in the introduction to one of Boubat's books, sums up the photographer's working methodology: "When everywhere else, reporters of misfortune work amidst carnage, Boubat, be it in nearby towns or in the farthest flung countries or the great expanse of weary desert, seeks and finds an oasis. He is a correspondent of peace."

Manuel Alvarez Bravo
born 1902

As a boy in Mexico City, Manuel Alvarez Bravo often visited the Anthropology and History Museum, with its impressive pre-Hispanic art collection, and viewed European artwork at the San Carlos Museum. Both would later greatly influence his work. Leaving school early because of the Mexican Revolution, at age thirteen he took a job at a company that manufactured textiles. A year later, in 1916, he started the first of various government jobs, among them assistant to the paymaster in the Second Regiment of Campaign Artillery and a position in the Ministry of Education. In 1918 he studied music and painting at the Academia de San Carlos. Using various international photo magazines as technical guides, he taught himself photography. In 1927 he met Tina Modotti, who introduced him to the vibrant international artistic community in Mexico during this period. After her deportation from Mexico, he replaced her as a photographer for the art magazine *Mexican Folkways.* In 1929–30 he taught photography at the San Carlos Escuela Central de Artes Plasticas; he became a freelance photographer in 1931. Though Bravo feels his work is more fantasy than surreal, in 1938 André Breton asked him for a surrealist photograph for an exhibition; *La buena fama durmiendo* was the result. In 1943 he joined the film industry, working primarily as a cameraman until 1959. In that year he helped found the Fondo Editorial de la Plasticas Mexicana to publish fine art and photography books. Many well-known contemporary Mexican fine art photographers, including Graciela Iturbide, Flor Garduno, and Rafael Donz, worked under Bravo, documenting for publication the indigenous people and crafts of Mexico.

Horace Bristol
1908–1997

Born in Whittier, California, Bristol grew up in a family that owned and published a local newspaper, the *Santa Ana Blade*. Later they moved to Santa Paula, where his grandfather had purchased another newspaper. After studying photography at the newly established Art Center in Los Angeles, Bristol moved his own family to San Francisco in search of work during the depression years of the 1930s. As with most photographers during the depression, he took any commercial assignments that came his way, but having grown up in a family of newspaper people, he always identified most closely with journalism. He opened a studio loft downtown near the St. Francis Hotel, next to a little gallery that Ansel Adams owned, on occasion competing with Adams for advertising business.

While a stringer for *Time* and several other magazines, Bristol was hired by *Life* on the recommendation of *Time*'s San Francisco bureau chief. Impressed by what one of his photographer friends, Dorothea Lange, was doing for the Farm Security Administration on migratory labor, Bristol suggested a story for *Life* magazine on the people who had left the dust bowl, lured by false hopes of plentiful work in California. After reading *In Dubious Battle*—John Steinbeck's book about labor problems—Bristol asked Steinbeck to be his writing partner on the project. In the end Steinbeck decided to fictionalize the story, which became *The Grapes of Wrath*. Bristol's photos were used to cast the screen version of the Pulitzer Prize–winning novel, and appeared as a spread in *Life* about the characters in the movie.

During World War II Bristol joined Edward Steichen's navy unit of photographers, covering events in both the Atlantic and the Pacific theaters. After the war Bristol based himself and his family in Japan, working as a stringer for several publications, including *Fortune*, and later establishing the East-West Photo Agency in Tokyo. After meeting Japanese photographer Jun Miki, who was working with Nikon lenses—virtually unknown outside Japan at that time—he was so impressed by the qual-

ity of the optics that he and his friend photographer David Douglas Duncan began to use the equipment, helping Nikon gain international recognition. In 1956 his wife Virginia committed suicide, having become despondent after a hysterectomy. A year later he met and married his second wife, Masako, a librarian at the Foreign Press Club. In 1967 he moved his new family to Guadalajara, Mexico, and then in 1976 to Ojai, California.

Jean-Philippe Charbonnier
born 1921

Jean-Philippe Charbonnier was born in Paris on August 28, 1921. His father was a painter and his mother the writer Annette Vaillant. Graduating in philosophy, English, and German, he began his career working with cinema portraitist Sam Lévin. He worked at the Blanc and Demilly photo laboratories in Lyon in 1941, then spent the following two years in Switzerland before returning to France in 1944, where he joined the daily *Libération* as a layout artist. In that same year he used his newly acquired Leica Summar F2 to document on a single roll of 35mm film the entire story of the execution of a collaborator in the small town of Vienne. After the war he continued working for newspapers, including *France-Dimanche*, *Temps de Paris*, and *Temps de France*. In January 1950 Charbonnier joined the staff of the monthly *Réalités*, which enabled him to travel the world filling its pages with what he described as "human interest photojournalism" until the journal's demise in 1974. His editorial work has taken him throughout the former Soviet Union, Africa, the Middle East, and Asia. In addition to his reportage, he has worked on advertising campaigns and teaching.

Alfred Eisenstaedt
1898–1995

Alfred Eisenstaedt was born in Dirschau, West Prussia, where he lived until his family moved to Berlin in 1906. In 1911 an uncle gave him an Eastman folding camera #3 with red bellows. He bought a daylight processing kit and used the bathroom to develop his pictures, which

became a serious hobby. At age sixteen and a half he was drafted into the German army; the Great War ended for "Eisie"—as he was later known by his friends and colleagues—when he was shot through both legs on April 12, 1918. After the war, while continuing his photographic hobby, he became a salesman of belts and buttons. In 1927 he photographed a woman playing tennis. A friend who also dabbled in photography slid Eisie's Zeiss Ideal 4x5 camera into "some sort of wooden contraption with a matte bulb," cropped out trees and benches, and revealed a graphic image of the tennis player and her shadow. The photograph was published in *Der Foto Freund*, then in *Der Welt Spiegel*, the weekly German equivalent of the *New York Times Magazine*, earning a payment of twelve marks (about $3.00). Several photographs later, the editor of *Der Welt Spiegel* suggested that Eisie buy an Ermanox, the same camera that Eisie's hero Dr. Erich Salomon used. He began working for Pacific and Atlantic Photos (later the Associated Press) as a freelancer, shooting parties, concerts, and openings. His first major assignment was to photograph Thomas Mann accepting the Nobel Prize in literature in Stockholm in 1930. He continued to cover news events, including the fighting in Ethiopia, until he left Germany for New York in 1935. Introduced to *Life* founder Henry Luce by Kurt Korff, a former editor of the *Berliner Illustrierte Zeitung*, Eisie became a staff member of *Life* along with Margaret Bourke-White, Thomas McAvoy, and Peter Stackpole when the magazine began in 1936. He completed more than 2,500 assignments for the publication during his career; the events and personalities captured by his lens includes Thomas Mann, Hitler, Mussolini, Joseph Goebbels, Winston Churchill, Marlene Dietrich, George Bernard Shaw, Albert Einstein, General Douglas MacArthur, V-J Day, the aftermath of Hiroshima, Emperor Hirohito and General Tojo of Japan, Haile Selassie, Jawaharlal Nehru, John F. Kennedy, Marilyn Monroe, Sophia Loren, Ernest Hemingway, and Martin Luther King.

Elliott Erwitt
born 1928

Elliott Erwitt's photographs show a highly developed awareness of the little ironies in life—the man who has written, "Unattractive people stay away from certain beaches, like Ipanema in Rio or St. Tropez, as a public service" (in *Elliott Erwitt: On the Beach*, 1991), needs at times to be taken with a grain of salt. Yet the same Erwitt, after joining the photo agency Magnum, risked his professional career fighting for the rights of fellow photographers. Erwitt was born in Paris in 1928 to Russian immigrants; that same year his family moved to Italy, only to return to Paris briefly in 1938 because of the rise of Mussolini and fascism. Arriving in New York in 1939, just as the war in Europe broke out, the family settled in Hollywood in 1941. While attending Hollywood High School in 1944, Erwitt began working in a commercial darkroom. In 1948 he moved to New York, where he met Edward Steichen, Robert Capa, and Roy Stryker, who encouraged him to pursue his photographic career. During a stint in the army—he was drafted in 1951—he won a prize in a *Life* magazine photo contest while stationed in Europe. Back in the United States in 1953, he joined Magnum Photos and along with Robert Capa fought for photographers' rights of ownership of their photography, often at the cost of being blackballed. He served as president of the prestigious agency from 1962 until 1966. In his book *Personal Exposures*, Erwitt wrote that "making someone laugh and cry, alternately, as Chaplin does, is the highest of all possible achievements."

Andreas Feininger
born 1906

Taken with a super-telephoto lens, Andreas Feininger's urban landscape photographs are unsurpassed in impact and scale. At the other end of the spectrum, he has photographed the tiniest of natural objects with extreme close-up lenses that reveal their natural beauty and symmetry. Feininger sees in photography the opportunity to "show the viewer something that he wouldn't or couldn't have seen or something he didn't know or something he hadn't thought of before." Born in Paris in 1906 and growing up in Germany, the son of painter Lyonel Feininger, Andreas rebelled at the rigidity of the German school system. At age sixteen he enrolled at the Bauhaus, where his father had accepted a professorship, and graduated with honors, but he found the prevailing attitudes toward photography there too intellectual and abstract. In 1925, borrowing his mother's $6^{1}/_{2} \times 9$ cm Voightlander camera, he exposed his first picture—crows feeding in a snow-covered field—onto a Perutz glass plate. His inspiration came not so much from an interest in photography as from a desire to make a visual record of the things that were important to him; the camera itself is to Feininger merely "a tool that for me has no more fascination than a typewriter for a novelist." In 1933 Feininger moved to Sweden where he decided to devote himself to photography, though his interest in architecture permeates his work. When war broke out in 1939 between the Soviet Union and Finland, the government's ban on foreigners using cameras ended his photographic career in Sweden. He moved to New York, a city ripe for a photographer interested in monumental design. In 1943 Feininger became a staff photographer at *Life* where he continued to work until 1962. Throughout his career he has produced numerous technical and fine art photographic books.

Eikoh Hosoe
born 1933

Eikoh Hosoe was born in Yonezawa City, Japan, the son of a Shinto priest who was an avid amateur photographer. The younger Hosoe became interested in photography as a high school student in the early 1950s in Tokyo, experimenting with his father's old Thorntonflex camera and darkroom equipment. In addition to his interest in photography, a desire to learn English conversation from native speakers led him to the gates of Grant Heights, a compound for the families of American servicemen, to which he gained access with the help of a classmate's elder brother who worked there. He made friends and photographed the GI's children at play. A sensitive portrait, entitled *Poddie-Chan*, of a young American girl won first place in the student division of a Fuji Film photo contest in 1951. Everything that had anything to do with photography—magazines such as *Look* and *Life*, photo exhibitions—fascinated Hosoe. He enrolled in the Tokyo College of Photography (renamed the Tokyo Institute of Polytechnics), which opened in 1920 and is the oldest school of photography in Japan. In 1953 he was deeply moved by an Edward Weston exhibition at the American Cultural Center in Tokyo; from then on, he "knew that photography would be a part of me for the rest of my life." After graduating in 1954, he began a professional career, and in 1959, having established a successful commercial and fine art career, he helped found the agency VIVO with Ikko Narahara, Shomei Tmatsu, Kikuji Kawada, Akira Saito, and Akira Tanno. On Hosoe's first trip to Barcelona in 1964 he discovered the work of another artist, the Spanish architect Antonio Gaudi, which was to become one of his greatest and continuing sources of inspiration. His vision of Gaudi's architectural creations was transformed into a book, *The Cosmos of Gaudi* (1984), which shows, in both words and photographs, his unique ability to blend Eastern philosophy and Western themes. Other artist and writers have served Hosoe as sources of inspiration for his series, including László Moholy-Nagy, Man Ray, Ei-Q, and author Yukio Mishima. Hosoe now serves as inspiration to future photographers teaching classes at the Tokyo Institute of Polytechnics and various international workshops.

Annie Leibovitz
born 1949

Annie Leibovitz's subject matter ranges from beleaguered citizens of war-torn nations to celebrities and politicians fallen from grace to milk-, paint-, mud-, and rose-covered rock and movie stars. Born in Waterbury, Connecticut, the third of six children, Leibovitz was a college art major at the San Francisco

Art Institute when she found the vehicles—first the camera and then the magazine *Rolling Stone*—that would take her to the top of the photographic world. A successful first assignment for publisher Jann Wenner, photographing Grace Slick of Jefferson Airplane, led to hundreds of rock and celebrity portraits during her thirteen years with *Rolling Stone*, and she continues to this day with assignments for *Vanity Fair*. Her American Express and Gap portrait series are highlights among her award-winning advertising campaigns. In 1991 the National Portrait Gallery in Washington, D.C., in conjunction with the International Center of Photography in New York, organized a 150-image international touring retrospective of her work. More than a simple documentarian of popular culture, with her keen aesthetic sense Annie Leibovitz has helped define it. While many photographers' work might be recognizable to the general public, she is one of the few who have become celebrities in their own right.

Peter Lindbergh
born 1944
The trend-setting work of a few photographers has helped define the look of a particular decade: the 1960s belong to Avedon, the '70s Helmut Newton; the 1980s have most often been awarded to Bruce Weber and Peter Lindbergh. With an ever growing client list that includes Giorgio Armani, Prada, Donna Karan, Calvin Klein, Isaac Mizrahi, and editorial work constantly on display in numerous fashion magazines, Lindbergh's influence has continued well into the last decade of the twentieth century. Born in 1944 in Germany, young Lindbergh primed his early fashion sense and awareness as a window designer for department stores in Germany and Switzerland while studying design and decorative arts at art schools in Berlin and Krefeld. In 1972 and 1973 he assisted advertising photographer Hans Lux in Dusseldorf. Lindbergh's wife, who had been working at a photography agency, opened her own agency with a partner and began to get Lindbergh clients. For one of his first

campaigns for Samson, a tobacco used for rolling cigarettes, he used the reportage-style photography that would become his trademark. The unstaged-looking editorial images attracted art directors including Willy Fleckhaus, who offered Lindbergh ten pages in *Moda & Vonen* with the designer Kenzo in Paris. This spread brought attention to Lindbergh's work from *Stern* and *Marie-Claire*, the latter bringing Lindbergh to Paris to be a monthly contributor. In Paris Rei Kawakubo hired Lindbergh to photograph her Comme des Garçons catalog, for which Lindbergh created a series of bold images that reflected his youth in Germany's industrial Ruhr Valley. In the 1980s and '90s American magazines including *Vogue* and *Harper's Bazaar* have taken advantage of Lindbergh's editorial style and his emphasis on the model as a living, breathing, and thinking person.

Mary Ellen Mark
born 1940
After years of painting and drawing in high school and college, Mark graduated from the University of Pennsylvania School of Fine Arts in 1962, "not knowing what I was going to do." But an interest in photography since her youth with a Brownie camera led her to the Annenberg School to study photography, receiving a master's degree in 1964. She credits one of her instructors, Lou Grassman, as an important influence: "He allowed people to be themselves and did not try to force them into a mold." Mark is particularly interested in recording the experiences of people who "don't have all the breaks in life." Assignments for *Look* magazine—photographing Federico Fellini, followed by a piece on heroin addicts—were her first big breaks. In the late sixties she began doing stills on films, including *Carnal Knowledge, Apocalypse Now, The Day of the Locust,* and *One Flew Over the Cuckoo's Nest,* but documentary work has always been her passion. Venues for Mary Ellen Mark's work include books, exhibitions, and magazines from *Life, National Geographic, GEO, Stern,* and *Fortune* to *Rolling Stone*. Her documentary portraiture is known for its cutting-edge directness. Mark's perceptive, provocative photographs—whether they be of heroin

addicts or the destitute—portray the human condition with dignity, even in the depths of despair.

Carl Mydans
born 1907
Though in large measure he has made a career documenting war for *Life* and *Time* magazines, Carl Mydans would, like Robert Capa, "prefer to remain unemployed as a war photographer." But the news of the twentieth century has been dominated by two global conflicts and innumerable regional confrontations. As one hot spot cools, another heats up. Going far beyond documenting soldier killing soldier, Mydans has put a human face on war. Soldiers and civilians become individuals in front of Mydans's lens.

Mydans's first job after graduating from the Boston University School of Journalism in 1930 was as a reporter for the *American Banker* in New York City, where he often spent lunch hours with his Contax 35mm camera. On one midday outing, he photographed Eugene Daniell standing on a soapbox, agitating against America's domestic policies. The year before, Daniell had thrown a stink bomb into the ventilating system of the New York Stock Exchange, stopping it for the first time during business hours since World War I. Dan Longwell of *Time* decided to run the photo the following week. Longwell later suggested Mydans to the Washington representative of the newly formed Farm Security Administration (FSA), who was picking a small team of photographers to go out across the country and make pictures to draw public support for Franklin Roosevelt's New Deal. After a stint with the FSA, Mydans in 1936 was invited by Longwell to join the staff of *Life;* he has continued to work for Time/Life for over half a century. At *Life* he met his wife Shelly, a staff writer, with whom he often works. His first combat experience was during the Russo-Finnish War in 1939. During World War II, after the fall of France, the husband-and-wife team were sent to Asia, first to China, covering the war against the Japanese, then

to Burma, Malaya, and finally to the Philippines. While they were there, the Japanese attacked Pearl Harbor as well as the Philippines, and the Mydanses were captured. They spent two years in two Japanese prison camps until being exchanged with 1,500 other American and Canadian civilians for 1,500 Japanese who were in America and Canada in the neutral port of Portuguese Goa on a ship that the Swedes provided. Reaccredited to the U.S. Army, Mydans was sent back into the war, first to Europe, and later back to the Pacific to document General MacArthur's triumphant return to the Philippines.

Helmut Newton
born 1924

A hallway lined with towering, powerful floor-to-ceiling black-and-white female nudes greets visitors to June and Helmut Newton's Monaco apartment. Just as commanding is the view of the principality's beaches far below. Here is a man who could write the script for *Lifestyles of the Rich and Famous,* and it is this apparent affluence, mixed with imaginative, mischievous sexuality, that often finds its way into the exposed frames of Helmut Newton. Newton's beginnings were far from glamorous, nevertheless. He started taking pictures in Berlin at the age of twelve, photographing girlfriends in his room using a tungsten photo flood with a 100-watt globe. Newton's mother arranged an apprenticeship with Yva, a well-known Berlin fashion photographer, whom he considers his master. In 1938 he fled Germany to avoid almost certain death at the hands of the Nazis, and in the same year he left Singapore before the unwelcome arrival of Japanese military forces, landing in Australia and right into an army uniform, which he wore for five years. It was Down Under that Newton established himself photographically, in that nation's edition of *Vogue.* Newton credits his wife June, whom he met in Australia and married in 1948, as an important and continuing influence. The two traveled to Europe in 1957 for a short stint with British *Vogue.* Though he found the experience too restrictive—

he returned to Australia in 1959 after an also brief but more inspiring period at *Jardin des modes* in Paris—it did expose him to Europe and the fashion mainstream. As the sixties began, Newton was ready to take on the fashion establishment, planting himself in Paris, where he began his push toward and at times over the moral edges of fashion photography. By the 1970s, with the help of Francine Crescent, editor of French *Vogue* at the time, Helmut brought that magazine to the creative lead in the fashion world with his unique combination of humor, voyeurism, affluent decadence, classical imagery, and the constant sexual undertones and overtones that accompany his photographs. Far from following trends, Newton has created them. His images of women continue to inspire photographers, who find the drama of a Newton image of far more interest than the simple story-less 300mm background-out-of-focus pictures that grace the pages of countless fashion journals.

Gordon Parks
born 1912

Gordon Parks's artistic ability emerged early in his hometown of Fort Scott, Kansas. By age six he had learned to play the piano by ear. As a teenager, he moved to Minnesota, where a sister lived. He earned money playing the piano at a brothel until one Saturday night a man fell a few feet from his piano with a knife lodged in his chest. The customers, the prostitutes, the pimps, and Parks fled. This was not the first time the young Parks had been exposed to violence: he had witnessed two drunken women knifing each other to death in front of a pool hall, and lost many friends to guns. In 1929 a job as a busboy at the prestigious Minnesota Club opened up a new world to him. Borrowed books from the club library became his textbooks. He continued to expand his world as a waiter on a train, the North Coast Limited, in 1937 and 1938. On one journey he saw a photoessay about migrant workers in a magazine that a passenger had left behind, and could not forget the images of the dispossessed roaming the country or the names of the photographers who cap-

tured them on film—Arthur Rothstein, Russell Lee, Carl Mydans, Walker Evans, Ben Shahn, John Vachon, Jack Delano, and Dorothea Lange. Overcoming prejudice and the not-so-insignificant fact that he didn't own a camera at the time, let alone know how to use one, by 1942 he had joined the ranks of this esteemed group as a photographer himself for the Farm Security Administration. Earlier, for his first professional photo assignment of fashions for a department store, Parks double-exposed all but one image; it was the first time he had used a Speed Graphic camera, and he had not turned the 4x5 film holder around. He took the one photograph that was not double-exposed to Madeline Murphy, the store owner's wife. "Would they all have been this nice?" she asked. "Of course," he replied, "It was the worst one." They did it again, this time successfully. Boxing great Joe Louis's wife Marva came to town, saw Parks's work in the window of the store, and encouraged him to come to Chicago. After seeing some documentary work Parks had done on the city's South Side, Jack Delano of the Farm Security Administration encouraged Parks to join the FSA, which he did in 1942. In 1948 he began a career with *Life* magazine. After leaving *Life,* Parks began to concentrate on books, film, music, and more abstract color photographic work.

Marc Riboud
born 1923

Marc Riboud grew up in a family of great travelers. The journals from his father's round-the-world trip in 1910, "fascinated me, rather more perhaps, than Jules Verne." Reading the personal accounts of his uncle's expeditions to Morocco and the Congo at the turn of the century had an equal impact. (He never met this uncle, who was killed in World War I.) To follow in their footsteps, however, he had to first escape from the glass factory where he worked as an engineer. Turning a hobby that had begun with his father's vest-pocket Kodak camera at the 1937 World's Fair into a career, he left his job and his

hometown of Lyon in 1952, ending up in Paris with a Leica. In France's capital he met Henri Cartier-Bresson, who gave him an old viewfinder camera; the master felt that its inverted image was helpful for learning composition. With it, Riboud, being something of a tourist in Paris, walked over to the Eiffel Tower—fortuitously in the process of being repainted—climbed up the spiral staircase, spotted men who looked more like "acrobats than painters," and captured one of his most memorable images. Robert Capa, checking his contact sheet, singled out one shot, which was sold to *Life* magazine.

By 1953 Riboud was a member of Magnum (where he stayed until 1980), traveling the world as a photographer. Just over a decade later and a continent away in Vietnam, Riboud, as a French citizen, was able to move freely through both the North and South, gaining a unique perspective on the conflict—in fact, he was the last European journalist to photograph and interview Ho Chi Minh. Riboud also photographed the war on America's home front. His 1967 image of a young woman clutching a flower as she confronted a seemingly endless row of bayonet-wielding soldiers guarding the Pentagon symbolized the growing antiwar sentiment. That single image was the visual equivalent to John Lennon's lyrics for "Give Peace a Chance." While he has covered world conflicts, Riboud is more interested in countries and societies in the process of change, finding China in particular fascinating.

Herb Ritts
born 1952

Though Herb Ritts was voted most likely to succeed at Paul Revere Junior High School in Los Angeles, he really didn't know at what—perhaps in the music industry, at the business end. In 1979, while working as a sales rep for his father's furniture company he photographed a friend—an aspiring actor by the name of Richard Gere—with his Miranda camera while waiting for a flat tire to be fixed at a San Bernardino gas station. Gere mentioned Ritts's photos

to his publicist and suggested that they should be considered alongside those of the professional photographers that were shooting him. The photographs of Gere ended up in *Vogue, Esquire,* and *Mademoiselle* and on the cover of *L'Uomo Vogue* in Italy. *Mademoiselle* got so much fan mail from Gere's picture that Ritts was hired without a portfolio (his only formal training in photography had been three sessions of an evening photo class) to photograph Brooke Shields. He continued to photograph friends, including Matt Collins, a top male model in the late 1970s. While at a furniture show in New York for his parents he brought a little paper sack of around fifteen of his pictures. A girlfriend of a friend of his who worked for *Harper's Italia* saw his work and sent trunks of men's clothes—Versace, Armani, Missoni—from Italy to Ritts who by this time was back in Los Angeles and asked him to shoot the whole men's collection. He took Matt Collins to the beach in Santa Monica and shot twenty pages of the fall collection under the pier. Eventually Franca Sozzani, the editor of *LEI* Magazine at the time, started sending clothes. Soon he was able to put a portfolio together, buy some Nikons, and seriously pursue a career in photography. Assignments from *Look* magazine ranging from hot tubs to the Bottoms Brothers family bolstered his portfolio, along with work for *TV Guide* and *People,* and fashion campaigns, including Armani. As his eye matured, so did his interest in developing personal assignments and book projects such as *Duo, Notorious,* and *Africa.* He is based in Los Angeles, where Hollywood has often turned to him with its biggest stars.

Joe Rosenthal
born 1911

Just out of high school in the spring of 1930, with the depression setting in, Joe Rosenthal left Washington, D.C., for San Francisco with just enough money for a one-way train ticket to join his brothers and an uncle and his family. He soon landed a job as an office boy in a newspaper syndicate, a subsidiary of the *San Francisco News* and the Scripps-Howard chain, for fifteen dollars a week, sweeping floors, filing papers, and using the

copy camera to make copies of photos to be distributed. After a short time he was handed a Graflex and shown how to use it, and told to go out and shoot a few pictures, bring them back, develop them, and get critiqued. The on-the-job training enabled Rosenthal in 1932 to land a job on the *San Francisco News* as a reporter/photographer covering hospital emergency rooms, the police headquarters, and the courts, as well as various events, including the great waterfront strike of 1934, where a mob of rioters not wanting to be identified sent him to the hospital for eight days.

In 1936 Rosenthal became the chief of the San Francisco bureau of Wide World Photos, which was sold to the Associated Press in 1941. When Pearl Harbor was attacked, he applied to go overseas for the AP but was passed over. In the middle of 1943 he joined the Maritime Service's newly formed correspondent section. He was first stationed in Britain, where his orders were to go around to the seamen's hospitals to get adventure stories, which were meant to entice volunteers for the Merchant Marine. After similar work in Algiers, Rosenthal was asked to meet a writer in New Guinea. On the way to his new assignment he stopped by the office of the Associated Press in San Francisco, where an assistant photo editor said they were looking for a replacement in the South Pacific. Wanting to get closer to the action, Rosenthal resigned from the Maritime Service, and in January 1944 was accredited as an Associated Press correspondent. His first published action photos as an official war photographer were of the assault on Hollandia, New Guinea, followed by Peleliu. On February 23, 1945, Rosenthal, a relatively unknown war correspondent, ascended Mount Surabachi on the strategically vital island of Iwo Jima and put himself in the history books with one sheet of film. After the war and the intense notoriety from the flag-raising image, Rosenthal resigned from AP, went up a flight of stairs, and joined the *San Francisco Chronicle,* a paper he worked with for the next thirty-five years, retiring due to cataracts in 1981.

Sebastiao Salgado
born 1944

Born in Brazil in 1944, the only son among eight children, Sebastiao Salgado Jr. trained to be an economist. Upon earning a master's degree from Sao Paulo University, he worked for the Brazilian Ministry of Finance and two years later in 1969 moved to Paris to continue his study. In the early 1970s, while working for the International Coffee Organization in collaboration with the European Development Fund, the United Nations' Food and Agriculture Organization, and the World Bank on the development of coffee plantations in Africa, he began to experiment with photography. Soon the self-taught photographer's newfound passion turned into his life's calling. Acutely aware of the causes and effects of financial policies and environmental changes on a country's citizenry, Salgado sees economics in human terms and expresses his intellectual understanding and emotional feeling visually through his photographs. Salgado's major photojournalistic coverage includes Portugal after the overthrow of the dictatorship (1974–75), the independence movements in Angola, Mozambique, and Rhodesia, the famine in the Sahel region of Africa, migrants in Europe, peasants in Latin America, the troubles of war-torn Bosnia and Rwanda, and a portrait of manual labor around the world, documenting a vanishing way of life.

Jeanloup Sieff
born 1933

A black plastic Photax camera that Sieff received for his fourteenth birthday became the catalyst for a career that has spanned more than four decades. Sieff taught himself through books how to develop film and enlarge prints. Girlfriends and landscapes, the subjects of his early photographs, have held his interest over the next half-century. From his high school days in charge of the school's movie club, Sieff feels he has been more visually influenced by the films of master directors—including Sergei Eisenstein, Roberto Rossellini, Jean Renoir, Michelangelo Antonioni, and Orson Welles—than by other photographers.

Sieff's professional career began in 1954 as a freelance photographer. In 1956 he started shooting for *Elle.* In 1958 he joined the prestigious photo agency Magnum but found their attitude too dogmatic. He moved to New York in 1961, living and working there until he returned to Paris in 1966. He has worked with many of the world's great fashion magazines, including *Vogue, Harper's Bazaar,* and *Elle,* as well as contributing feature spreads in non-mode periodicals. Throughout his career Sieff has refused to be labeled as a fashion photographer, a documentary photographer, or a fine art photographer; his work has ranged from reportage to fashion, from nudes to landscape, with his singular eye finding beauty in all.

Index of Titles

Acknowledgments

My sincerest thanks to editor Owen Dugan for steering me in all the right directions, to designer Molly Shields for so beautifully performing the difficult balancing act between photographs and text, and to publisher Bob Abrams and the staff of Abbeville Press.

I am grateful to the following curators, photo editors, agents, writers, studio managers, photo assistants, and friends who helped this book become a reality:

Martha Bardach, Naomi Ben-Shahar, Bonni Benrubi, Nigel Boekee, Dean Brierly, Masako Bristol, Henri Bristol, Briana Beukenkamp, Tricia Burlingham, Debra Cohen, Stephen Cohen, A. D. Coleman, John Cooper III, John Cranham, Kim Creighton, Uri Davidov, Mari Deno, Maggie Devcich, Lon Diamond, Susan Easton, Jennifer Erwitt, David Fahey, Linda Ferrer, Daniela Ferro, Peter Fetterman, Michele Filomeno, Johanna Fiore, Michael Fisher, Lottie Flores, Gary Fong, Mark Fogelman, Harry and Yoko Friedman, Arny Freytag, Michael Froehlich, David Friend, Sarah Gaddis, Rudy Gaines, Amy Gantman, Jane Gilman, Vicki Goldberg, Robert Goldrich, Michelle Goldstein, David Gregg, Sylvie Grumbach, Shona Gupta, Marina De Santiago Haas, Mika Haneishi, Bob and Sheila Harris, Laura Harris, Roy Harris, Thom Harrop, Russell Hart, Andrew Hathaway, Lorenzo Hernandez, Charlie Hess, Julian Hills, Jennie Hirschfeld, Charlie Holland, Dave Howard, Ana Jones, Julie Jordan, Andrew Jurun, Marc Kane, Carolyn Kass, Robert Kirschenbaum, Ghassan Kitmitto, Maryann Kornely, Mary LaFleur, Annie L'Hospitalier, Patrick Langier, Sylvie Languin, Sharon Lebowitz, Jean-Francois Leroy, Gordon Lewis, Gus Low, David Manfredi, Lupe Marmolejo, Jay Mason, Mark McKenna, Robin Massee, Remy Meraz, Colleen Miller, Hugh Milstein, Ira Mintz, Francoise Mommessin, Mary Morano, Robbie-Lee Moreno, Xavier Moreau, Kerry Morris, Karen Mullarkey, Phillip Nardulli, William Neill, Anh Nguyen, Veronique Noe, Ara Nuyujukian, Melissa O'Brien, Stacie O'Connor, Mio Okita, Richard Papel, Bobbi Peacock, Francoise Piffard, Vivette Porges, Gene Prizer, Sandra Ramirez, Jane Levy Reed, Catherine Riboud, Peter Ridding, Richard Reinsdorf, John Rice, Christopher Robinson, Billy Rose, Naomi Rosenblum, David Rudnitsky, Kurt Sanders, Yvonne Sarceda, David Schonauer, Rob Sheppard, Phil Shockley, Rose Shoshana, Manuela Salgo, Molly Schaeffer, Marie Schumann, Jeffrey Smith, Robert Sobieszek, Rick Smolan, Mark Solomon, Paula Symonds, Lisa Thackaberry, Van Thomas, Christopher Thorpe, Kris Toma, Cecile Traissac, Linda Trozzolino, Miki Tsubuya, Mayra Villa, Alan Wakamatsu, Masako Watanabe, Kelly Wearstler, Steven Werner, Bill White, Garrett White, Don Weinstein, Bonnie Winston, Sandra Wong, Tim Wride, Chloe Ziegler, Tim Zinnemann.

My ultimate appreciation must go to the extraordinary photographers who have so generously shared their thoughts and photographs.

The photographers' portraits were made with Nikon F3 and N90S cameras with 28mm, 35mm, 50mm, and 85mm Nikkor lenses on Kodak TRI-X and T-MAX films and were printed by Kris Toma at Photo Impact, Los Angeles.

Photography Credits